Classic Ikebana
Moribana Style

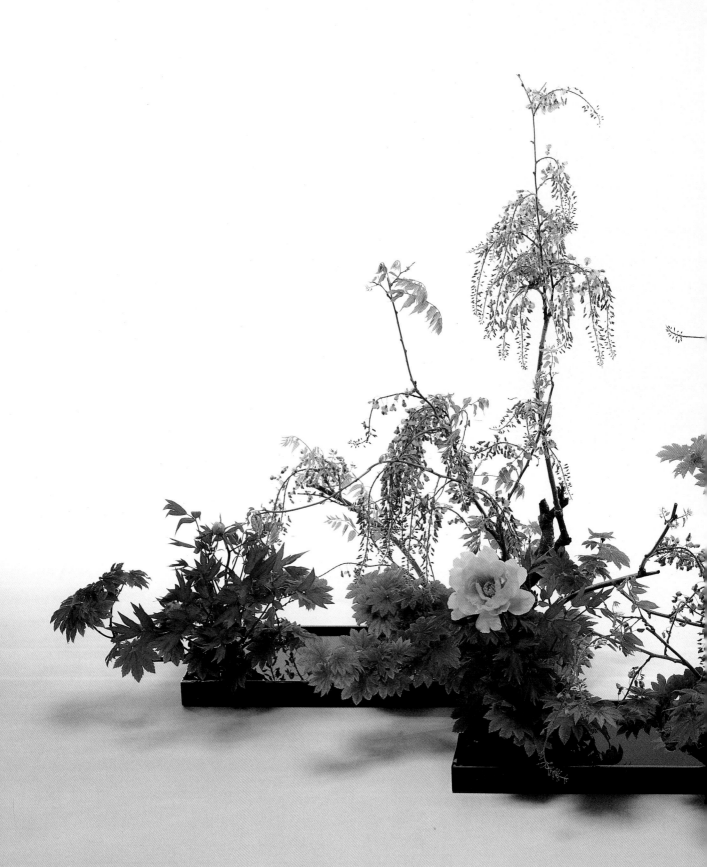

Classic Ikebana
Moribana *Style*

Kazuhiko Kudo

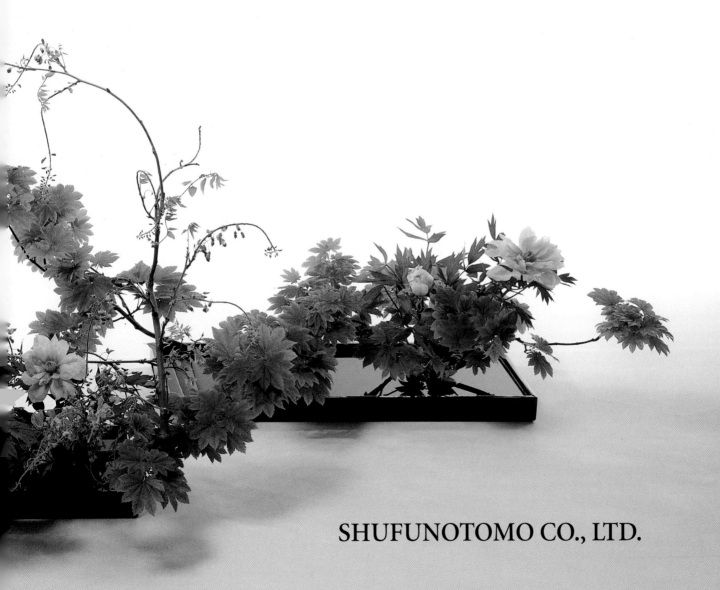

SHUFUNOTOMO CO., LTD.

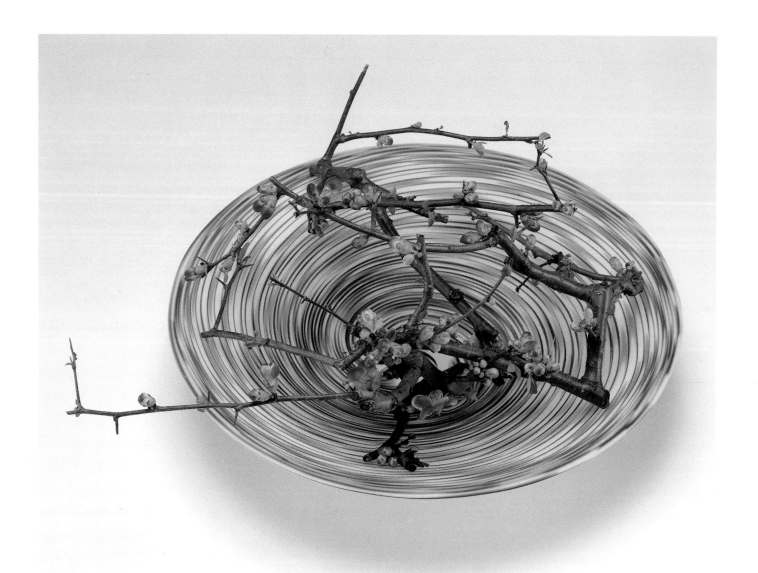

First printing, 1996

© Copyright in Japan 1996 by Kazuhiko Kudo
Photographs by Mikio Matsuo
English text supervised by Joseph LaPenta
Book design by Momoyo Nishimura

Published by Shufunotomo Co., Ltd.
2-9, Kanda Surugadai, Chiyoda-ku, Tokyo 101 Japan

ISBN: 4-07-976385-9
Printed in Singapore

Contents

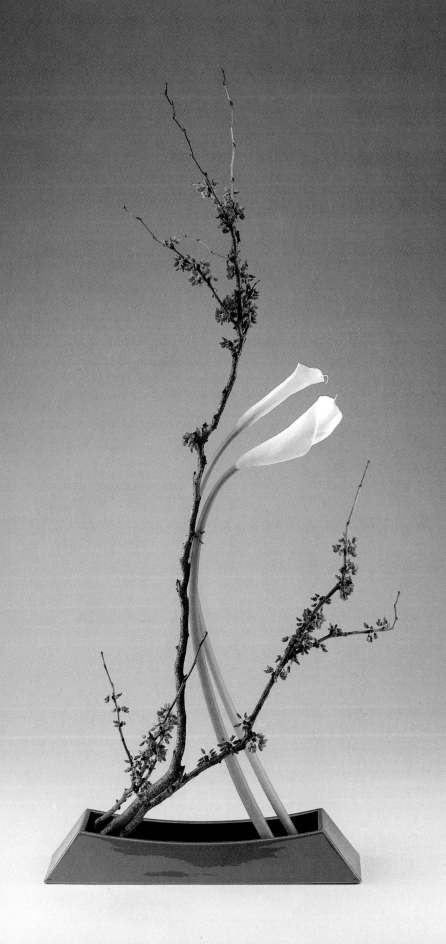

Preface

Moribana is a form of ikebana originated by Unshin Ohara in 1895, that is, in the middle of the Meiji era (1868-1912). In Moribana (literally "piled up flowers"), materials are arranged in large, wide, shallow containers called *suiban,* thus giving the artist sufficient scope to display his or her individual character.

During the Meiji era, Western plants were rapidly introduced into Japan and the number of cultivated species increased dramatically. Color Scheme Moribana, which actively utilized these new varieties, and Landscape Moribana, which represented a "sketch" of a natural scene in the limited space of the *suiban,* developed into the two major pillars that form the very core of twentieth century ikebana.

Landscape Moribana, arranged in a *suiban* with a variety of supports used to fix the materials in place, expresses the dramatic character of natural landscapes. Materials are not forced into predetermined shapes, as is the case with more traditional methods, but are used in such a way as to faithfully preserve their natural appearances.

Color Scheme Moribana also rejects the traditional approach to creating and displaying ikebana. Capturing the beautiful forms of flowers, branches and leaves in combination with containers, it has liberated ikebana from the confines of the traditional *tokonoma* alcove, and developed the art in forms that can decorate all kinds of spaces where people live and work.

The works introduced in this volume include all forms of Moribana. While some may assume that the creative possibilities of the style, with its one-hundred year history, have already been thoroughly explored, I believe that we can look forward to the development of new forms in the future.

Kazuhiko Kudo

I
The Basics of Moribana

The Basics of Moribana

Elementary Form Styles

There are four Elementary Form Styles: A, B, C and D. In Elementary Form Styles A and B, the principal stem, called the Subject, is arranged to rise vertically. In Elementary Form Styles C and D, the Subject is arranged slanting at an angle. All four styles are composed of two principal stems, the Subject and the Object, and intermediaries called Filler stems.

Elementary Form Style A

This style expresses the beauty of flowers or branches that rise vertically. It is arranged in the center of the container.

*

The gladiolus as the Subject is twice the length of the diameter of the container, and is inserted rising vertically in the front center. A prairie gentian as the Object is one third the length of the Subject, and is inserted at the base of the Subject gladiolus. It slants forward at an angle of 45 degrees to complete the basic structure. Next, a second gladiolus, slanting slightly to the left, is inserted in front of the Subject. Gladiolus leaves, used to complete the form, are arranged to the left and right, in front of and behind the Subject. Finally, two prairie gentians are used as Filler stems to support the Object.

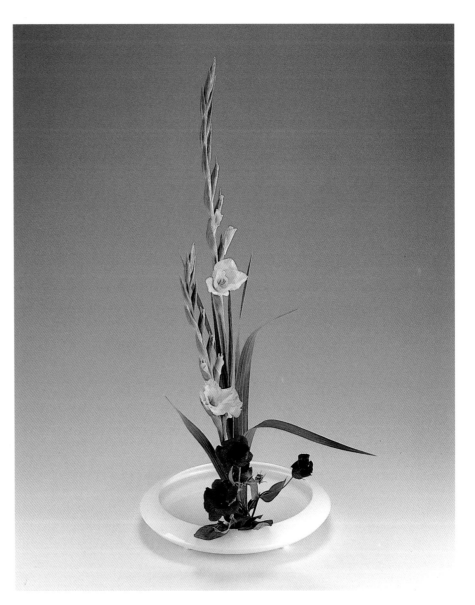

Materials: Gladiolus, prairie gentian
Container: White-glazed *suiban* with legs

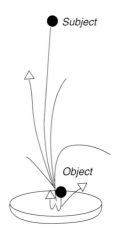

Elementary Form Style B

The trumpet lily as the Subject is 1.5 times the length of the diameter of the container, and is inserted vertically in the left rear of the container in a *hongatte* arrangement. (See note on *hongatte-gyakugatte* at the end of this section.) A single rose as the Object is one third the length of the Subject, and is inserted at the base of the Subject lily. It slants forward at an angle of 45 degrees to complete the basic structure. Next, a second trumpet lily used as a Filler stem is placed in front of the Subject and swings slightly to the left. A second rose is arranged behind the Object as a Filler. Finally, a third rose that is one half the length of the Subject lily is placed in the space on the right to complete the arrangement.

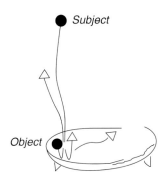

Hongatte Arrangement

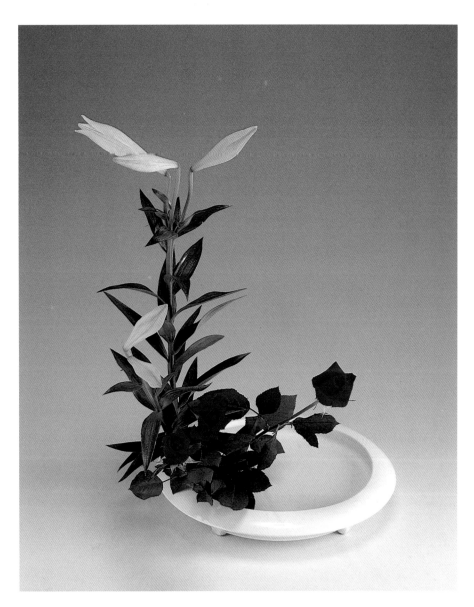

Materials: Trumpet lily, rose
Container: White-glazed *suiban* with legs

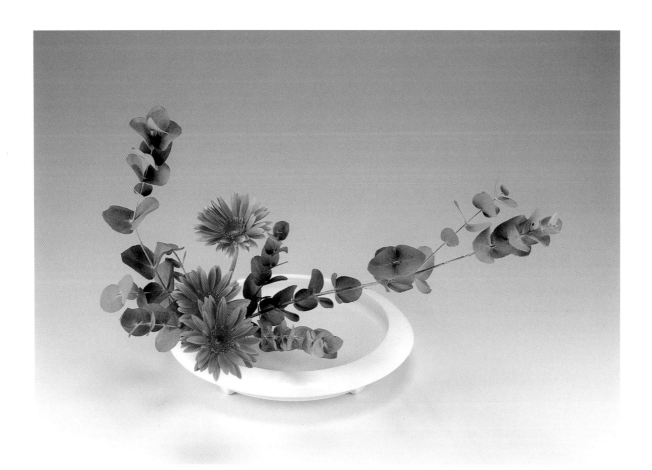

Elementary Form Style C

Materials: Eucalyptus, Transvaal daisy
Container : White-glazed *suiban* with legs

Eucalyptus as the slanting Subject stem is 1.5 times the diameter of the container. It emerges from the right, slants down 70 to 80 degrees and swings 30 degrees forward from an imaginary horizontal line drawn through the center of the container. Some leaves are trimmed to create rhythmical variations along the line of the branch. The Object, a Transvaal daisy, is one third the length of the Subject, and is inserted slanting forward in front to complete the basic structure of the composition. Next, a branch of eucalyptus is placed as a Filler slanting to the left. Additional Filler stems of eucalyptus are added in front of and behind the Subject to fill out the space. A second daisy, about half the length of the Subject, is arranged tall and in an expressive upright posture in the space behind the tall Filler of eucalyptus. At its base, a third daisy is added to strengthen the color effect of the Object.

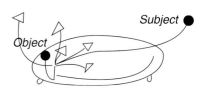

Hongatte Arrangement

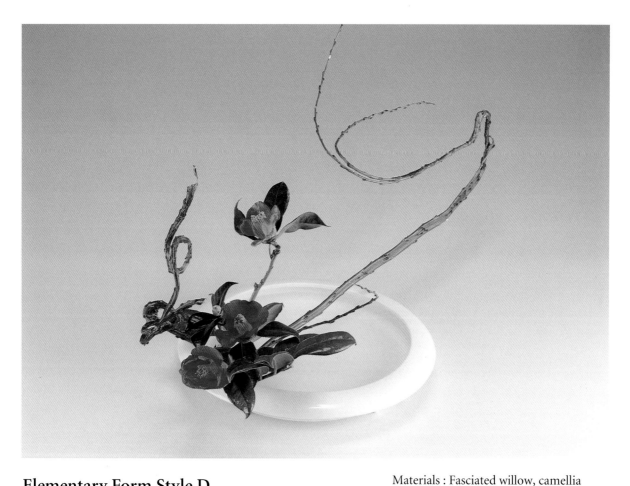

Elementary Form Style D

Materials : Fasciated willow, camellia
Container: White-glazed *suiban* with legs

The Subject is a sinuous branch of fasciated willow that is 1.5 times the length of the diameter of the container. It is inserted at the center on the left side. It slants downward 70 to 80 degrees and flows backward to the right at an angle of 45 degrees from an imaginary horizontal line in the center of the container. The Object stem, a branch of camellia with an open blossom, is placed at the base of the Subject. It leans forward 45 degrees to complete the basic framework of the composition. Next, a branch of fasciated willow with an interesting looping form is placed as a Filler stem slanting slightly forward on the left. Here, due attention should be paid to the balance between

this stem and the Subject. A small branch of willow placed near the front supports the Subject stem. Finally, a branch of camellia that is about half the length of the Subject is arranged tall in the center, and leafy twigs are added at the base to complete the arrangement.

Note:
Arrangements on the left side of the container are called *hongatte* in Japanese. Those on the right side are called *gyakugatte*. This distinction does not apply to Elementary Form Style A because it is always arranged in the center of the container.

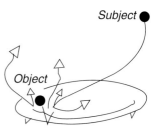

Hongatte Arrangement

Moribana Style

In the Ohara School, the term "style" designates a floral composition created according to detailed rules. The following are the six styles and one variation defined as Moribana styles. The principal stems are called the Subject, the Secondary and the Object. All other elements in the composition are called Filler stems.

Moribana Styles

The Upright Style is the standard Moribana style. It expresses the beauty of materials that stand upright.

The Heavenly Style is arranged in the front center of the container. It highlights the distinctive features of materials that rise vertically.

The Slanting Style and the Slanting Style Variation express the beauty of the slanting line of materials.

The Cascading Style expresses the figure of plants that arch and cascade.

The Contrasting Style emphasizes the beauty of the shapes of materials arranged symmetrically.

The One-row Style produces a captures beauty with plants arrayed in a single row and in a shallow space.

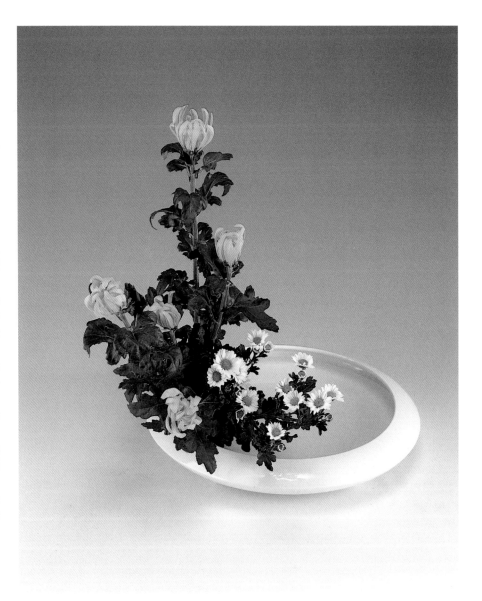

Materials: Chrysanthemums (medium-sized yellow and small white)
Container: White-glazed *suiban* with legs

UPRIGHT STYLE

The length of the Subject, a yellow chrysanthemum, is equal to the diameter plus the depth of the container. It is placed in an upright position at the left rear of the *suiban*. The Secondary, also a yellow chrysanthemum, is cut to two thirds the length of the Subject, and is placed at the left front. It slants forward 45 degrees and swings 30 degrees to the left. Another yellow chrysanthemum at half the length of the Subject is inserted in front of the Subject and slants forward. A fourth chrysanthemum slants deeply in front, supporting the Secondary. The fifth and final medium-sized yellow chrysanthemum is placed low between the Subject and the Secondary. A stem of small white chrysanthemums as the Object slants forward 60 degrees and swings 45 degrees to the left. To complete the arrangement, two additional stems of white chrysanthemums are inserted, one in front of the Object and one behind it.

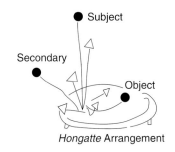

Hongatte Arrangement

HEAVENLY STYLE

In order to capture the free, upward-rising figure of young pine, the Subject stem is cut to 1.5 times the diameter of the container and placed in the front center. It is slanted forward 15 degrees, giving full play to the smaller offshoots that diverge from the main branch. The Secondary, another branch of young pine at one half the length of the Subject, is placed in front of the Subject. It slants 30 degrees forward and swings slightly to the left. A third pine branch is inserted as a Filler stem behind the Subject and slants slightly to the right, that is, in a direction opposite that of the Secondary. A single pincushion as the Object is placed directly in front, slanting 80 degrees forward. Another pincushion with its stem swinging slightly to the right is used as a Filler to support the Object. Finally, three small pine branches are arranged low to give a neat, consolidated appearance to the base of the work.

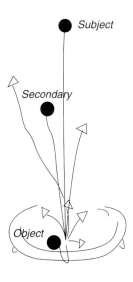

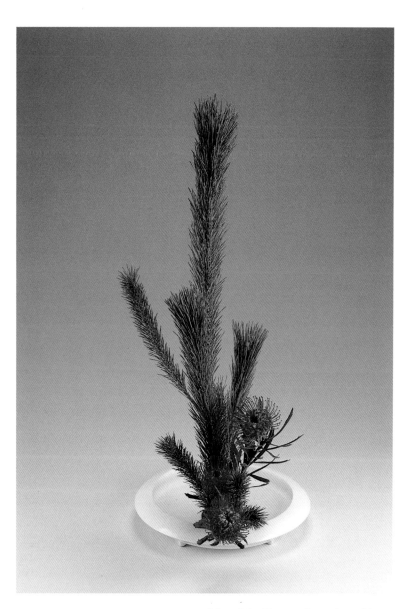

Materials: Young pine, pincushion
Container: White-glazed *suiban*

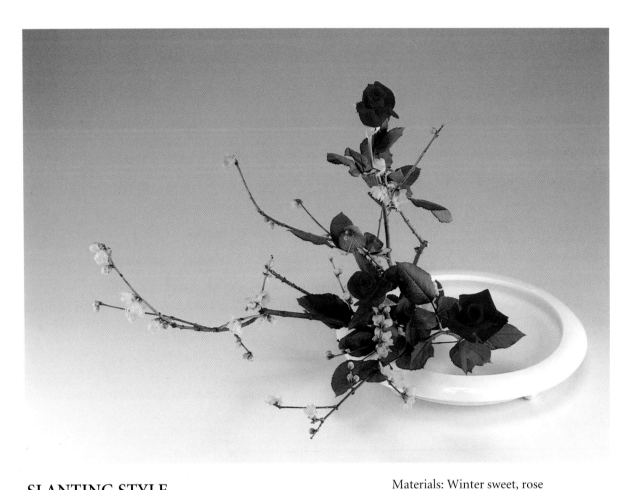

SLANTING STYLE

Materials: Winter sweet, rose
Container: White-glazed *suiban* with legs

A beautiful curving branch of winter sweet that is 1.5 times the length of the diameter of the container is selected for the Subject and inserted at the left front of the *suiban*. It slants forward 70 degrees and swings 45 degrees to the left. The Secondary, another branch of winter sweet that is one half the length of the Subject, is inserted in the left rear with its tip drawn back toward the left. A tall Filler stem of winter sweet is inserted at the base of the Secondary and slants forward. Small branches are added at the base of the Subject and between the Subject and the Secondary to give the winter sweet a fuller, more expansive appearance. With emphasis on its tall posture, a rose is positioned in the space between the tall Filler of winter sweet and the Secondary, and another rose is placed low between the tall Filler and the Subject. Finally, as the Object, a third rose slants forward 50 degrees, swings 30 degrees to the right and neatly consolidates the base area of the arrangement.

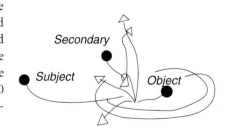

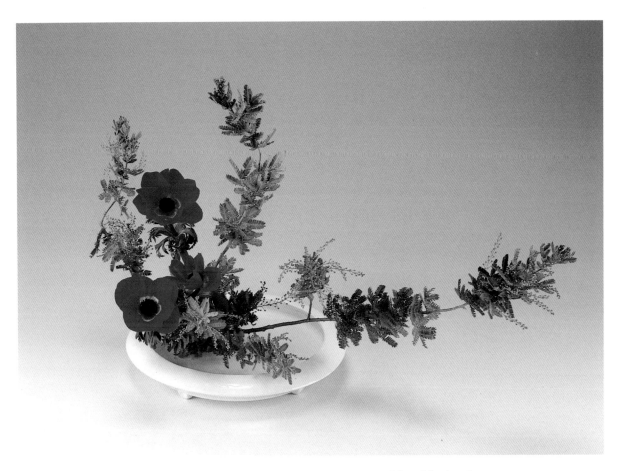

SLANTING STYLE VARIATION

Materials: Acacia, anemone
Containar:White-glazed *suiban* with legs

To capture the curving form of acacia, the Subject, a branch that is 1.5 times the diameter of the container, is inserted in the left rear of the *suiban*. It extends to the right, flowing over the surface of the water at a low slant, and swinging 45 degrees back from the front. Some leaves are trimmed to create a rhythmical linear form. The Secondary, another branch of acacia that is half the length of the Subject, is placed at the left rear with its tip slanting to the left. A tall Filler of acacia inserted at the base of the Secondary emerges slanting forward to balance the Subject and Secondary. Next, small branches of acacia are added in front and behind the Subject to consolidate the base area. An anemone is arranged tall in the center with its flower facing forward, and a second anemone, the Object, is placed in front at a very low slant and with its flower swinging 30 degrees to the left.

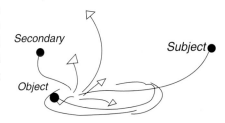

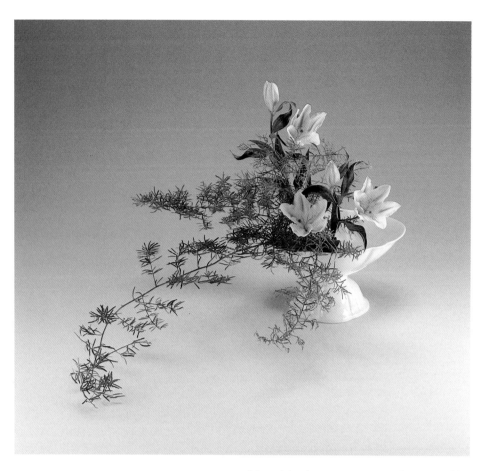

CASCADING STYLE

Materials: *Asparagus sprengeri*, Le Rêve lily
Container: White-glazed compote

The Subject, a cascading stem of *asparagus sprengeri* that is more than three times the height of the compote, is inserted at the left front of the container. It swings 45 degrees to the left and cascades downward at an angle of about 120 degrees from an imaginary vertical line drawn at the point of insertion. The Secondary stem of asparagus at about one third the length of the Subject emerges from behind the Subject, is drawn slightly backward and slants to the left. Additional stems of the same materials are added: one in the center, and the other under the Subject. One Le Rêve lily is positioned as the tall Filler, and a second is placed low near the base of the Subject.

Finally, a third lily, the Object, is arranged at a gentle slant to complete the arrangement.

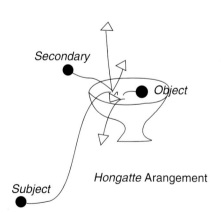

Hongatte Arangement

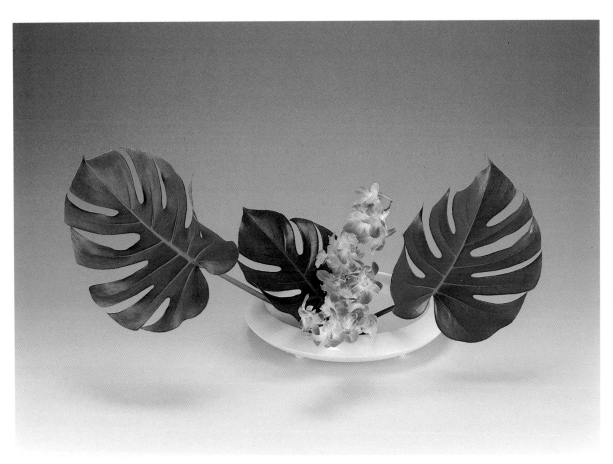

CONTRASTING STYLE

Materials : *Monstera, Dendrobium phalaenopsis*
Container: White-glazed *suiban*

To make the most effective use of the large surface area of monstera, one leaf as the Subject is inserted with the base of its stem in the front center. It fans forward 30 degrees from an imaginary horizontal line drawn through the center of the container. Another leaf as the Secondary is half the length of the Subject and is inserted on the right with the base of its stem crossing the base of the Subject leaf. It also fans forward at an angle of 30 degrees from the center and is positioned to place strong emphasis on the dramatic surface of the leaf. The point here is to bring out the asymmetrical beauty of the leaves placed on the left and right. A third leaf is arranged low behind the Subject, making effective use of the space and adding variety to the appearance of the surfaces of the leaves. A stem of *dendrobium phalaenopsis* is inserted slanting low as the Object, and two more Filler stems of the same material are placed along the central axis to complete the arrangement.

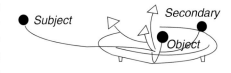

Hongatte Arrangement

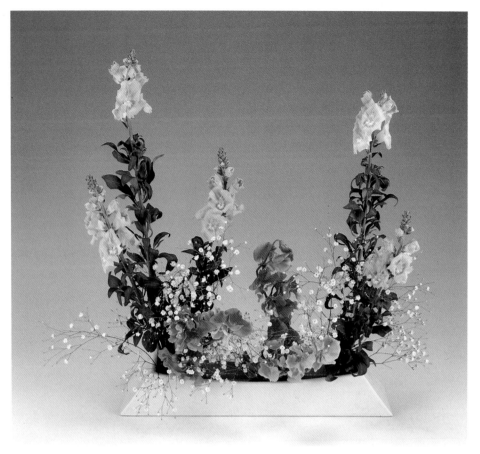

Materials: Snapdragon, sweet pea, baby's breath
Container: White-glazed *suiban*

ONE-ROW STYLE

The height of the stem of snapdragon used as the Subject is equal to the length of the diameter plus the depth of the container. It is placed in the left corner of the container and slanted slightly to the left. The Secondary, another stem of snapdragon nearly the same length as the Subject, is arranged in the right corner and slanted slightly outward to the right. A third snapdragon is inserted at the base of the Subject as a Filler that slants slightly to the rear. This creates a light sense of movement in depth between the Subject and the Secondary. A fourth Filler stem of snapdragon at the base of the Subject slants slightly forward and outward to the

left. The fifth and final snapdragon is inserted at the base of the Secondary, and slants outward to the right. These five stems complete the framework of the one-row composition. Next, sweet pea is massed together and arranged between the Subject and Secondary as the Object and its Filler stem. Sprays of baby's breath are added on the left and right to complete the arrangement.

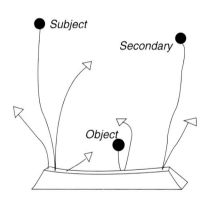

Hongatte Arrangement

HANAMAI

Hanamai is a form of ikebana that captures in a highly simplified composition the three-dimensional beauty of plants brought out by their mutual contact in space. Strelitzia and euphorbia, rising from opposite sides of the circular container, come into contact, and the contrast produces a unique kind of beauty. A leaf of New Zealand flax with its surface facing forward is inserted at the base of the euphorbia, and rises in such a way that its tip creates a sense of tension between the strelitzia and euphorbia flowers at the apex. The point here is to use only two or three kinds of material to create a multi-sided composition in which lines do not cross.

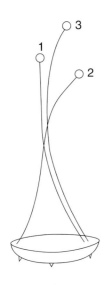

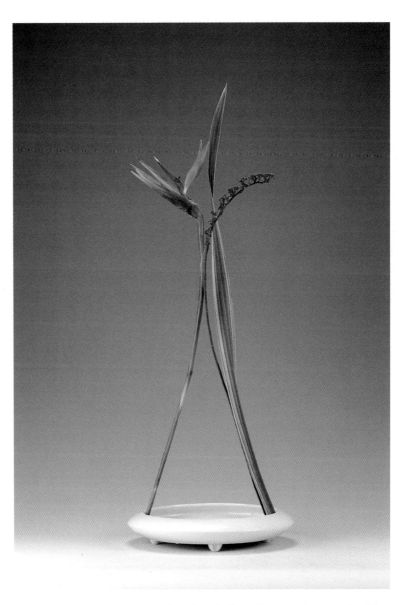

Materials : New Zealand flax, strelitzia, euphorbia
Container: White-glazed *suiban*

HANA-ISHO

Hana-isho is a multi-sided work of ikebana in which the base color is always green, but a different main color tone is chosen by the arranger. There are three types of arrangements in Hana-isho: Narabu (linear), Hiraku (radial) and Mawaru (circular).

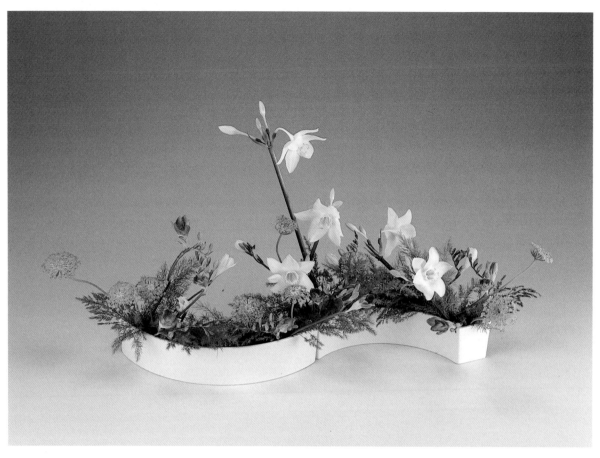

Narabu (Linear)

Materials : Eucharis lily, blue lace flower, freesia, *Asparagus myriocladus*
Container: Wave-shaped *suiban*

In Narabu, materials are arrange in a row. Lilies play the leading role in this work. First, a white eucharis lily is positioned in the center of the container as the Subject, the length of which is free. Another eucharis lily as the Secondary is placed at the right end of the container, facing in a direction opposite that of the Subject. Two more lilies are inserted low, one in front and the other behind the Subject. Due attention should be paid to varying the expressions of the flowers seen from different angles. The fifth and final lily is placed low at the base of the Secondary and faces in the opposite direction. Next, *asparagus myriocladus*, furnishing the base color, green, is placed low throughout the container. The Object, blue lace flower, is inserted at the left end of the container. Finally, freesia, as the Filler stems, are used to link the other materials and create an overall sense of continuity.

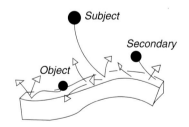

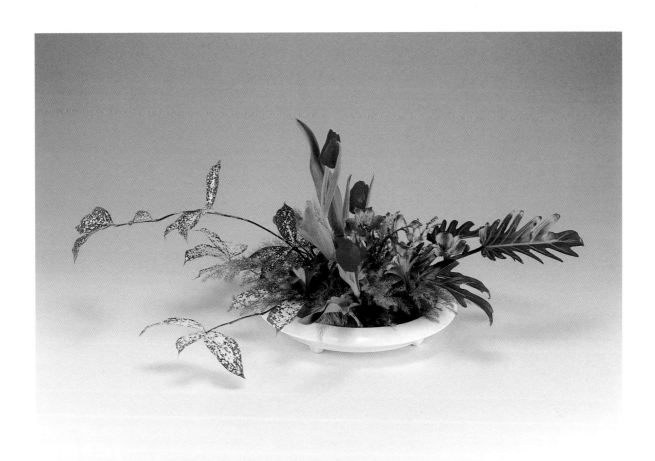

Hiraku (Radial)

Materials: *Dracaena godseffiana*, philodendron, tulip, alstroemeria, *Asparagus myriocladus*
Container: White-glazed *suiban*

The compositional framework of the second type of Hana-isho, called Hiraku, is characterized by bilateral radial symmetry. Different materials are used for the Subject and Secondary, which radiate to the left and right respectively. The Object is arranged in the center along the axis of symmetry. Three stems of *dracaena godseffiana,* as the Subject, emerge from the center and flow left within an angle of 30 degrees on either side of an imaginary horizontal line drawn through the long central axis of the work. Three philodendron, as the Secondary, are inserted at the right to radiate in a direction opposite that of the Subject. Next, a tulip is cut to slightly less than one half the length of the Subject, and is inserted in the front center as the Object. Two more tulips are added in front and behind: one slopes forward, the other slants deeply backward to establish the multi-sided character of the work. *Asparagus myriocladus* is placed low as the base color, and alstroemeria flowers are arranged at various points to fill out the space effectively.

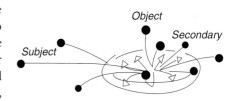

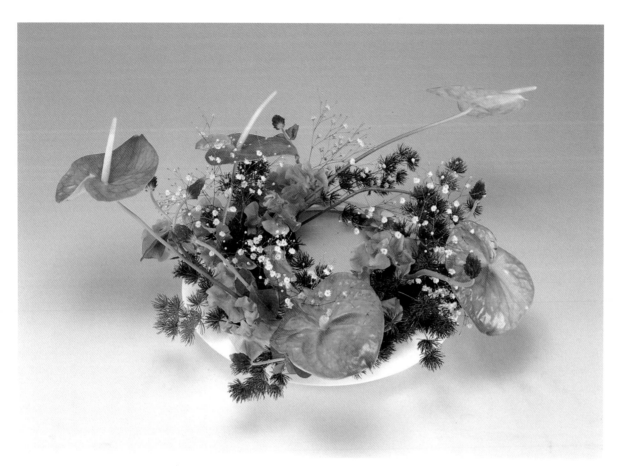

Mawaru (Circular)

Materials: Anthurium, sweet pea, strawberry candle, *Asparagus myriocladus*, baby's breath
Container: White-glazed *suiban*

In Mawaru, the third type of Hana-isho, the positions of the Subject, the Object, and the Filler stem that serves as the axis of the composition are fixed. The length of the Subject, an anthurium flower, is free. It may be placed anywhere along the circular rim of the container, but care should be taken to keep the angle between the flower and rim as small as possible. In addition, the angle of slant is low, which allows for the clear expression of the circular, rotating movement that a Mawaru arrangement should produce. The Object, another anthurium, is cut to about half the length of the Subject, and is placed at the opposite side of the container, emerging in the same manner as the Subject. Strawberry candle is used as the Filler that serves as the main axis of the composition. It is inserted at the base of the Object anthurium and slants in the same direction along the circumference. *Asparagus myriocladus* is arranged low all the way around the rim of the container. A third anthurium is placed at the third point of a triangle connecting the Subject and the Object flowers. Two more anthurium flowers are placed low within this triangular area to establish the multisided character of the arrangement. Other stems of strawberry candle are inserted in the same direction as the one serving as the main axis. They slant in a clockwise direction to emphasize the rotating movement. Filler stems of sweat pea are placed along the rim, and sprays of baby's breath are added as a final touch to complete the work.

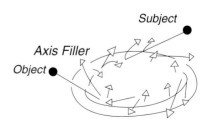

II
The Traditional Method in Moribana

In the Ohara School, the Traditional Method refers to formalized Moribana arrangements. There are two Traditional Methods, one in the Landscape Arrangement and another in the Color Scheme Arrangement.

Traditional Method in the Color Scheme Arrangement

The aim of the Traditional Method in the Color Scheme Arrangement is to bring out the beauty of color in works based on set rules for materials as well as methods of arrangement. Ten plants have been designated as main materials, and while the method of arranging them is prescribed, accompanying materials may be chosen freely, depending upon the season. The basic principle is to use three varieties, though there are occasions when five or seven varieties are used. The examples show representative arrangements using the most basic methods.

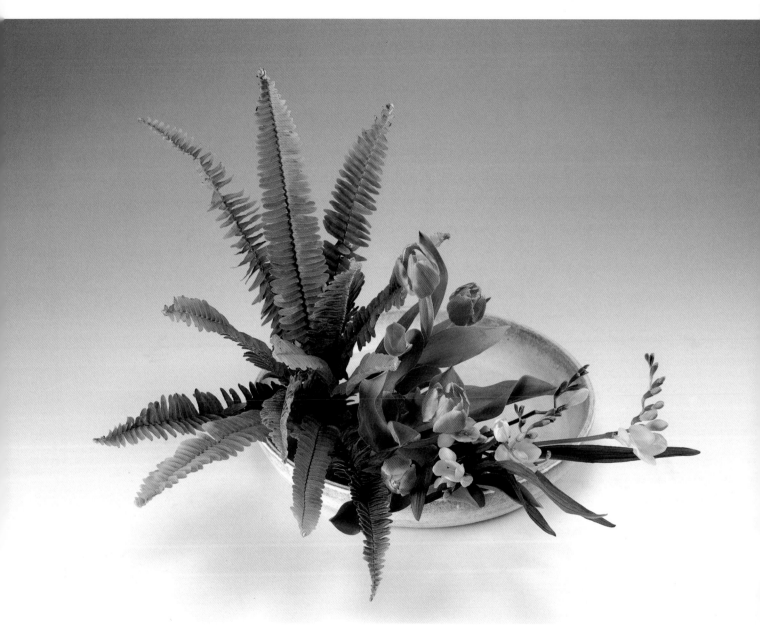

Upright Style
Usually eleven or thirteen fronds of sword fern are arranged in the Upright Style. They are gathered closely together at the base, with the tips spreading out like an open fan.
Materials: Sword fern, tulip, freesia / Container: Blue-glazed *suiban*

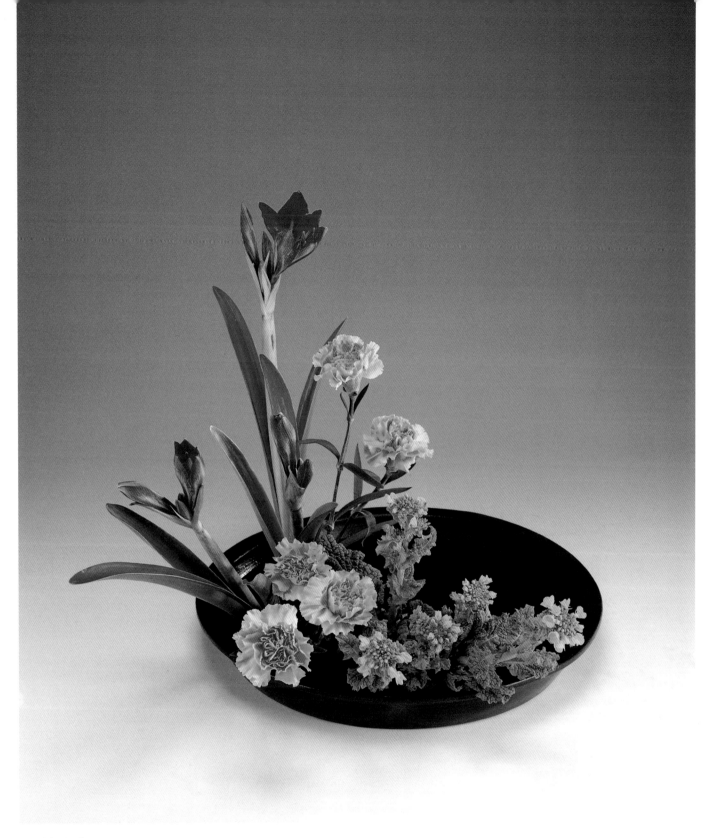

Upright Style
Amaryllis is arranged in the Upright Style with the flower in the center surrounded by three leaves.
Materials: Amaryllis, carnation, rape flower / Container: Black-glazed *suiban*

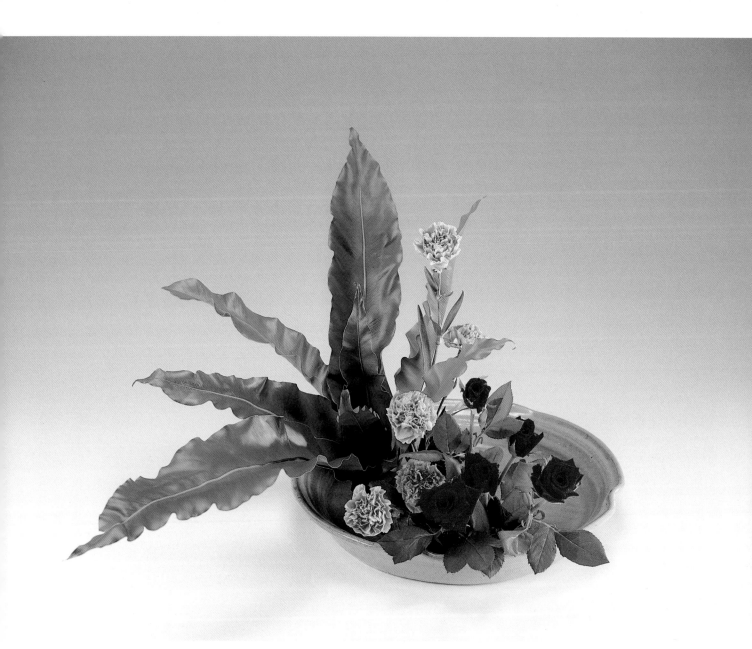

Slanting Style
Eight leaves of bird's nest fern are arranged in a single clump in the Slanting Style.
Materials: Bird's nest fern, carnation, rose, medium-sized chrysanthemum / Container: Celadon-glazed *suiban*

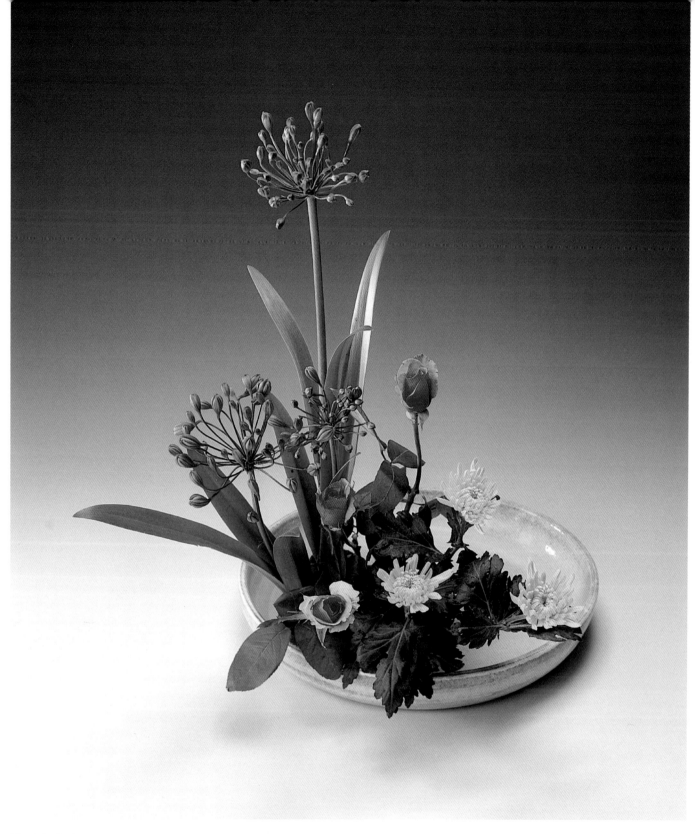

Upright Style
The stalk of the agapanthus flower is surrounded on three sides by leaves and arranged in the Upright Style.
Materials: Agapanthus, rose, medium-sized chrysanthemum / Container: Brown-glazed *suiban*

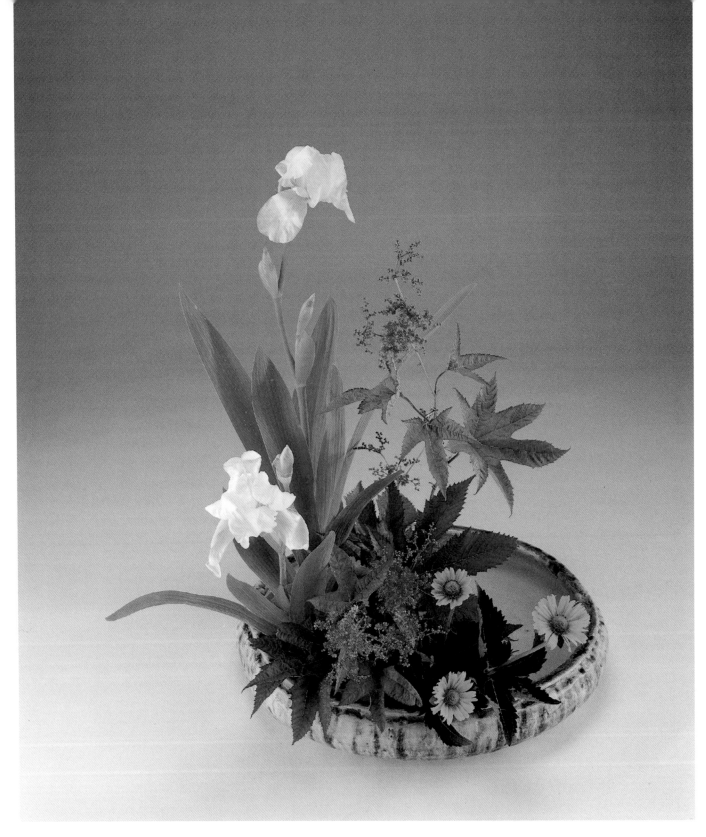

Upright Style
Individual natural groups of two or three leaves of roof iris are used. Five or seven of the two-leaf and three-leaf natural groups are placed in two clumps as the Subject and Secondary in the Upright Style. Two iris flowers are used, one each within the Subject and Secondary clumps, and one flower may also be used as a Filler.
Materials: Roof iris, *Filipendula purpurea*, Jerusalem artichoke / Container: Takatori-ware *suiban*

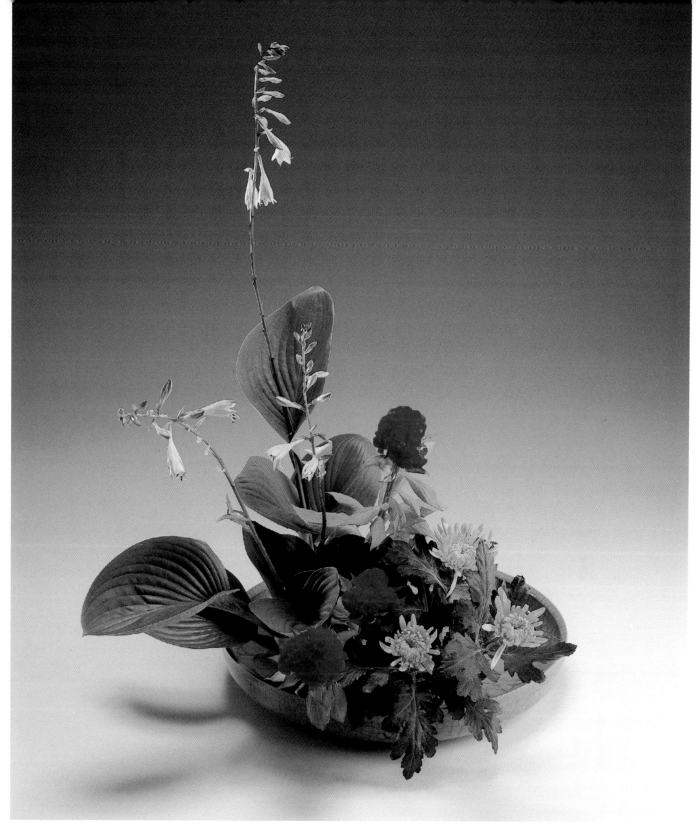

Upright Style
Three leaves of plantain lily are arranged around the flower in the Upright Style.
Materials: Plantain lily, cockscomb, chrysanthemum / Container: Celadon-glazed Yao *suiban*

31

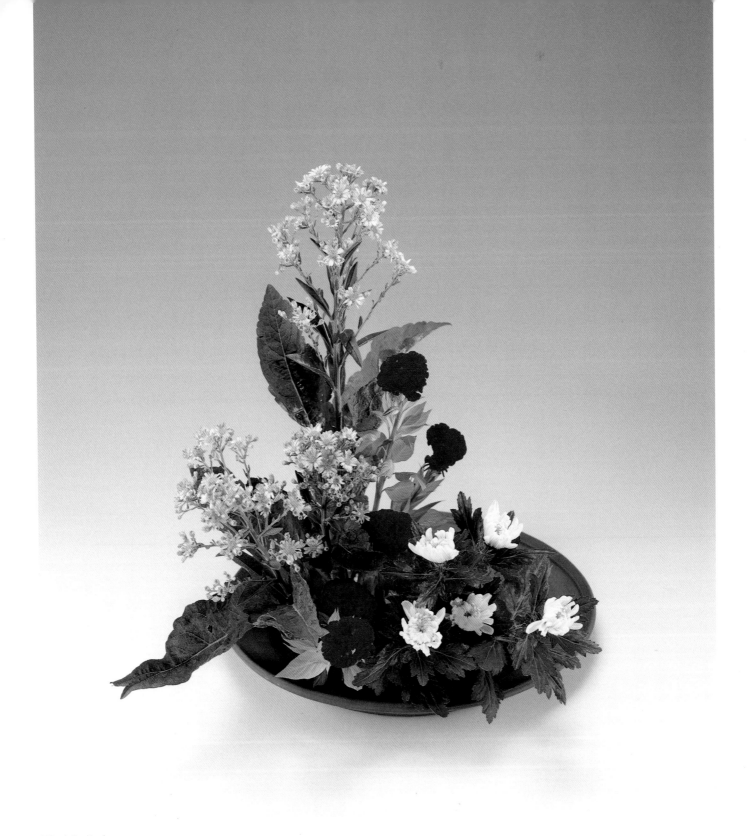

Upright Style

Arranged in the Upright Style, three large, radial leaves encircle the stalk of the flower. The number of leaves may be reduced when individual leaves are too large.

Materials: *Aster tartaticus,* cockscomb, chrysanthemum / Container: Nanban-style *suiban*

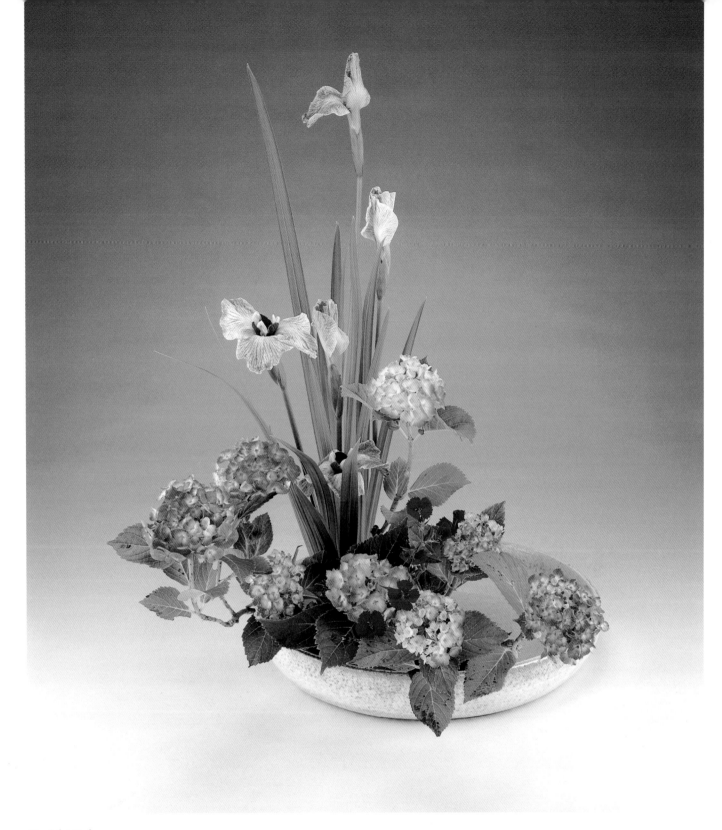

Upright Style

Natural leaf groups and five flowers of Japanese iris are arranged as the Subject and as Filler stems for the Subject group in the Upright Style. A different material, in this case, hydrangea, is used for the Secondary and for the Object.

Materials: Japanese iris, hydrangea, superb pink / Container: Blue-glazed *suiban*

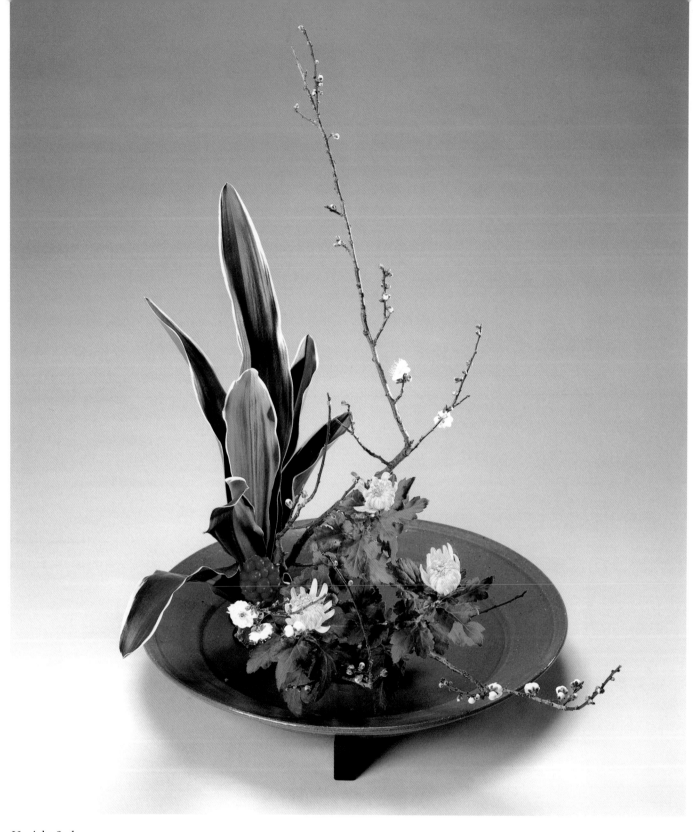

Upright Style
Arranged in the Upright Style, eight leaves and one cluster of berries are positioned tightly at the base in a single clump.
Materials: Japanese rhodea, Japanese apricot, chrysanthemum / Container: Celadon-glazed *suiban*

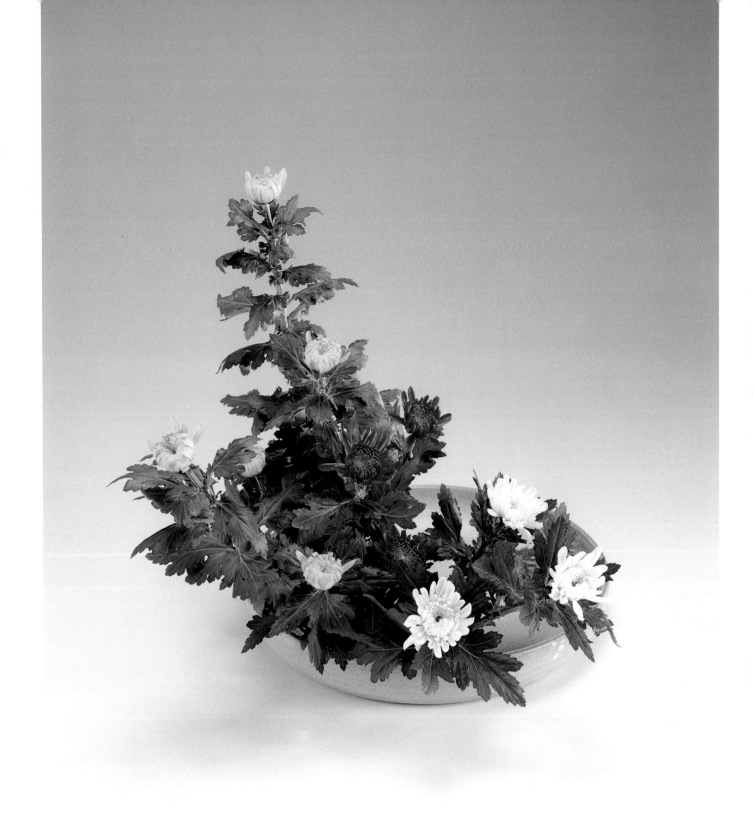

Upright Style
Five yellow, three red and three white medium-sized chrysanthemums are arranged in the Upright Style. In the Traditional Method in the Color Scheme Arrangement, the basic principle is to use three varieties, but there are occasions when five or seven varieties are used. The example shows the Traditional Method in its most basic form.
Materials: Chrysanthemum (three varieties) / Container: Blue-glazed *suiban*

Traditional Method in the Landscape Arrangement

The Traditional Method in the Landscape Arrangement is a highly stylized form of Moribana that expresses the beauty of a natural scene. It employs fixed methods of arrangement and a prescribed range of materials. The 20 examples that follow were chosen from a total of 48 arrangements in this category.

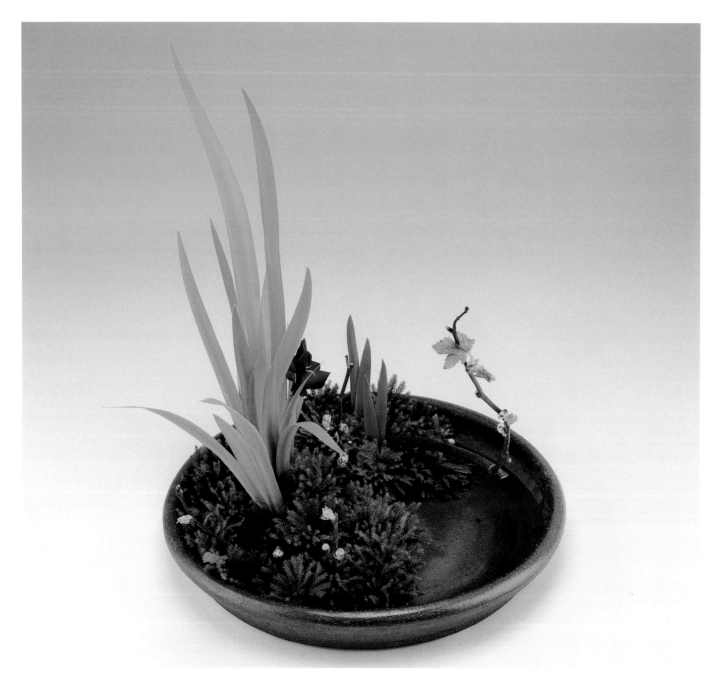

Upright Style, Near View, Early spring
Seed leaves and natural leaf groups of rabbit-ear iris are arranged in clumps in the Upright Style. The flower is positioned extremely low, with sprouting stems of raspberry emerging from the club moss.
Materials: Rabbit-ear iris, sprouting raspberry, club moss / Container: Nanban-style *suiban*

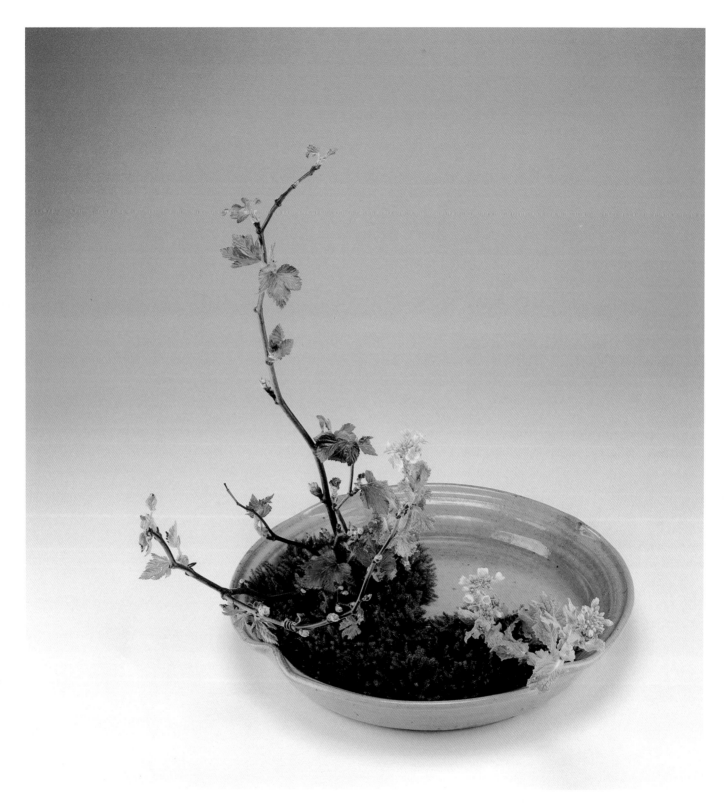

Upright Style, Middle View
In this Middle-View depiction, sprouting raspberry is arranged in the one-clump method. Stems of rape flower are used at the side of the clump of sprouting raspberry and as the Object. In spring, club moss covers two-thirds of the surface of the container. Sprouting raspberry may be arranged in either the Upright or the Slanting Style.
Materials: Sprouting raspberry, rape flower, club moss / Container: Celadon-glazed *suiban*

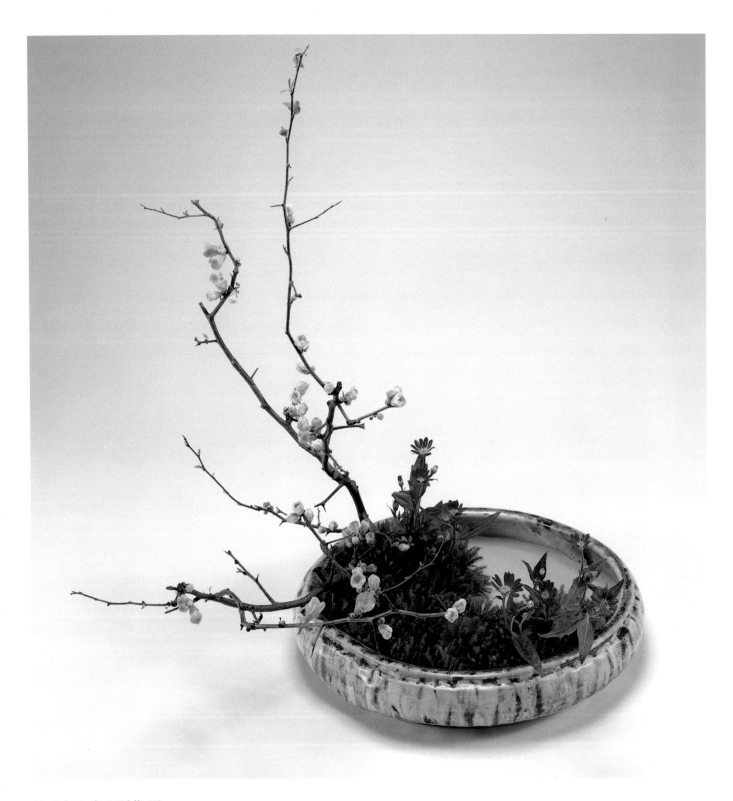

Upright Style, Middle View

Low shrubs like flowering quince are arranged with the base of their stems drawn closely together in the one-clump method. Branches of quince grow freely in all directions and often crisscross. This natural growth characteristic should be expressed in the arrangement. A tall aster is placed on the right of the quince, and asters are also used as the Object. This Middle-View Depiction may be arranged in either the Upright or the Slanting Style.

Materials: Flowering quince, aster, club moss / Container: Takatori-ware *suiban*

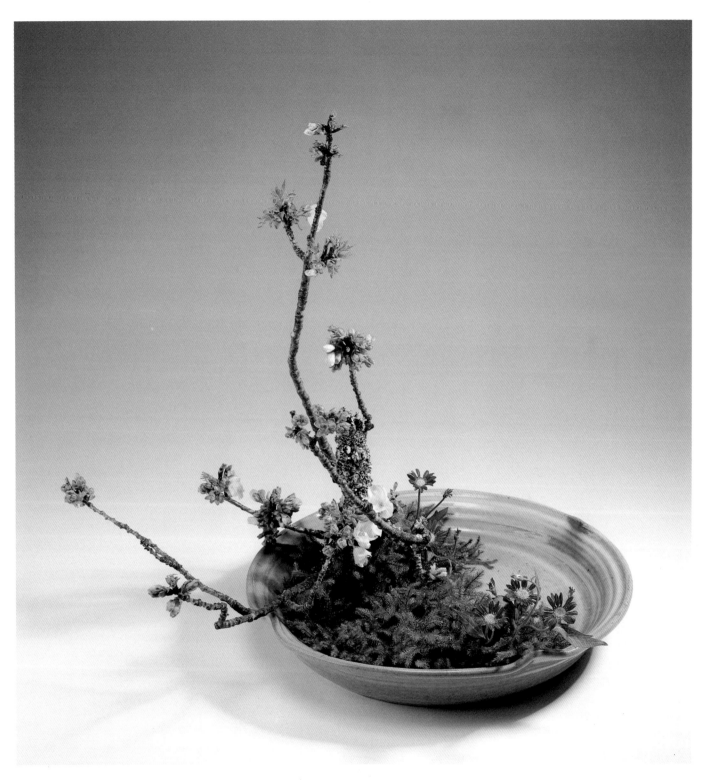

Upright Style, Far View

Cherry is arranged in the Upright Style with a thick trunk in the center. Thinner branches used as the Subject, Secondary and Filler stems are placed so that they appear to grow from this central trunk as a single tree. Called the one-tree arranging method, it is one of the techniques used in the Far-View Depiction. Techniques are applied to reduce the scale of the asters, which are arranged low to create the impression of a scene viewed at a distance.

Materials: Flowering quince, aster, club moss / Container: Takatori-ware *suiban*

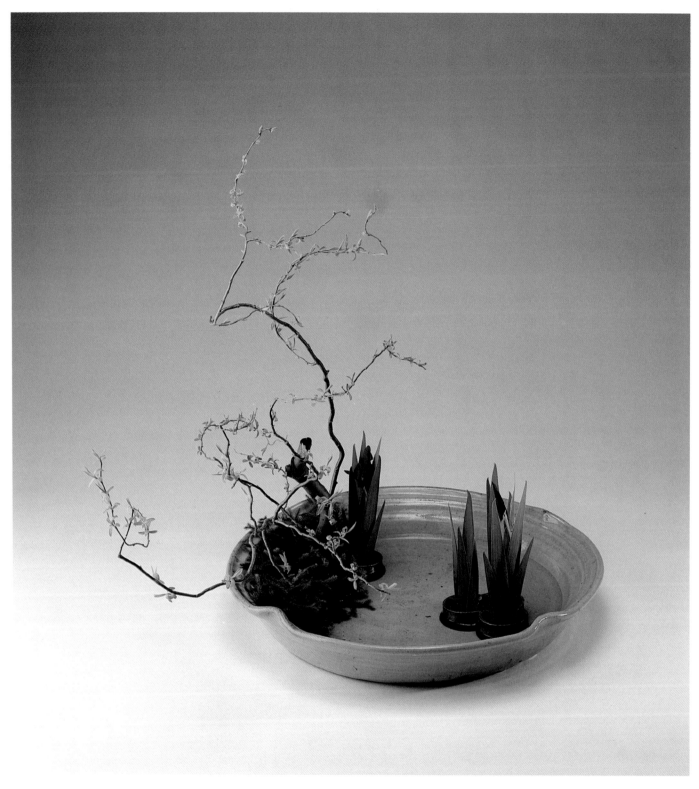

Upright Style, Far View
Unryu weeping willow is arranged with a thick trunk in the center. Thinner branches used as the Subject, Secondary and Filler stems are placed so that they appear to grow as a single tree, thus giving the appearance of a tall willow at the water's edge that is seen from a distance. Three spring clumps of rabbit-ear iris are arranged on a reduced scale in good balance with the willow.
Materials: Unryu weeping willow, rabbit-ear iris, club moss / Container: Celadon-glazed *suiban*

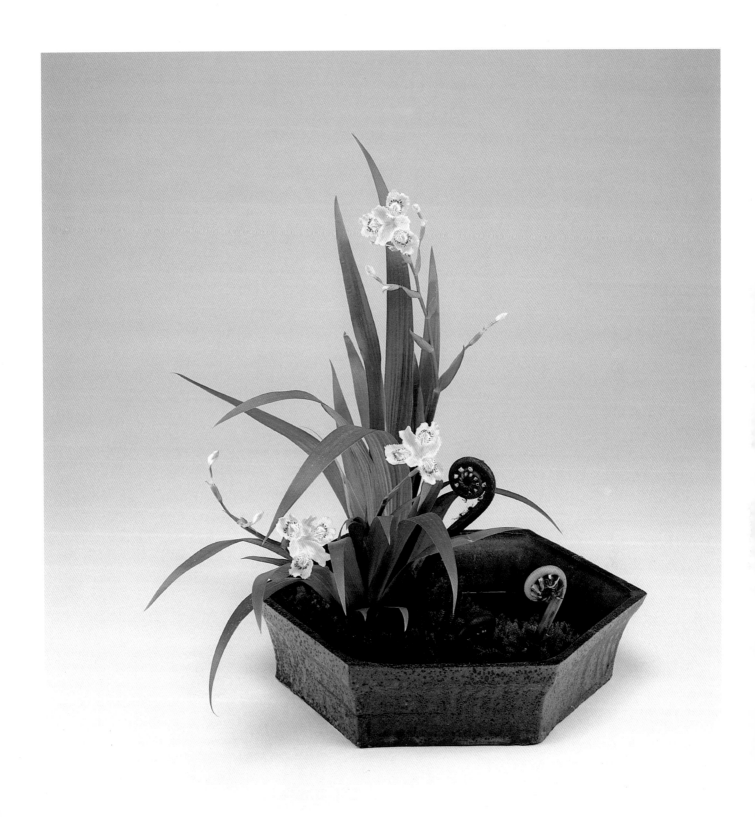

Upright Style, Near View
Seven natural leaf groups and three flowers of fringed iris are arranged in the Upright Style in a single clump as if they were sway-
ing. A single royal fern sprout is positioned on the right side of the iris group; two others, used as the Object, sprout from the car-
pet of moss. Keeping the royal fern sprouts low will give them a very clear sense of presence.
Materials: Fringed iris, royal fern shoot, club moss / Container: Hexagonal *suiban*

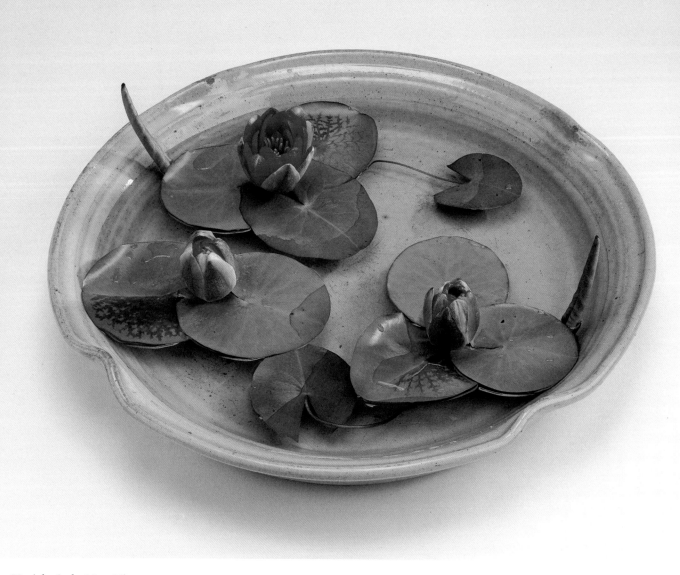

Upright Style, Near View
Arranging water lily with one flower, three leaves, one rolled leaf and two floating leaves is the prescribed technique in the Traditional Method. However, when many clumps are arranged, it is possible to omit some of the leaves.
Materials: Water lily: one-variety arrangement / Container: Celadon-glazed *suiban*

Opposite page, above: Upright Style, Near View
When lotus is displayed with other water plants it is treated in the Near-View Depiction. In addition, the flower is always placed higher and the rolled leaf lower than the accompanying tall standing leaf. The base of the stems of the flower and the rolled leaf are inserted at the same place, and with the exception of the rolled leaf, an odd number of leaves is always used. One flower, five leaves and a rolled leaf of pond lily are arranged in a single clump in the Upright Style.
Materials: Lotus, pond lily / Container: Beveled *suiban*

Opposite page, below: Upright Style, Far View
When lotus is arranged alone, the image is that of a lotus pond seen at a distance. In this Far-View Depiction, there are always seven or more leaves and two or more flowers.
Materials: Lotus: one-variety arrangement / Container: Celadon-glazed oval *suiban*

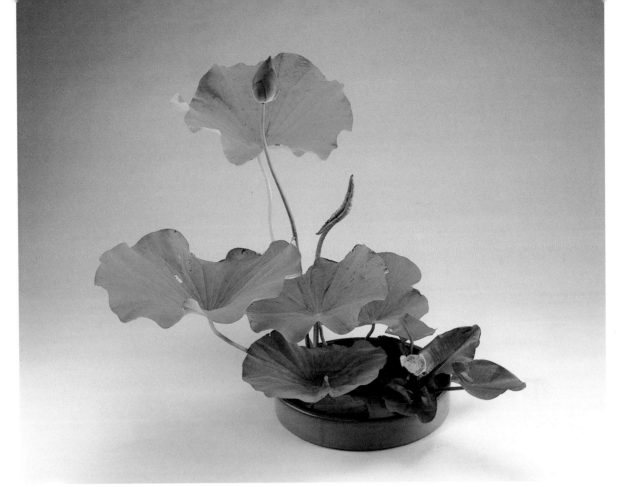

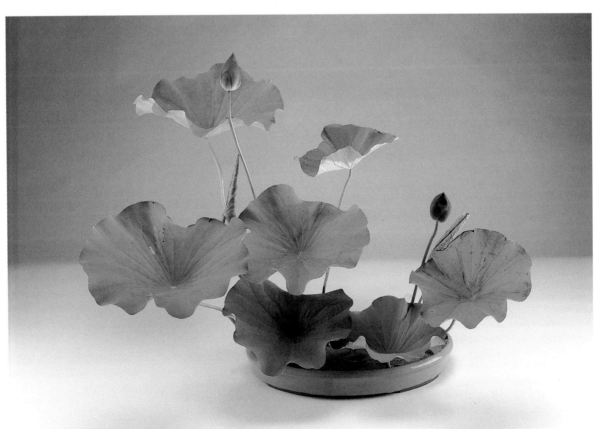

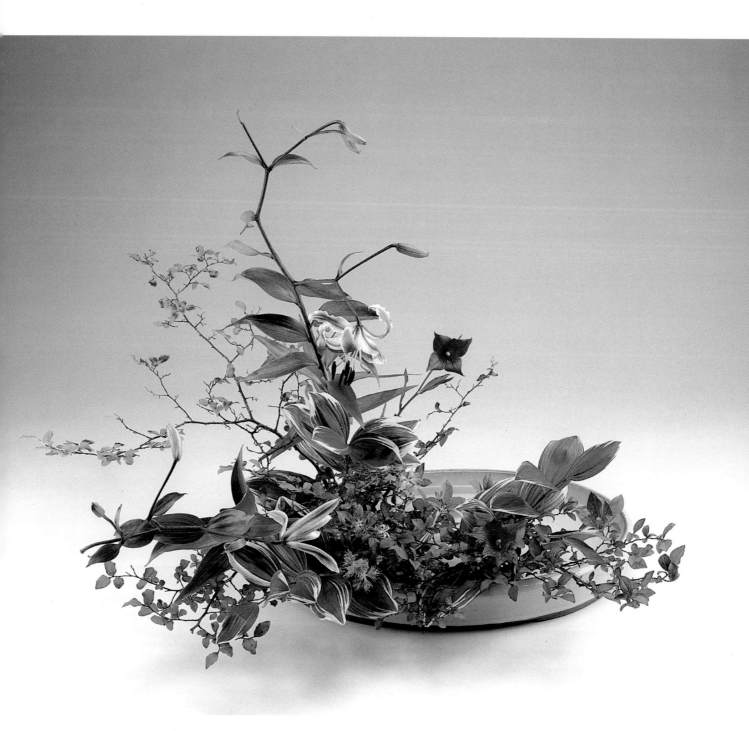

Upright Style, Near View, Multi-Variety Arrangement for Summer
A Moribana arrangement of more than three different materials is called a multi-variety arrangement. In this work, called the Multi-Variety Arrangement for Summer, showy lily, Chinese bellflower, Solomon's seal and superb pink are arranged together, with *vaccinium oldhami* as the base material. As a rule, the work is done in the Upright Style with showy lily as the Subject and the Secondary, and Chinese bellflower as the Object.
Materials: Showy lily, *Vaccinium oldhami,* Chinese bellflower, Solomon's seal, superb pink / Container: White-glazed oval *suiban*

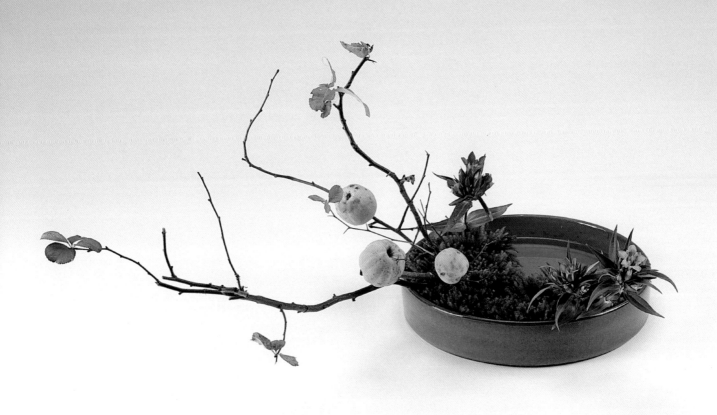

Slanting Style, Middle View
Quince branches with their bases drawn closely together may be arranged in either the Upright or the Slanting Style, but the skillful selection of fruit-bearing branches is essential. Those with fruit close to the base are better than those with fruit near the tip because the lower position of the fruit gives a denser, more substantial appearance to the entire group of branches. Gentian is used at the side of the quince branches and as the Object. The placement of club moss completes this Middle-View Depiction.
Materials: Fruit-bearing quince, gentian, club moss / Container: Beveled *suiban*

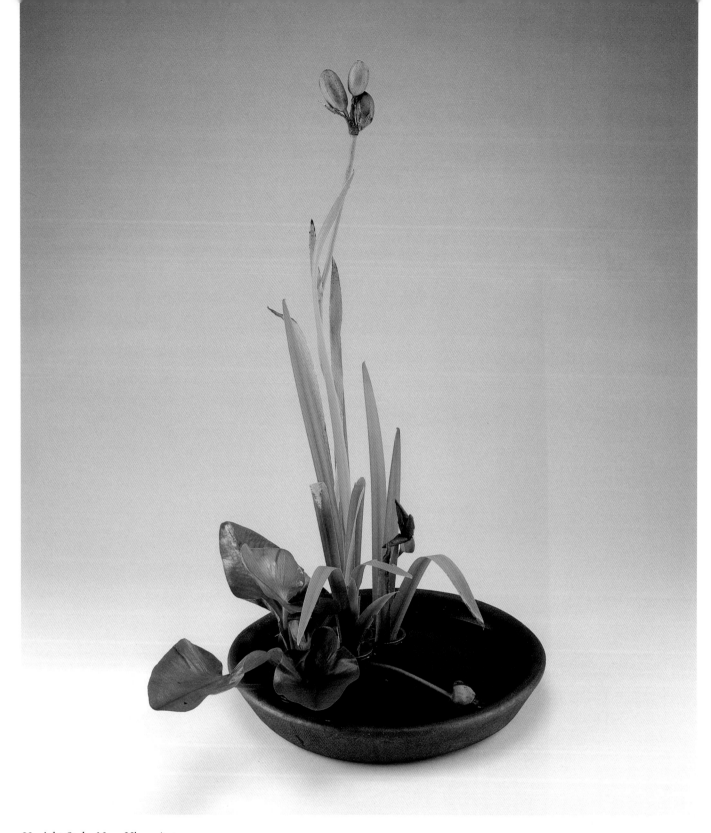

Upright Style, Near View, Autumn

When rabbit-ear iris is arranged in autumn, the seed pod is used high and the flower is positioned low. Fewer clumps are arranged, and withered and broken leaves, and those partially eaten by insects may be included. In the example, there are two iris clumps as the Subject, and pond lily as the Secondary. The autumn atmosphere is also captured here by the use of the heavy seed pod of the pond lily, which draws the stem downward and beneath the surface of the water.

Materials: Rabbit-ear iris, pond lily / Container: Nanban-style *suiban*

46

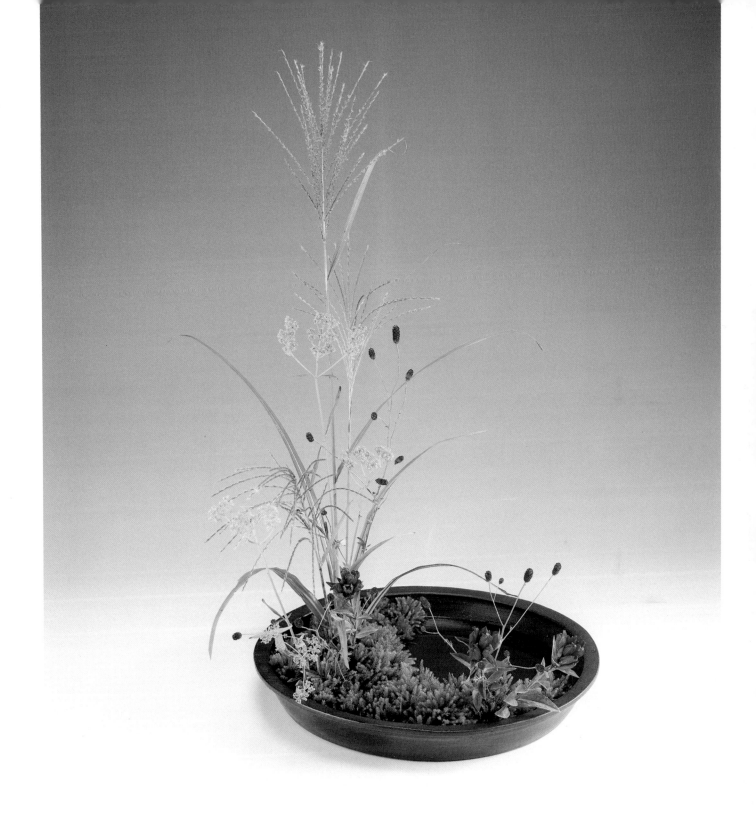

Upright Style, Near View, Multi-Variety Arrangement for Autumn

When many varieties of material are used, it is essential to create the basic framework first. This arrangement is done in the Upright Style with materials used in the following groups: Japanese pampas grass, patrina and burnet as the Subject group; patrina and burnet as the Secondary group; patrina and gentian as the Filler group; burnet and gentian as the Object group. Club moss, spread out at the base, gives the whole arrangement the realistic appearance of a natural scene.

Materials: Japanese pampas grass, patrina, burnet, gentian, club moss / Container: Nanban-style *suiban*

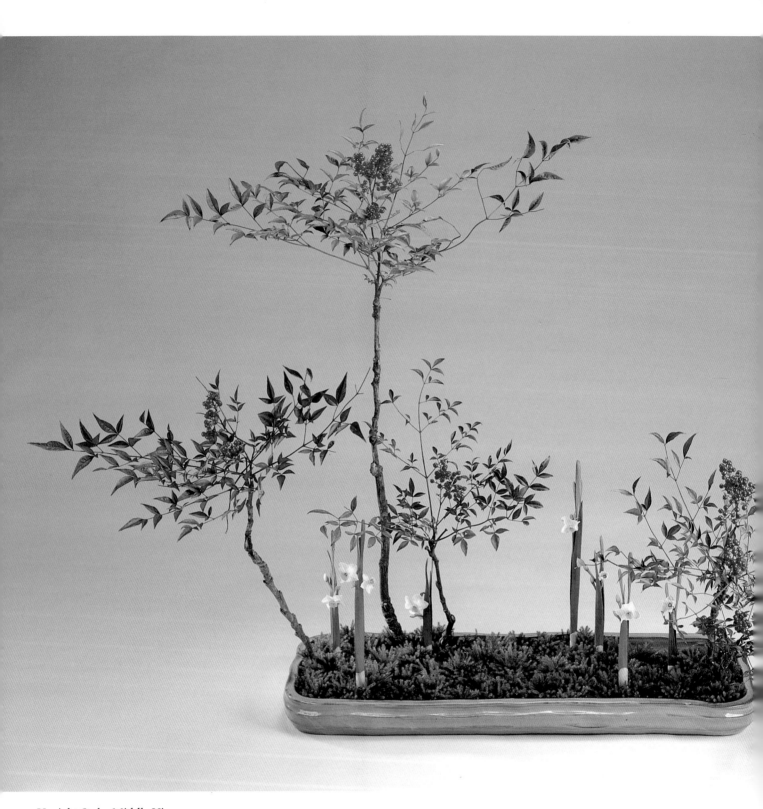

Upright Style, Middle View

Nandina is arranged in the Upright Style to emphasize its spreading, umbrella-like leaves. Five branches of nandina structure the space: one as the Subject, another as the Secondary, and a third as the Filler at the side of the Subject. A fourth branch is placed as the Object and a fifth, a short stem, supports the Object. When a rectangular *suiban* is used, narcissus in artificially assembled leaf groups is arranged at various points, and club moss covers the surface of the container.

Materials: Nandina, narcissus, club moss / Container: Sodeshi-ware rectangular *suiban*

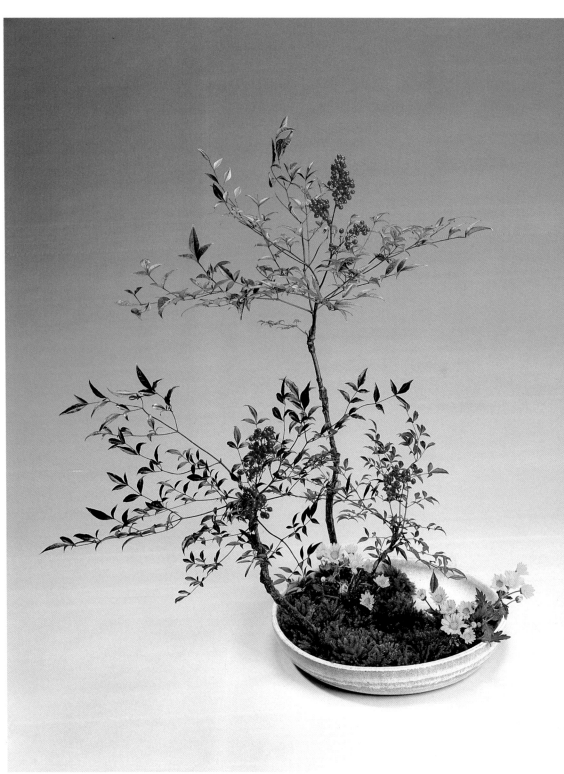

Upright Style, Middle View

When nandina is arranged in a round *suiban*, three branches are used, one for the Subject, another for the Secondary, and a third as the Filler stem at the side of the Subject. It is important to capture the beauty of these branches rising upward together. Winter chrysanthemums are placed at the base of the Subject and used as the Object, with club moss laid out over a wide area of the container.

Materials: Nandina, winter chrysanthemum, club moss / Container: Gray-glazed *suiban*

49

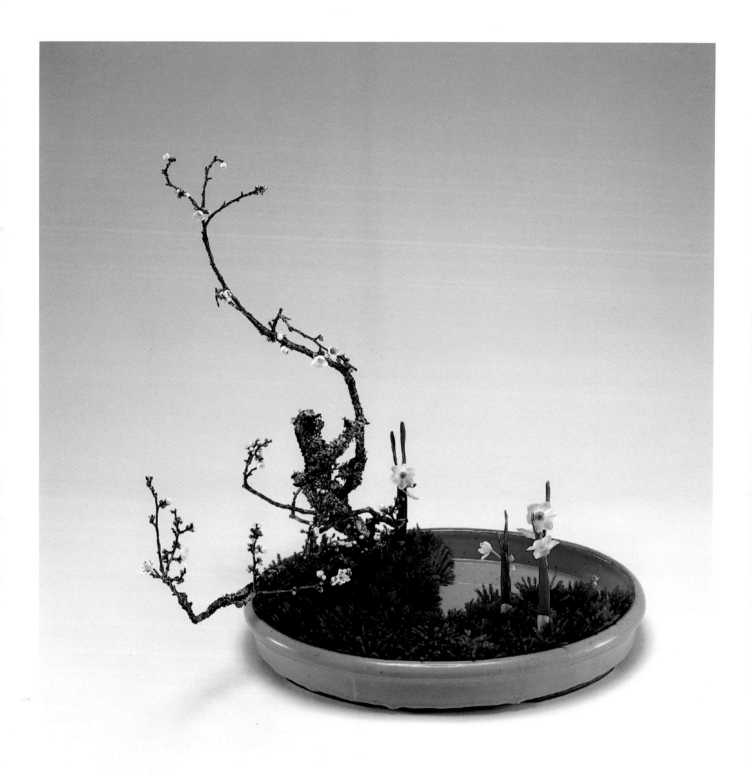

Upright Style, Far View
With a thick trunk of Japanese apricot at the center, the Subject, Secondary and Filler stems are added to create the appearance of a large tree seen from a distance. In the Ohara School, this is called the one-tree arranging method. One narcissus is placed low at the base of the apricot, and two others are added, one as the Object and another as its supporting Filler stem. Club moss is laid out on the surface of the container to complete the arrangement.
Materials: Japanese apricot, narcissus, club moss / Container: Celadon-glazed oval suiban

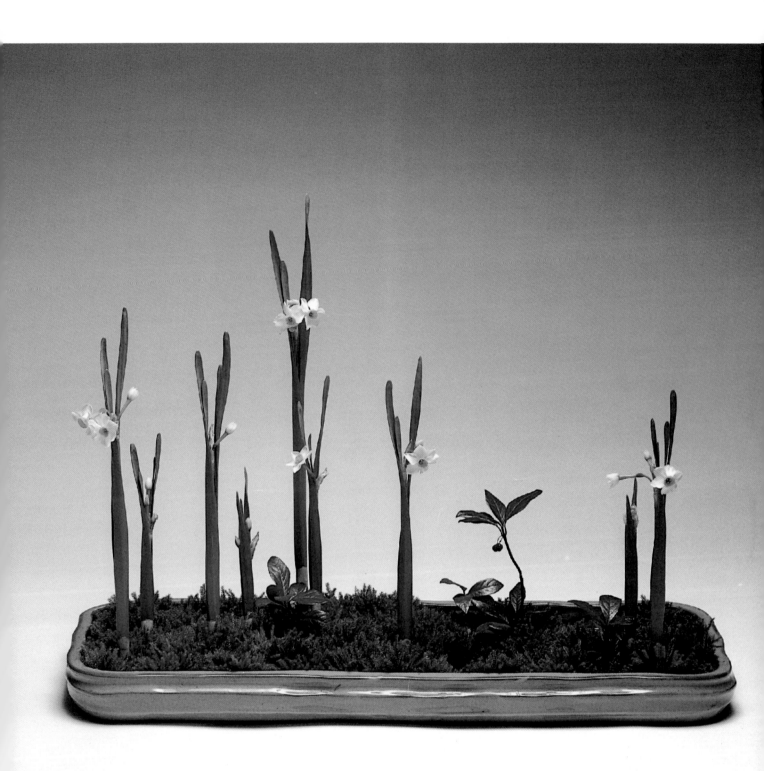

Upright Style, Near View

This arrangement depicts a scene where nine groups of narcissus grow straight up from the ground. The natural leaf groups are taken apart and reassembled to highlight the strong, upright character of the leaves. Their strength is further emphasized by clearly displaying the white sheath (*hakama* in Japanese) above the club moss at the base of each leaf group. Japanese ardisia is arranged at points among the narcissus groups to add detail to this portrayal of the ground seen at close range.

Materials: Narcissus (nine groups), Japanese ardisia, club moss / Container: Sodeshi-ware rectangular *suiban*

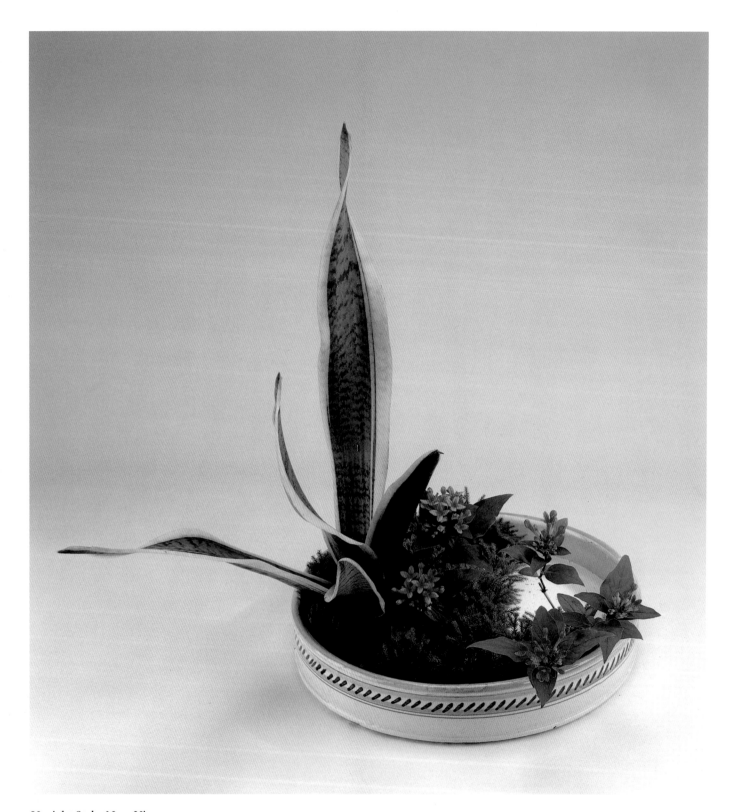

Upright Style, Near View

Here is an example of a foliage plant in a highly stylized arrangement. To capture the concentrated appearance of the base of san-sevieria, five leaves are arranged in the Upright Style. Two stems of bouvardia are placed at the side of the leaves and three are arranged as the Object. Finally, club moss is spread over the surface of the container to complete this Near-View Depiction

Materials: Sansevieria, bouvardia, club moss / Container: Majolica-ware *suiban*

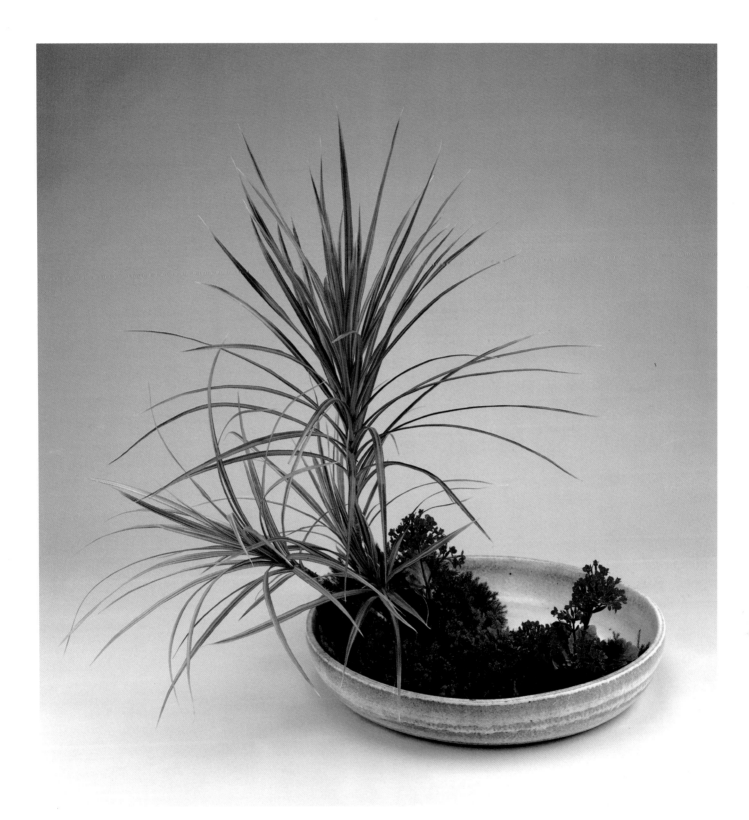

Upright Style, Middle View
Rainbow dracaena resembles a low tree and, therefore, it is treated in the middle view. It is arranged in the Upright Style, as the Subject, the Secondary and the Filler stems. Two kalanchoe are placed rather low beside the Subject stem of dracaena, three more kalanchoe are used for the Object, and club moss is spread at the base to complete the arrangement.
Materials: Rainbow dracaena, kalanchoe, club moss / Container: Blue-glazed *suiban*

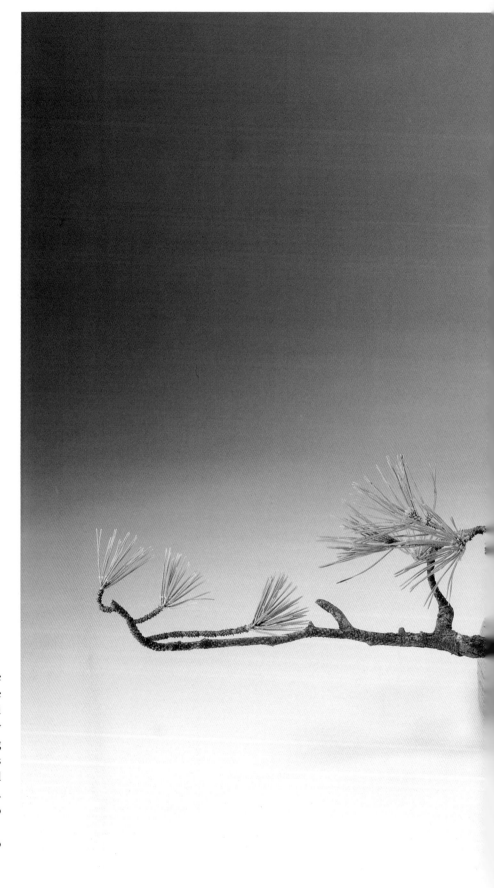

Upright Style, Far View
Pine branches are arranged in a *suiban* as the Subject, the Secondary and the Object in the Far-View Depiction. The Subject is treated as a windswept coastal pine. The Secondary and the Object are placed in strongly slanting postures. Since this is a far view of pines growing near a beach, the club moss should be carefully arranged to suggest a coastline. Japanese ardisia is placed at various points to complete this landscape.
Materials: Pine, Japanese ardisia, club moss / Container: Shigaraki-ware *suiban*

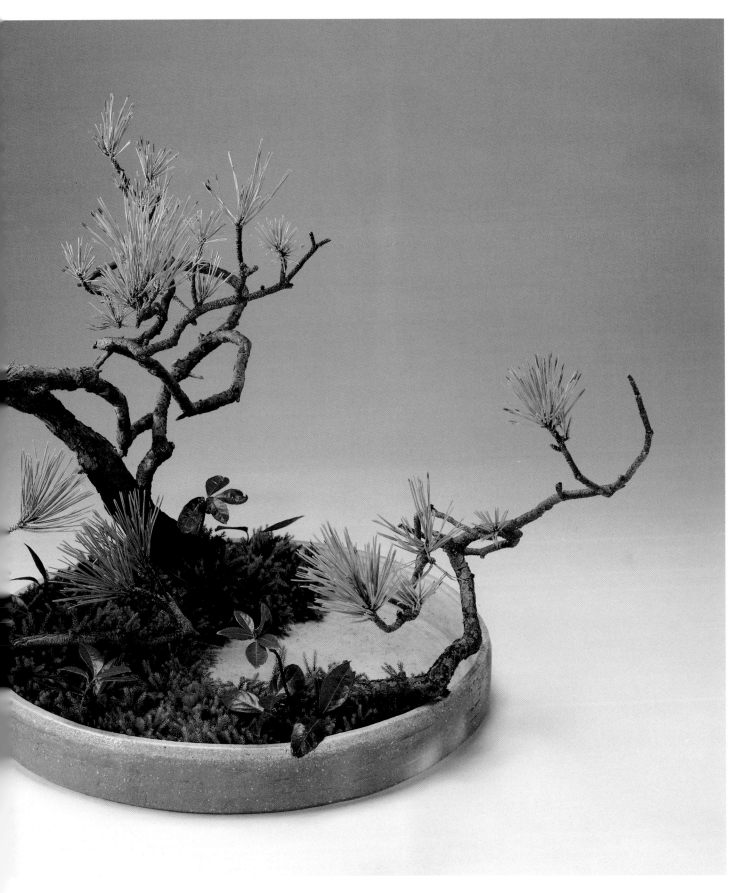

III
Moribana with the Seasons

Spring

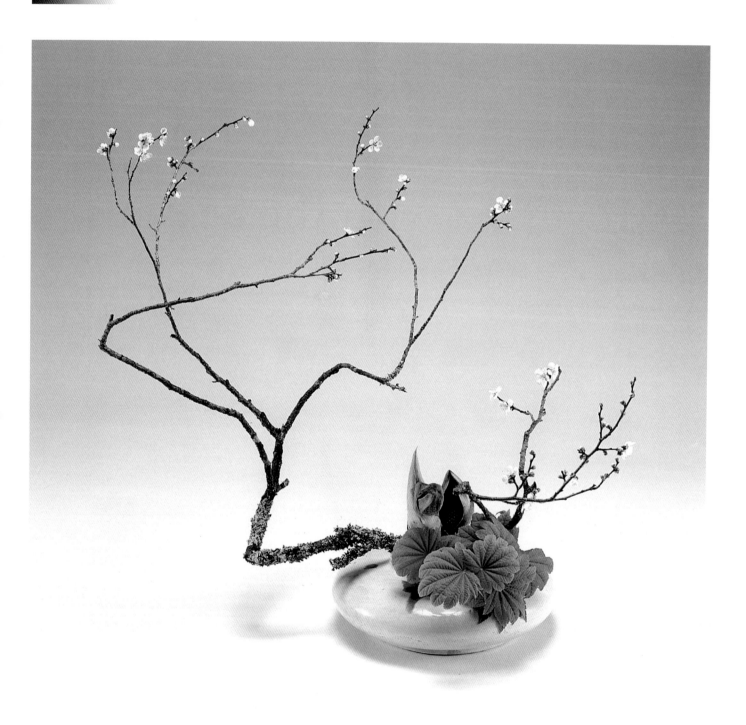

Theme: An image of Japanese music

The early spring atmosphere is represented by the blossoms just beginning to appear on the twisted branches of apricot as well as the fresh young maple leaves. The grotesque charm of skunk cabbage peeping from beneath the leaves creates a genial form.

Materials: Japanese apricot, maple, skunk cabbage / Container: Porcelain container

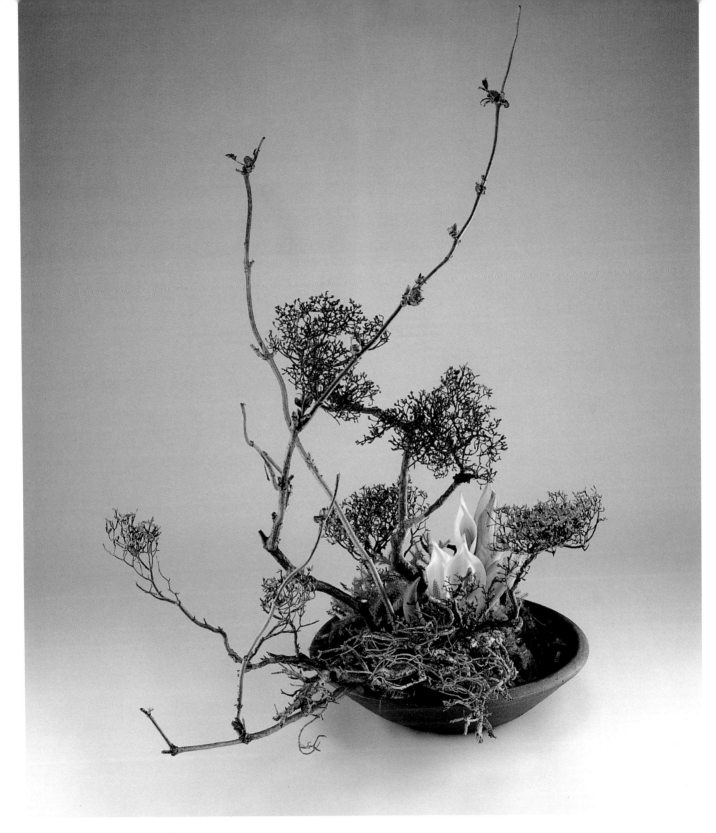

Theme: Spring in the marshlands
This arrangement depicts a scene in the marshlands where the arrival of spring is heralded by the blooming of skunk cabbage. Both the elder flower and the rhododendron have just started putting out new leaves. Though traces of winter remain, we can feel the plants breathing the spring air.
Materials: Elder flower, *rhododendron tschonoskii*, Japanese skunk cabbage, driftwood, club moss / Container: Shigaraki-ware *suiban*

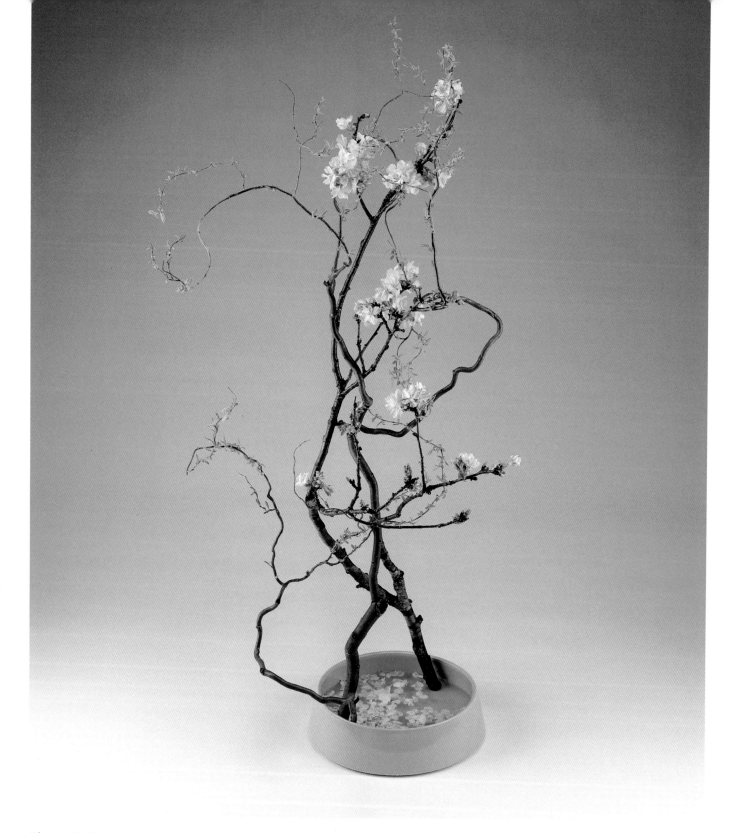

Theme: Spring message
The rising cherry and the curving lines of weeping willow paint a charming picture as they sing their spring message in tune.
Materials: Cherry, unryu weeping willow / Container: Hanamai *suiban*

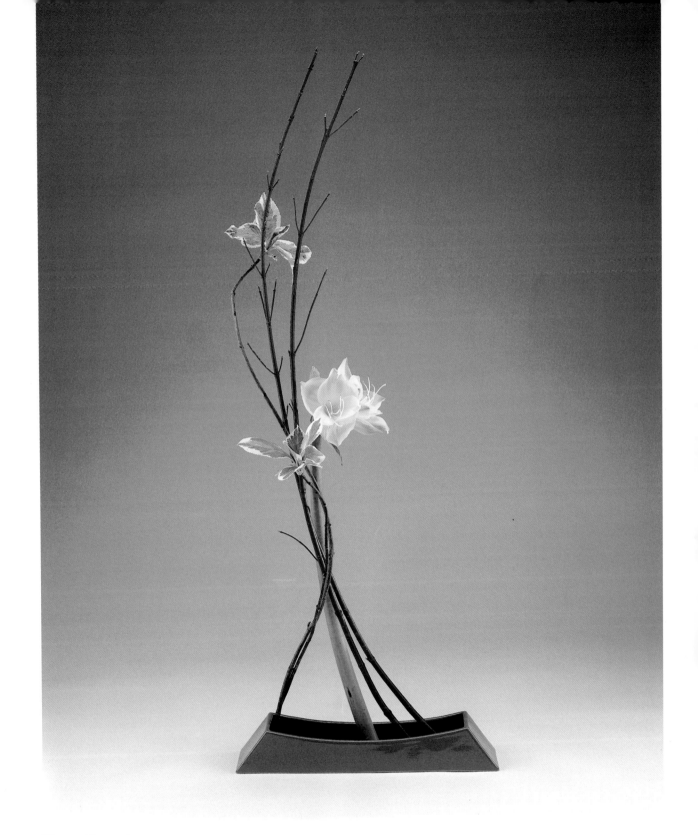

Theme: Flower dance
Two red lines of Siberian dogwood soar up into the spring sunshine with two branches of sprouting hydrangea twining round them. The white amaryllis sings a song of spring.
Materials: Siberian dogwood, sprouting hydrangea, white amaryllis / Container: Hanamai container

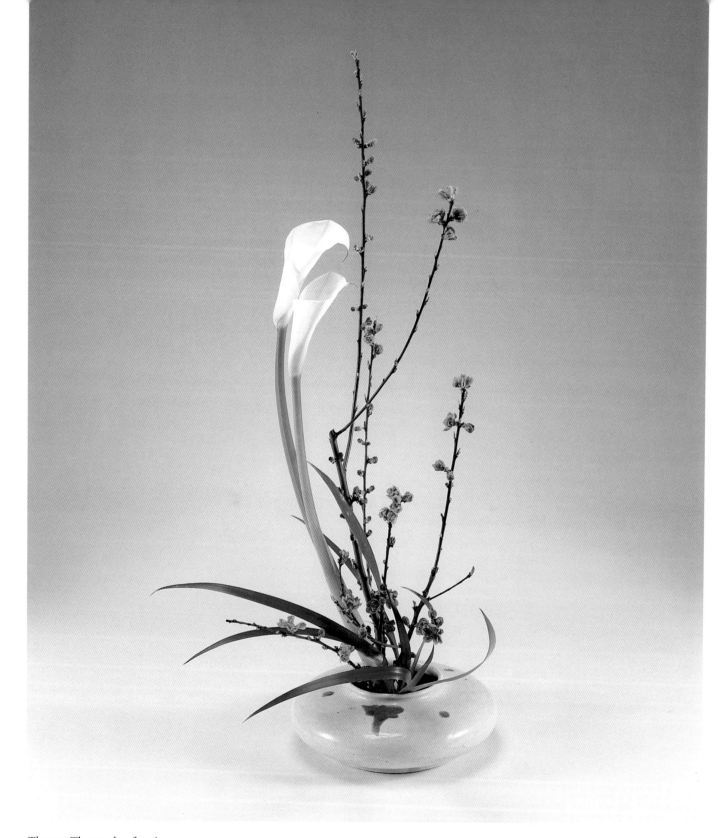

Theme: The rustle of spring
Two pure white calla lilies seem to be whispering to the straight, upright branches of lovely flowering peach. At their base, young leaves of fringed iris, heralds of spring, add lively accents to the leafless forms of peach and calla lily.
Materials: Flowering peach, calla lily, fringed iris / Container: White porcelain vase

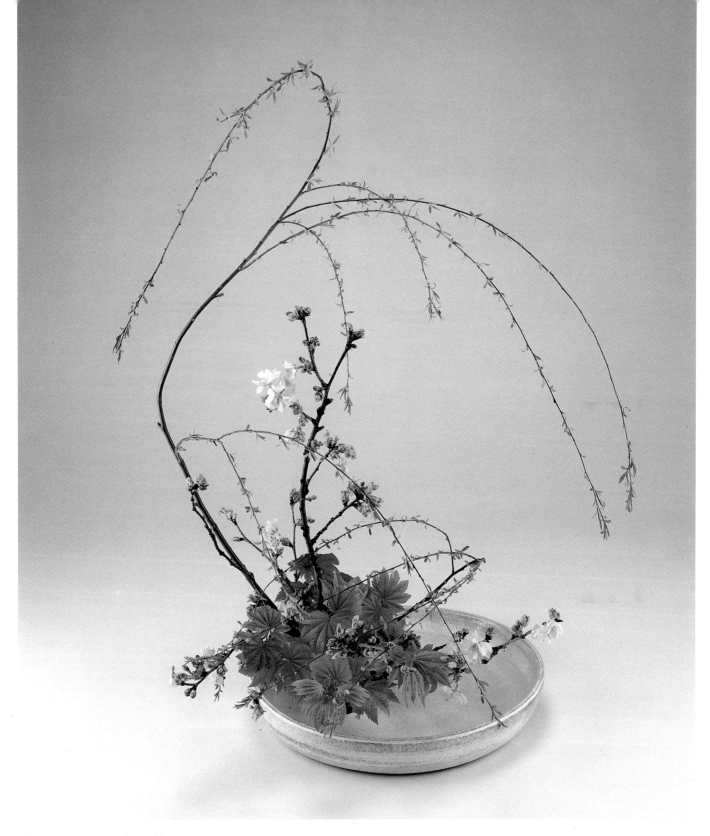

Theme: New-sprouting willow
The sprouting weeping willow greets the cherry blossoms. With the addition of young maple leaves, this work portrays a typical scene in the fresh warmth of spring time.
Materials: Weeping willow, cherry, maple / Container: Gray-glazed *suiban*

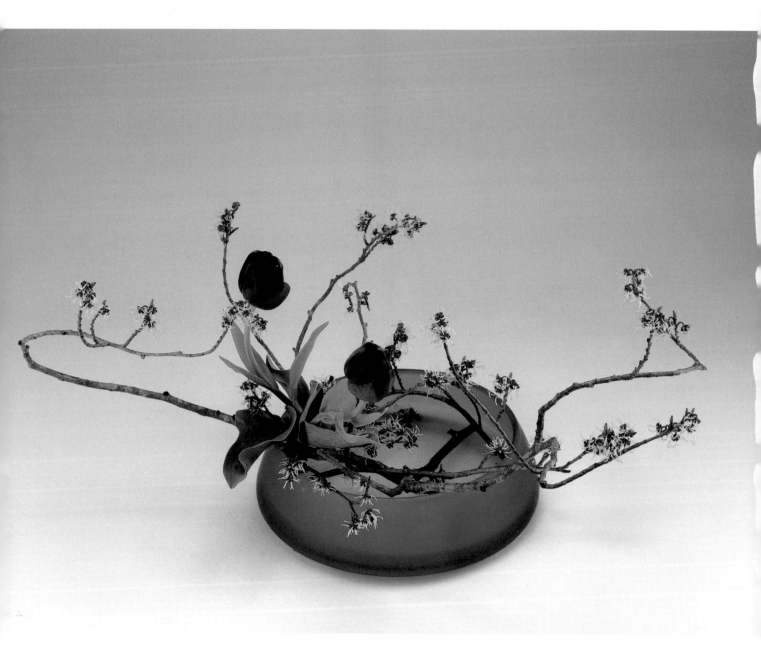

Theme: Awakening
Amid the sinuous, crossing branches of cornus that are dotted with yellow flowers, two tulips, as if awakened from sleep, open wide and breath deeply of the spring breezes.
Materials: *Cornus officinalis,* tulip / Container: Colored glass *suiban*

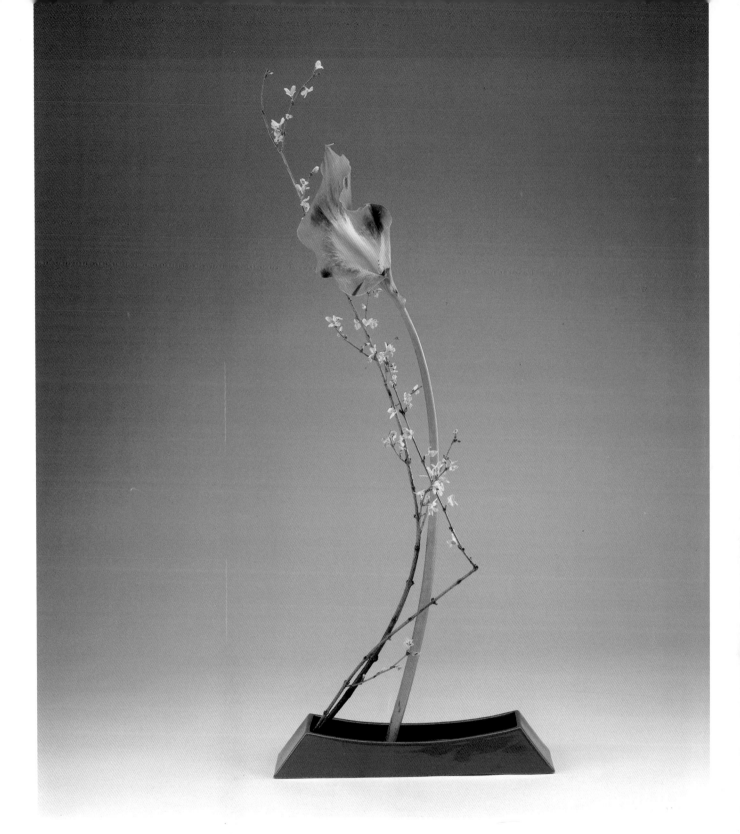

Theme: Dance of forsythia
In the charged atmosphere created by bringing together the supple, vine-like branches of weeping forsythia and the melodious shape of the green calla lily, one can almost hear the rhythms of the tango.
Materials: Weeping forsythia, green calla lily / Container: Hanamai container

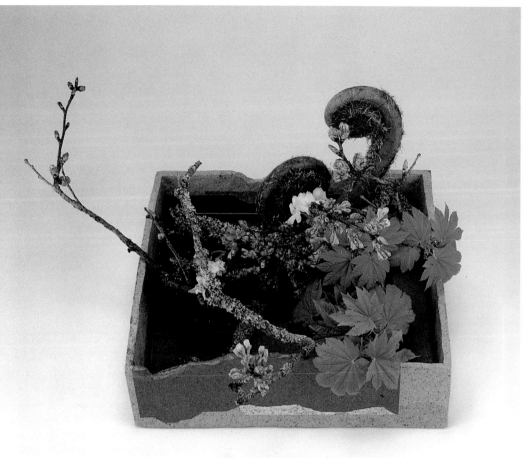

Theme: Cherry blossoms and the waters of spring
In the water-warming spring sunlight, a mysterious encounter between the strange shapes of the flowering tree ferns and the moss-covered cherry branches. Young maple leaves serve as the medium for this drama which unfolds after a spring shower.
Materials: Cherry, flowering tree fern, maple / Container: Original work by Kazuhiko Sato

Right page:
Theme: Dance of spring breezes
Arranged in a line, the meandering branches of the unryu weeping willow mix with the undulating shapes of the tulip leaves, and one can feel the spirits of these plants dancing on the spring breezes.
Materials: Unryu weeping willow, tulip / Container: Shigaraki-ware rectangular *suiban* with feet

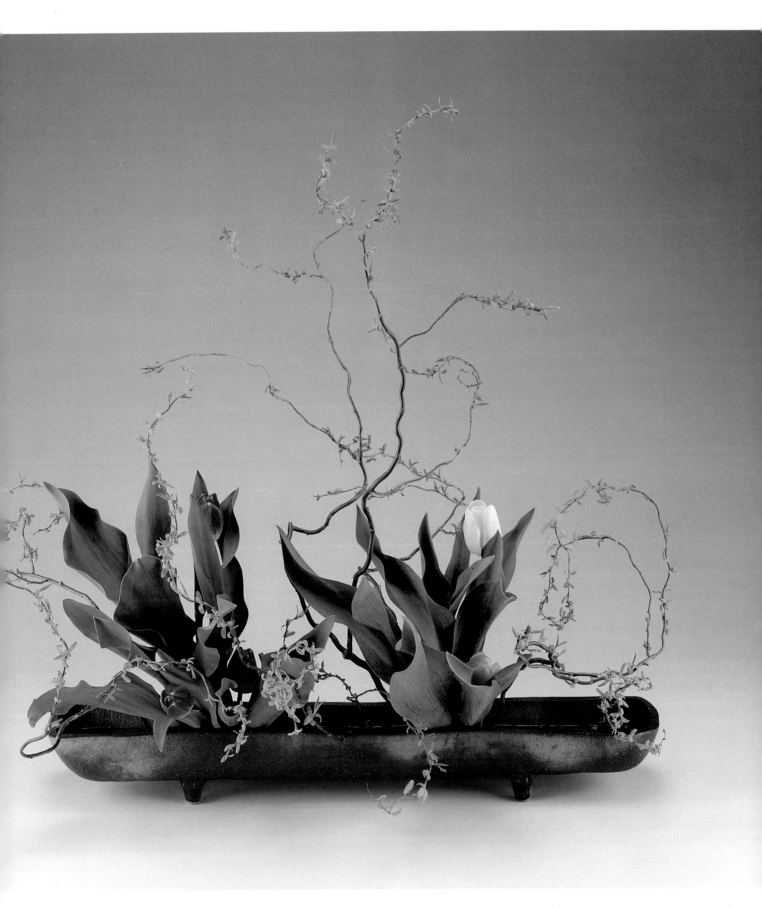

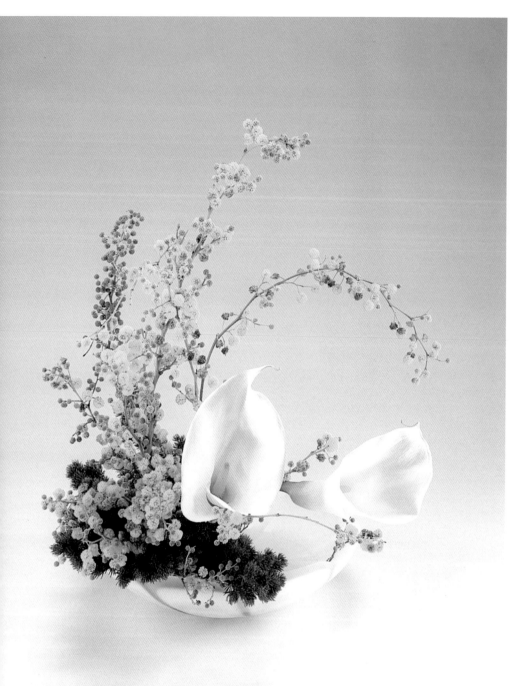

Theme: Voice of spring
Round yellow flowers of mimosa acacia, bursting from a mass of green myriocladus, play in the spring breezes. The two horn-shaped calla lilies leap from this mass to engage in a joyful conversation of spring.
Materials: Mimosa acacia, calla lily, *Asparagus myriocladus* / Container: Milk-colored glass

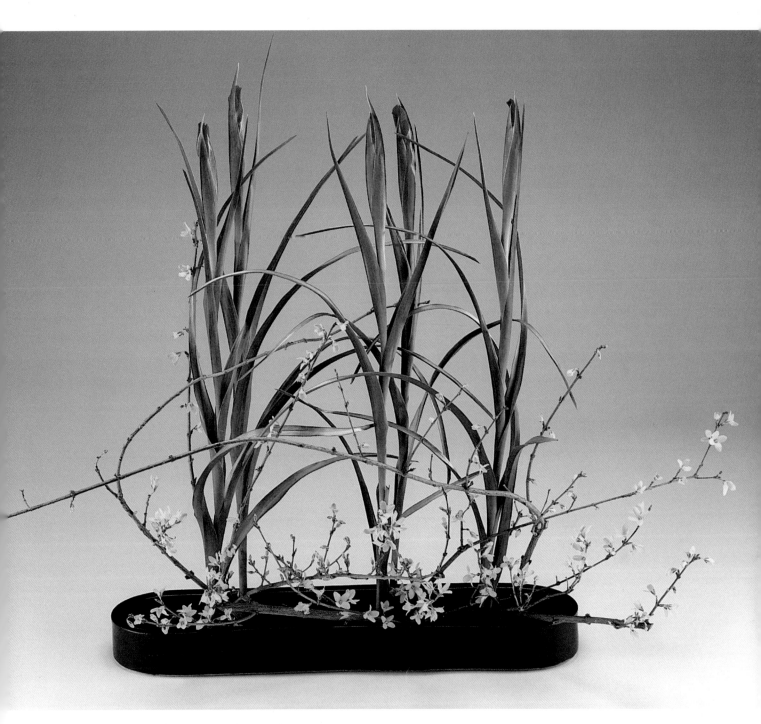

Theme: The beauty of sequence and interval

Rhythms created by crossing lines emerge in a space where irises with their beautifully curved leaves are composed standing in a row. They are joined by the vine-like branches of forsythia to bring forth even more harmonious rhythms.

Materials: Iris, weeping forsythia / Container: Black-glazed oval *suiban*

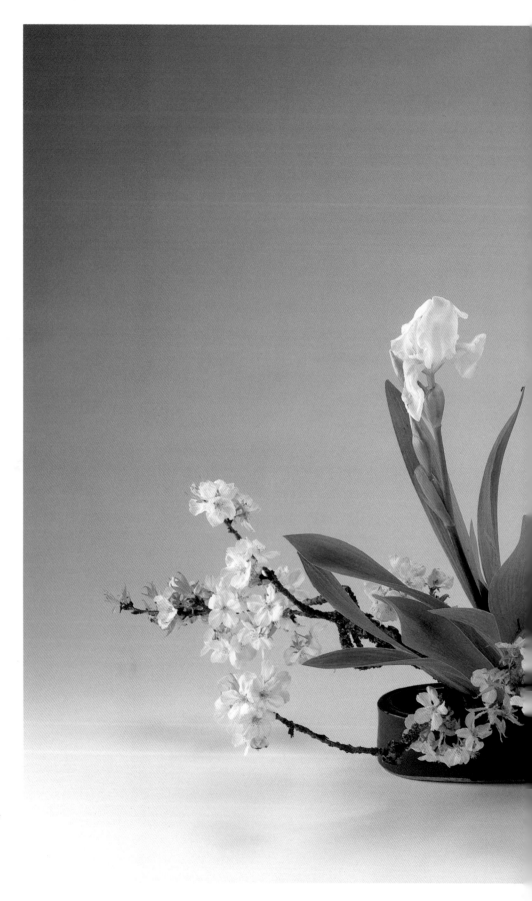

Theme: Swarm of flowers
The charming leaves of roof iris resemble the tails of birds of the kite family. The cherry blossoms massed beneath the two groups of leaves suggest a spring atmosphere of clouds or mist.
Materials: Roof iris, cherry
Container: Black-glazed oval *suiban*

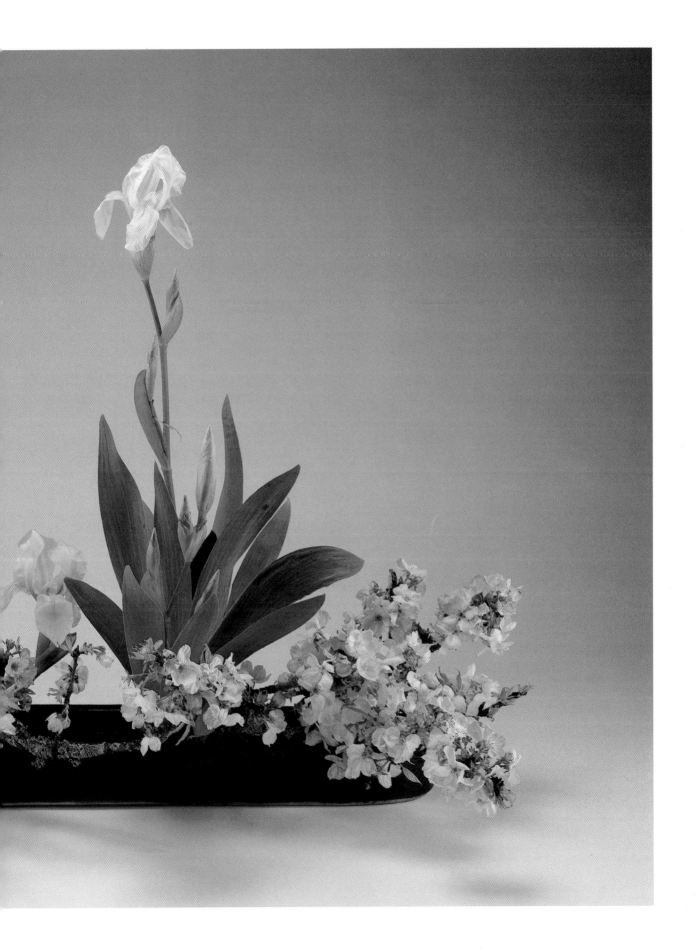

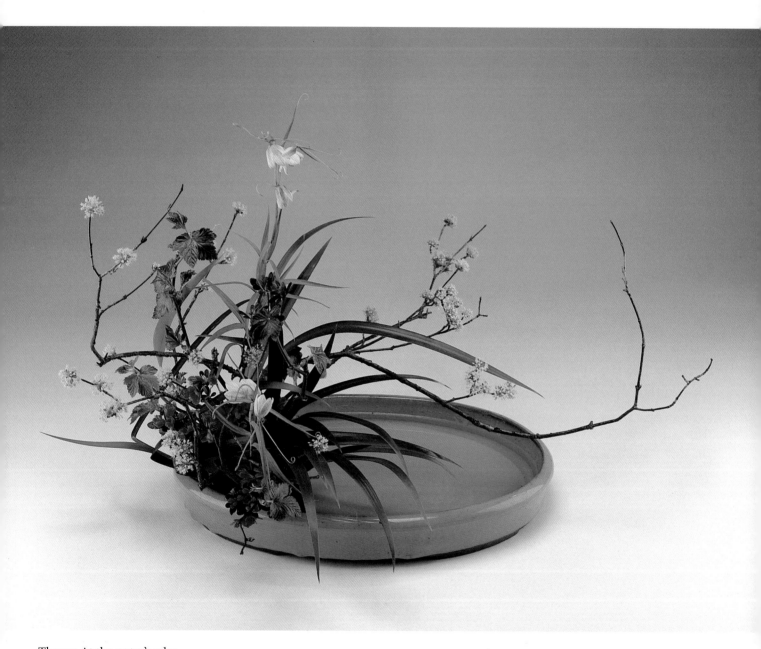

Theme: At the water's edge
Branches of cornus and sprouting raspberry reach out over the water to create a natural setting of spring at the water's edge. Here, an azalea bush coming into flower, fringed irises arching toward the water and gracefully blooming fritillary combine to depict a waterside scene.
Materials: *Cornus officinalis,* raspberry, azalea, fringed iris, fritillary / Container: Celadon-glazed oval *suiban*

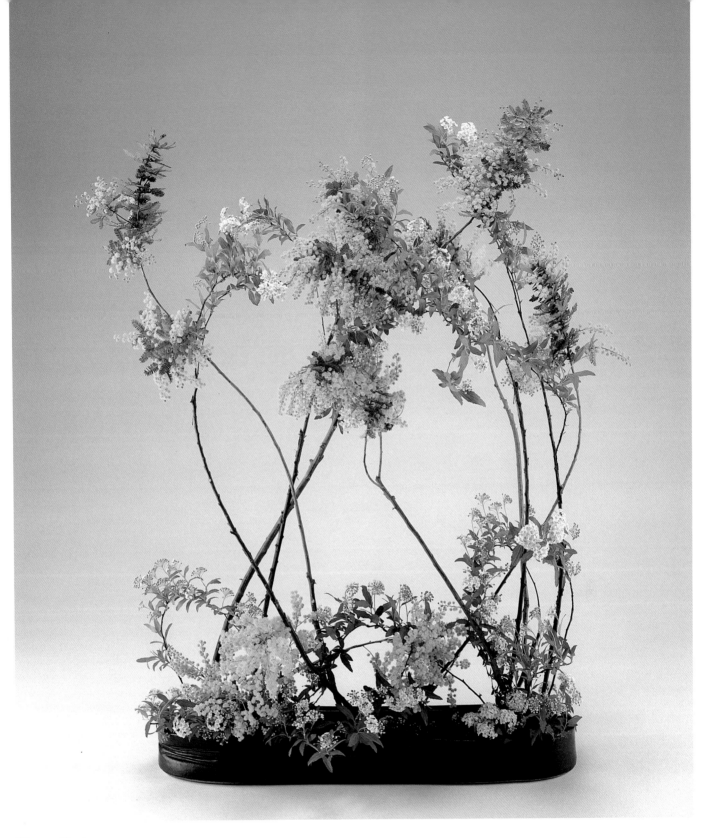

Theme: Duet

A uniquely spring-like rhythm emerges in the space created by the beautiful lines of crossing branches of spirea and mimosa acacia, which bear a certain formal resemblance. Gently curving branches traverse the occasional straight line, and spherical white and yellow flowers mingle naturally in the overall pattern.

Materials: Reeve's spirea, mimosa acacia / Container: Black-glazed oval *suiban*

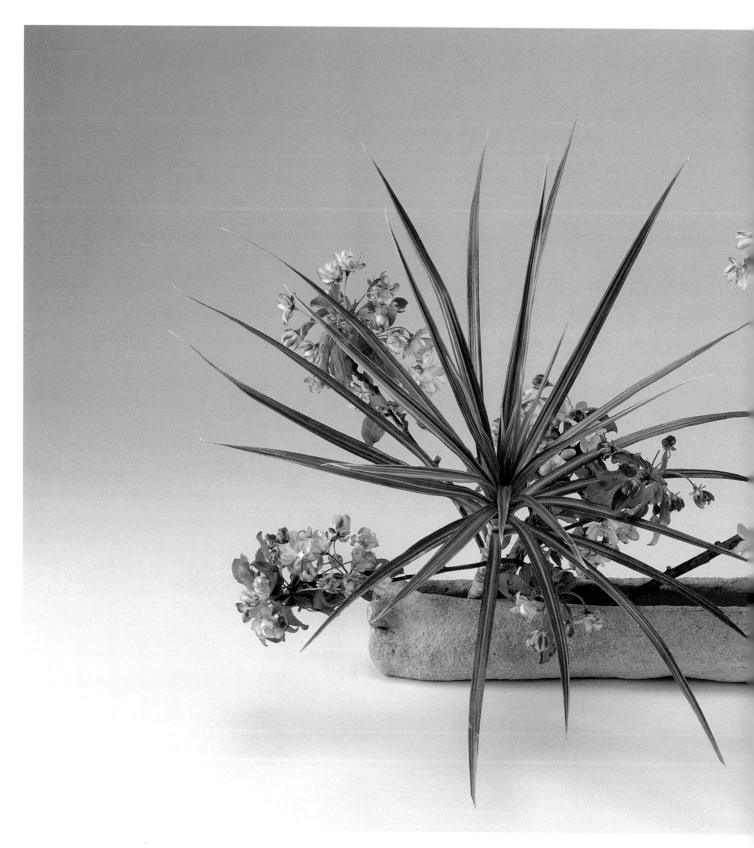

Theme: Refined taste
The elegance of flowering crab apple emerges when its rather plain branches are arranged in a row. The contrast between the powerful, flash-like radial form of the rainbow dracaena on the left and the dignified appearance of the roses on the right also helps to

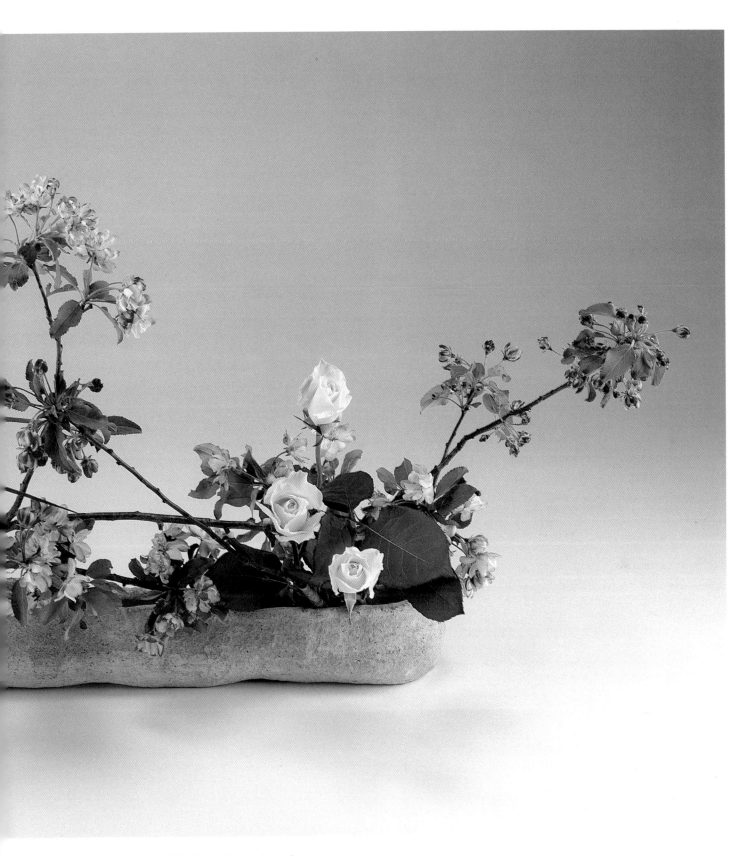

bring out the beauty of the flowering crab apple.
Materials: Reeve's spirea, mimosa acacia / Container: Black-glazed oval *suiban*

Summer

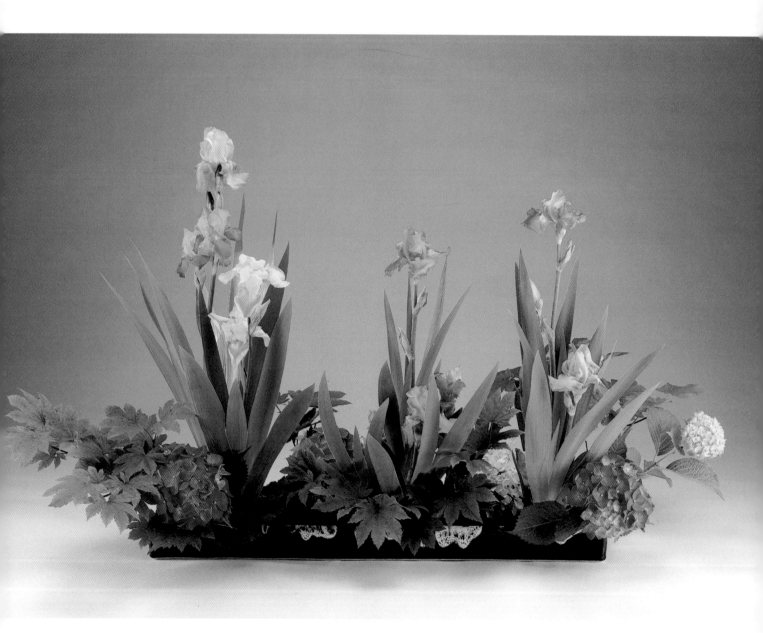

Theme: Pictorial charm

The roof irises are arrayed in a one-row composition that highlights their flowers. The iris leaves, which resemble the tails of birds of the kite family, give the arrangement an interesting pictorial quality. The maple and hydrangeas fill out the space so as to connect the base areas of the iris groups.

Materials: Roof iris, maple, hydrangea / Container: Takatori-ware rectangular *suiban*

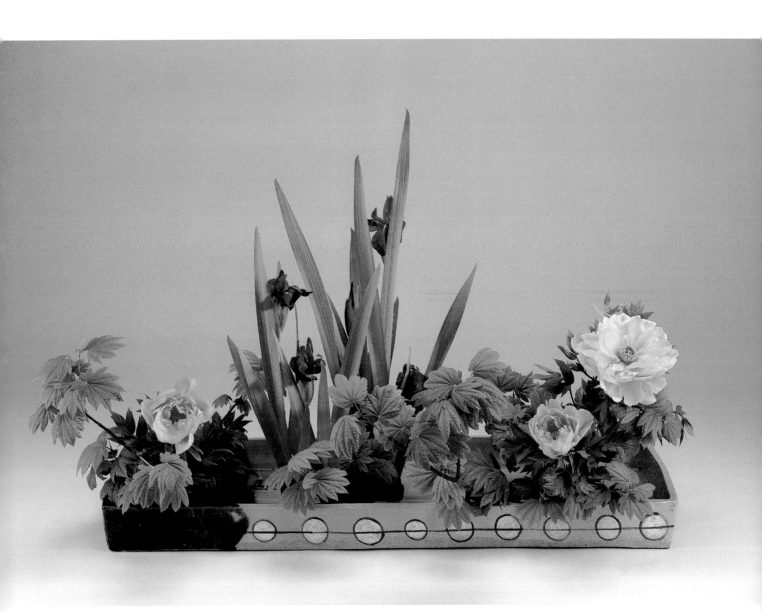

Theme: Courtly elegance

Rabbit-ear iris, arranged here with an emphasis on design, displays a refined beauty, and there is a regal dignity in the peony in full bloom. Accompanied by maple, this highly decorative Moribana arrangement is the very picture of courtly elegance.

Materials: Rabbit-ear iris, maple, peony / Container: Oribe-ware rectangular *suiban*

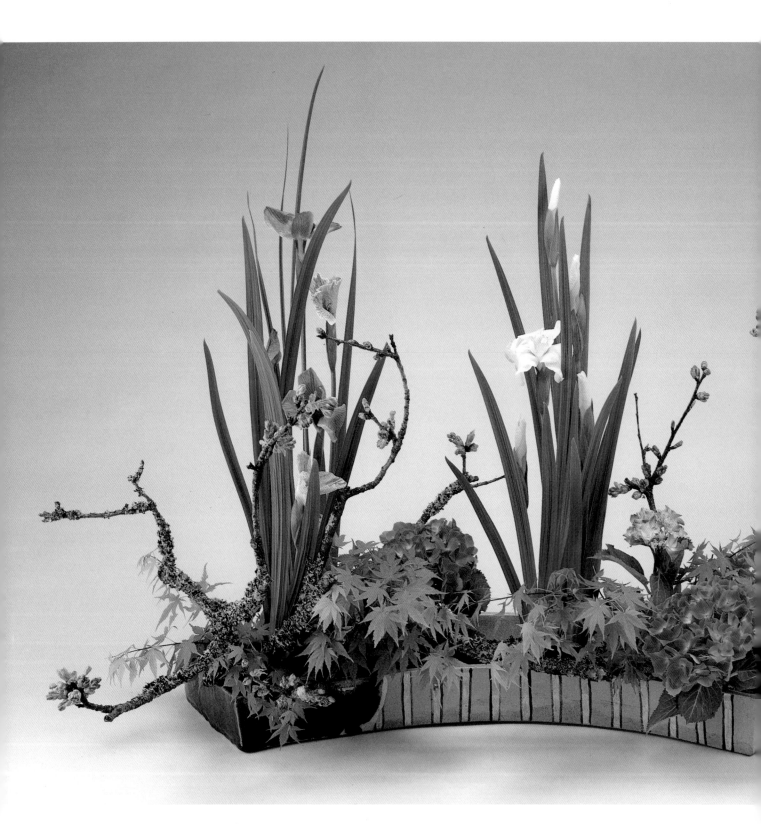

Theme: Seasonal beauty of spring and summer

Late cherry blossoms that appear after green leaves have already covered the trees are called *yoka* in Japanese. It may seem strange in terms of seasonal beauty to arrange spring cherry with summer irises, but here, the green maple serves to reconcile the different qualities of the two flowers. The hydrangeas in all their glory seem to be praising the iris season.

Materials: Japanese iris, cherry, green maple, hydrangea / Container: Oribe-ware fan-shaped *suiban*

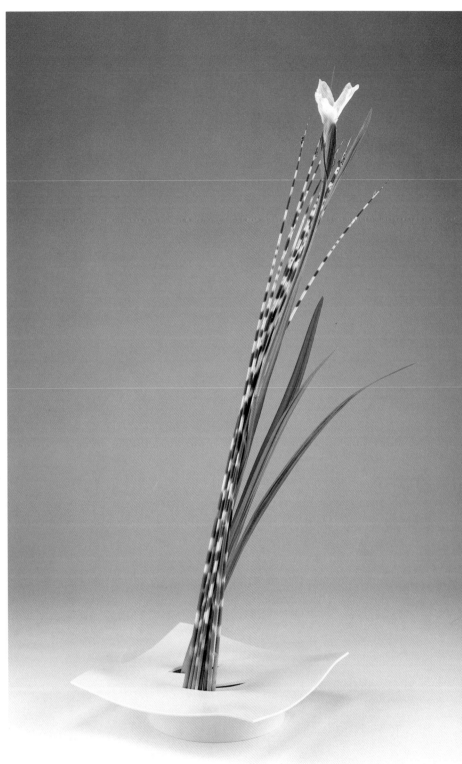

Theme: Slanting shadows
A handsome bunch of rising zebra bulrush accompanied by a single iris flower and its flowing leaves cast their slanting shadows in the summer sunlight.
Materials: Japanese iris, zebra bulrush / Container: Original work by Shigekazu Nagae

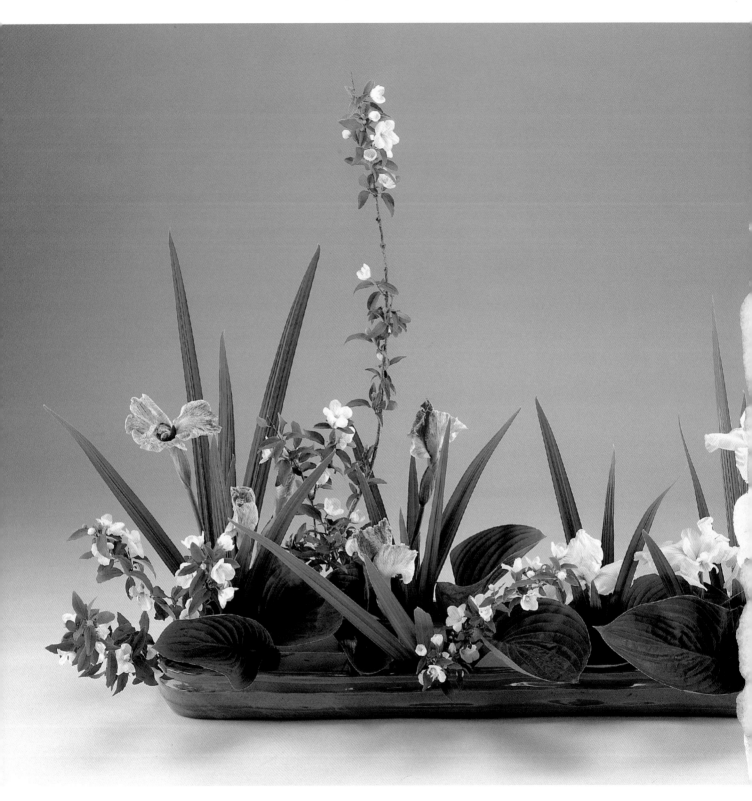

Theme: Design with flowers and leaves
The powerful shapes of the irises are captured in a one-line composition with a bold design of leaves of plantain lily used low to link the base areas of the separate iris groups. The addition of gently curving branches of mock orange completes this highly pictorial Moribana arrangement.
Materials: Japanese iris, mock orange, plantain lily / Container: Sodeshi-ware rectangular *suiban*

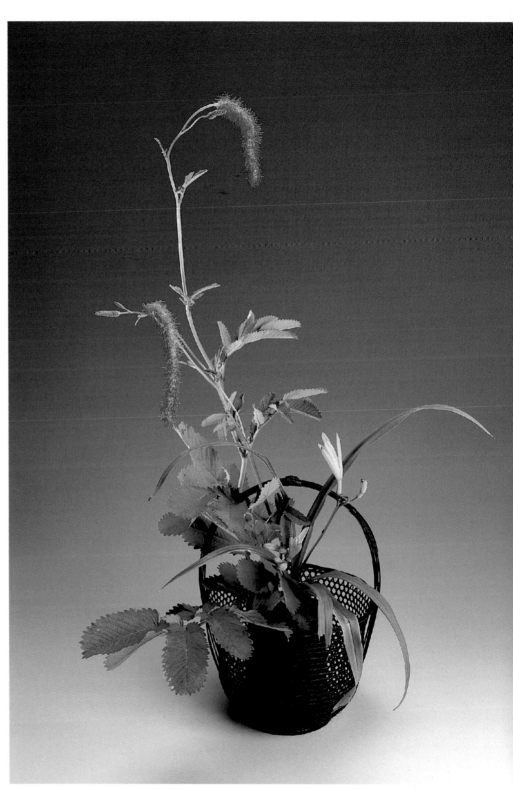

Theme: Refreshing breeze

Burnet, with silky thread-like flowers hanging from its stems, can suggest a refreshing breeze in the highlands. Adding some leaves at the base brings out the characteristic posture of this flower. Arranged in a basket, with tawny day lily and its leaves below, the burnet reveals its utmost natural beauty.

Materials: Japanese burnet, tawny day lily / Container: Bamboo basket with a handle

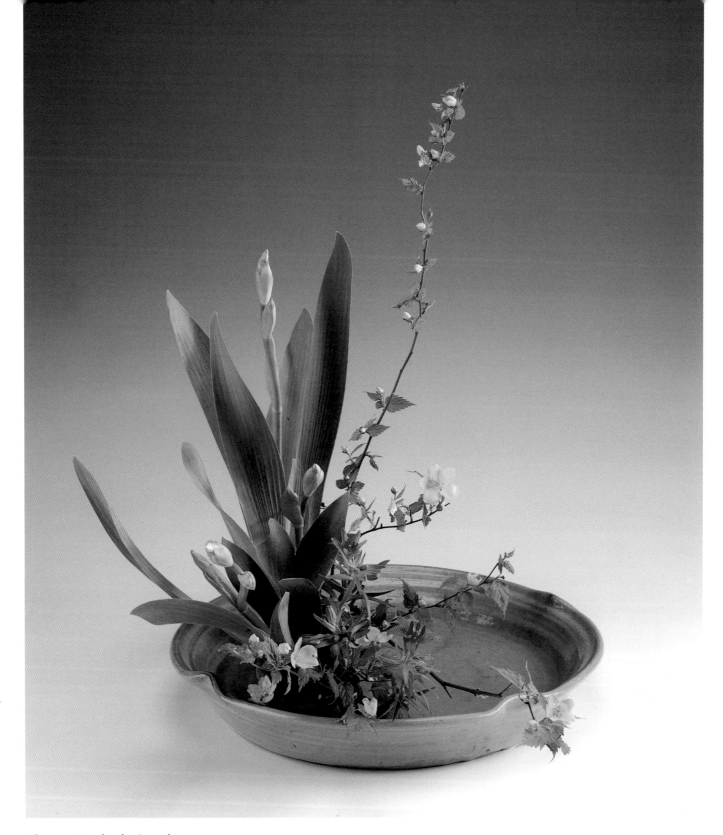

Theme: Water's edge in early summer

When the roof iris group growing at the water's edge puts forth three buds, kerria begins to flower. The lovely figure of star lily tells of the arrival of spring.

Materials: Roof iris, kerria, star lily / Container: Celadon-glazed *suiban*

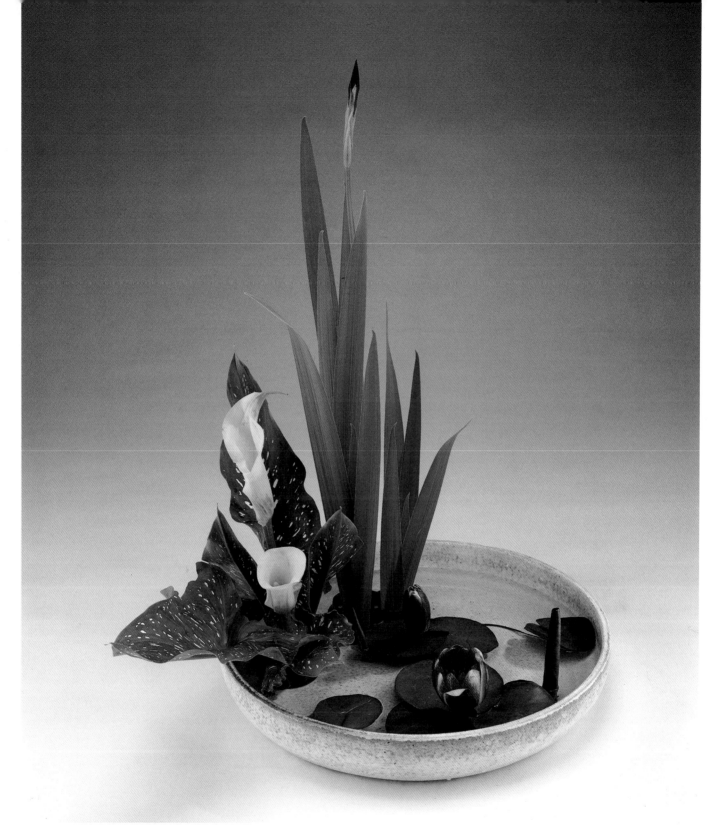

Theme: In a pond

Yellow calla lilies begin to bloom when rabbit-ear irises display their most vigorous growth. Water lilies, too, show their dream-like flowers on the surface of the water. The plants in the pond, each with its own vivid presence, seem like natural rivals trying to surpass each other in beauty.

Materials: Rabbit-ear iris, yellow calla lily, water lily / Container: Gray-glazed *suiban*

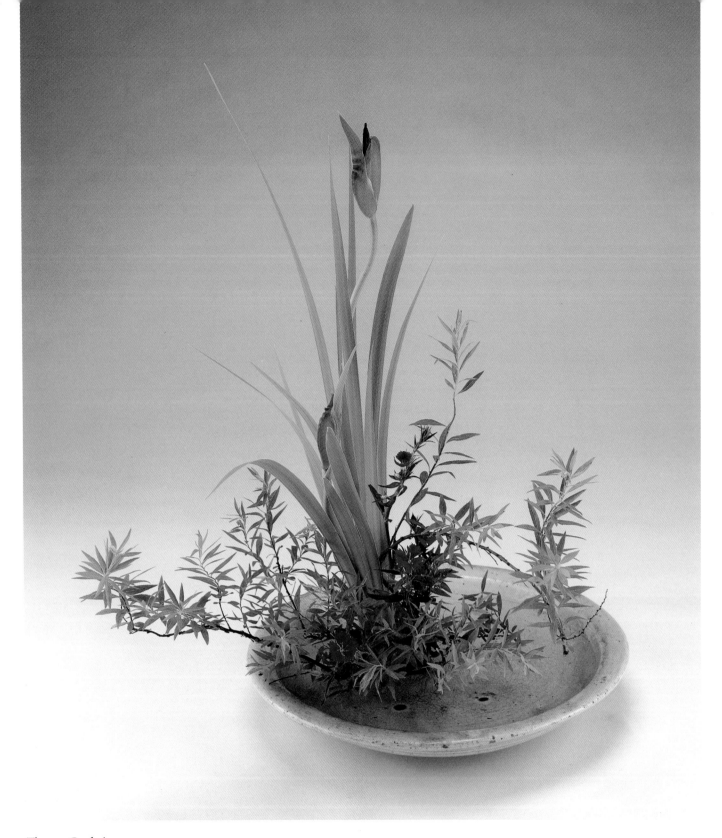

Theme: Cool air

In summer, the flowers of rabbit-ear iris grow taller than the leaves, but the leaves also develop vigorously. There is a noticeable change in the shapes of branches of Thunberg's spirea growing at the water's edge, while among them, superb pinks bloom quietly.

Materials: Rabbit-ear iris, Thunberg's spirea, superb pink / Container: Seto-ware yellow *suiban*

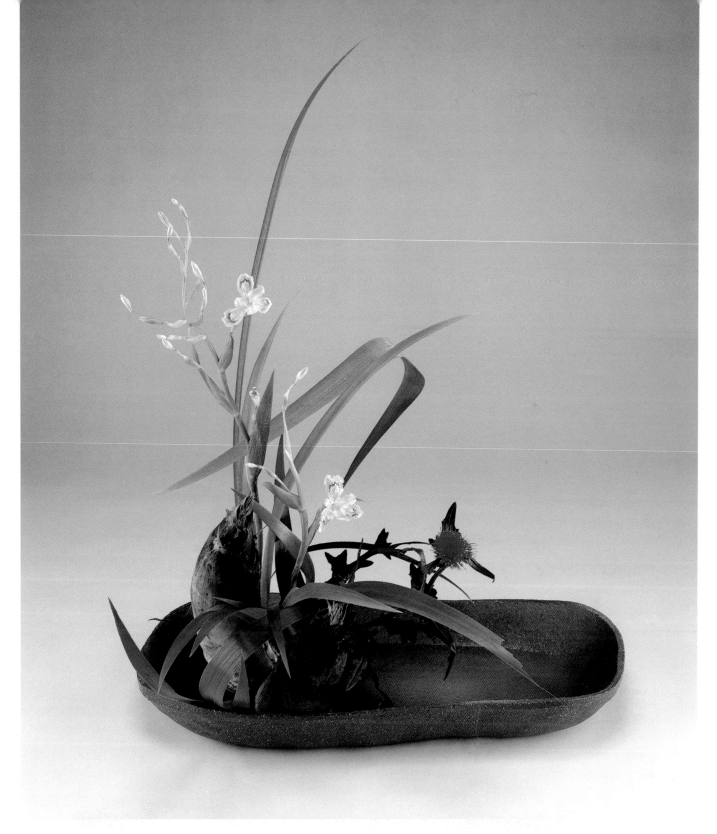

Theme: Poem to the Season

Bamboo shoots start to sprout when the butterfly-like flowers of fringed iris begin to appear. Thistles, too, bear their first flowers as if announcing the arrival of summer. In an earth-colored *suiban*, these three raise a song to the season.

Materials: Fringed iris, bamboo shoot, thistle / Container: Shigaraki-ware *suiban*

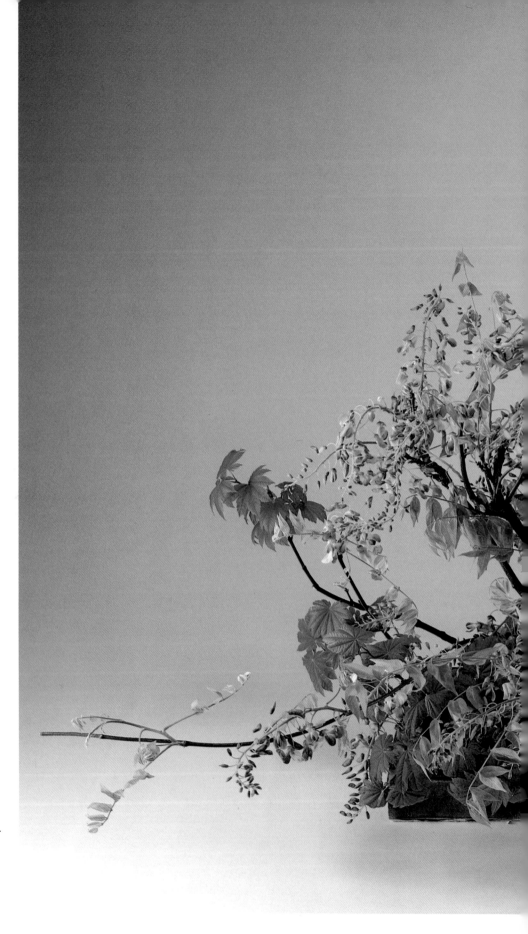

Theme: Affection
When hydrangea flowers take on their characteristic colors, wisteria in the mountainous countryside proudly puts forth its last blossoms. As rainy season is about to set in, maple, with its leaves in fine form, stands close by as if bearing witness to the change of seasons.
Materials: Wisteria, maple, hydrangea
Container: Oribe-ware rectangular *suiban*

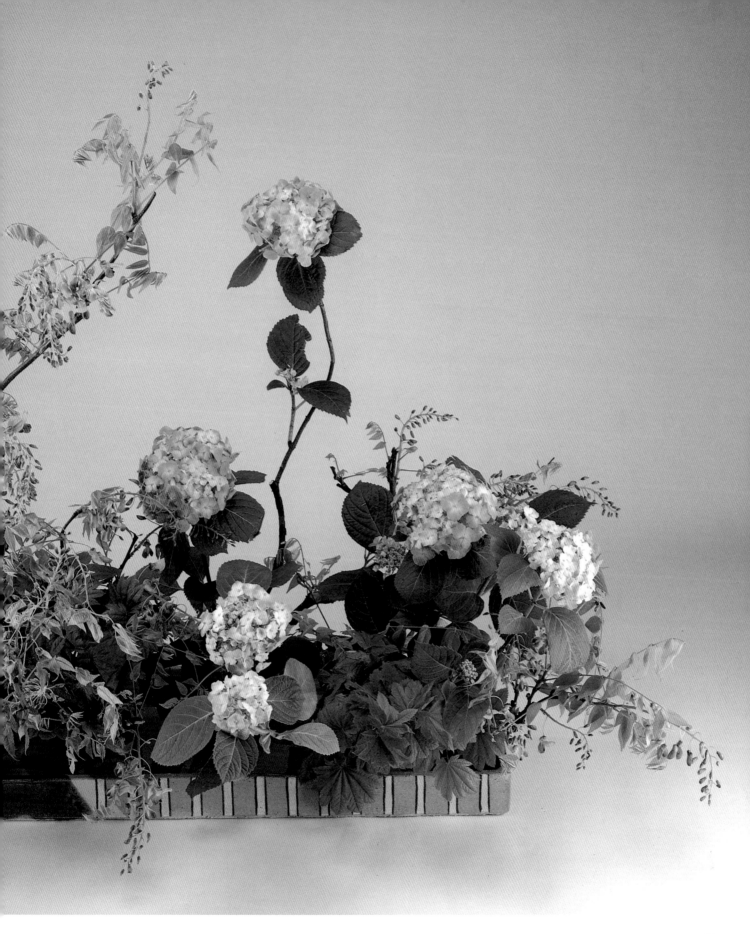

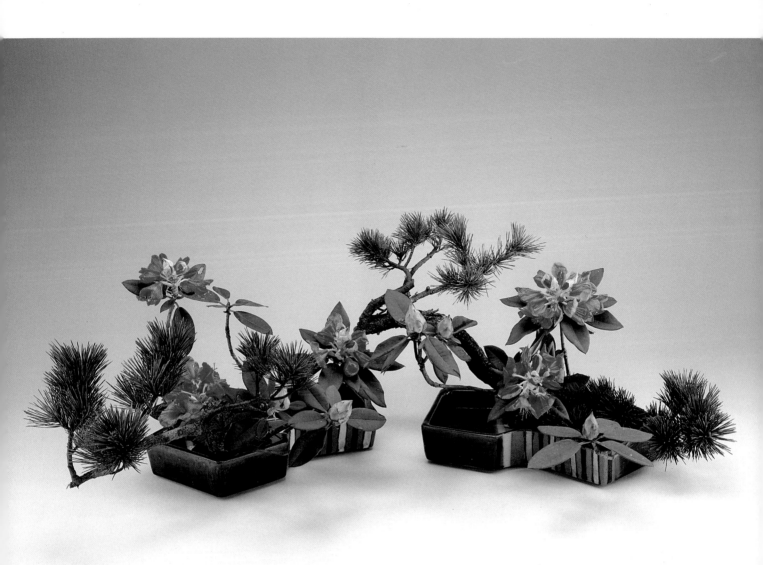

Theme: Powerful breath of nature
While they may be small, pine trees growing among craggy rocks have a great sense of dignity. In two *suiban*, rhododendron is arrayed among the pine branches to highlight their presence, and a feeling of the vitality and power of nature emerges.
Materials: Pine, rhododendron / Container: Oribe-ware fan-shaped *suiban* (2)

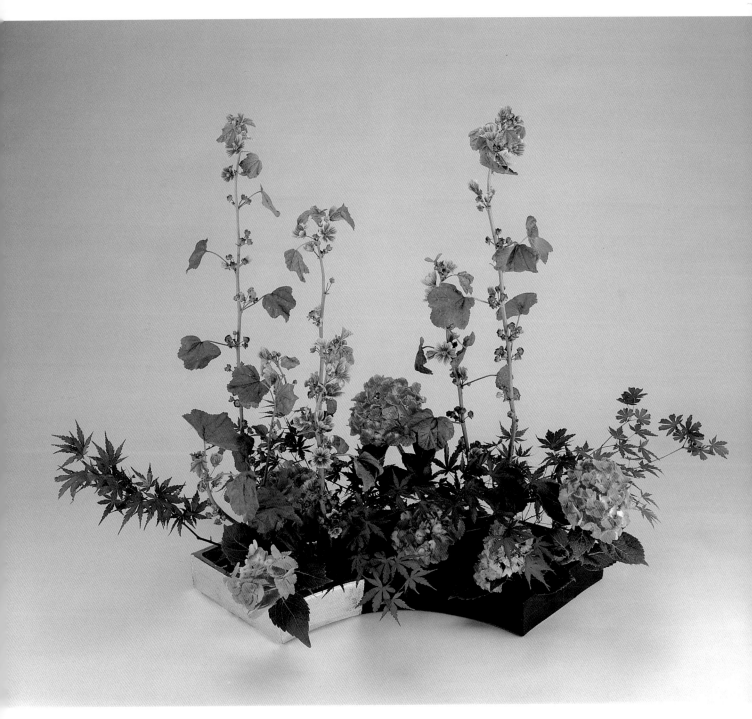

Theme: Early afternoon in the country
A dense stand of tree mallow flowers sweltering in the scorching summer sunlight is a common sight in the countryside. Here, maple with beautifully shaped leaves and hydrangea flowers in all their glory come to the aid of the tree mallow flowers.
Materials: Tree mallow flower, green maple, hydrangea / Container: Silver fan-shaped container

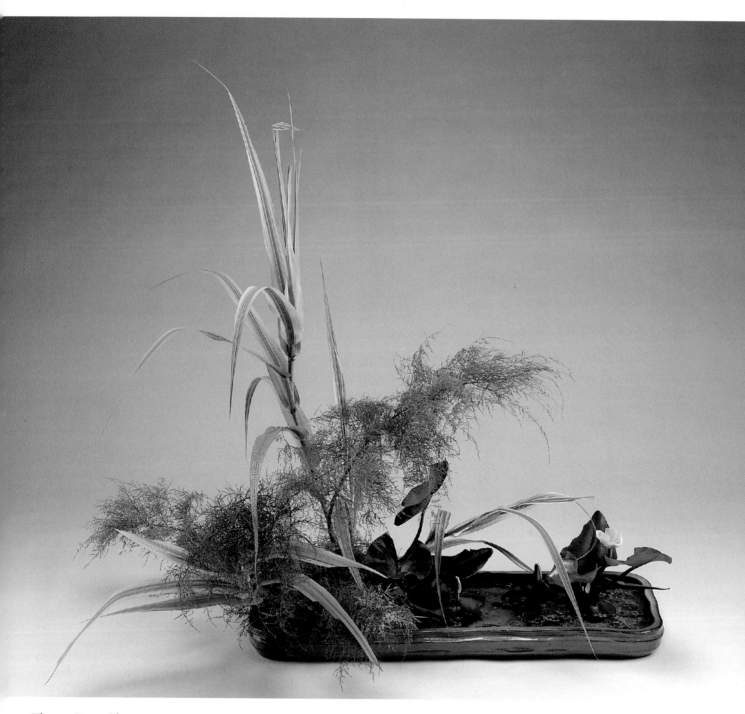

Theme: Past midsummer

The dense foliage of tamarisk has the kind of texture that seems to draw cooling water to it, and the posture of giant reed, which also grows on land, is suggestive of cool air. They have passed their peak and their forms begin to droop—a sure sign at the water's edge that midsummer is over. Both pond lily and water lily bloom among the floating weeds as if fully enjoying this time of year.

Materials: Giant reed, tamarisk, pond lily, water lily, floating weeds / Container: Sodeshi-ware rectangular *suiban*

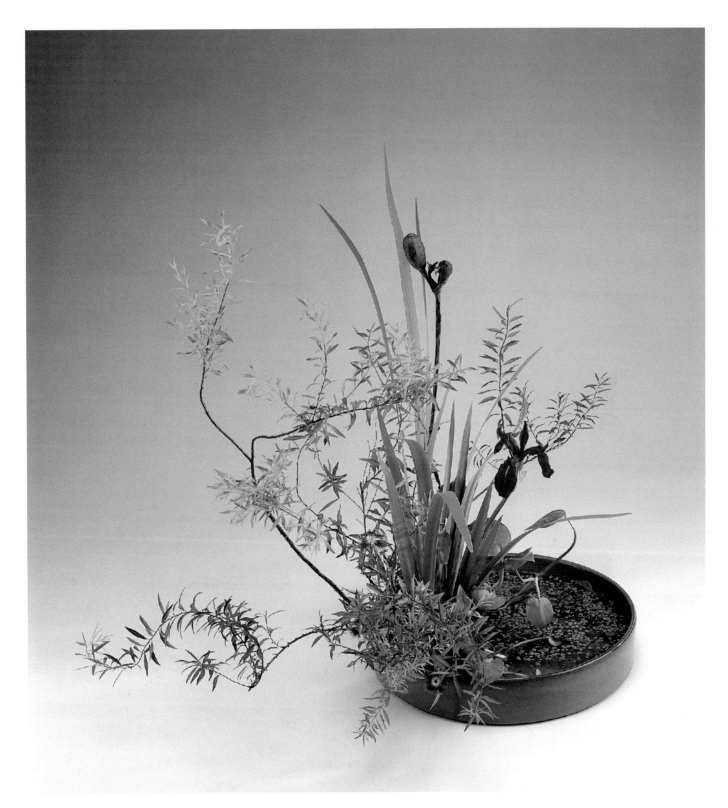

Theme: Late summer at the water's edge

In late summer, the first flowers of rabbit-ear iris turn to seed pods, the first autumn flowers begin to bloom, and leaves tend to grow large and untidy. At the water's edge, crooked branches of spirea become far more prominent. Nevertheless, lovely superb pinks continue to flower, but water hyacinth has finished blooming and its leaves drift on the surface of the water.

Materials: Thunberg's spirea, rabbit-ear iris, superb pink, water hyacinth, floating weeds / Container: Beveled *suiban*

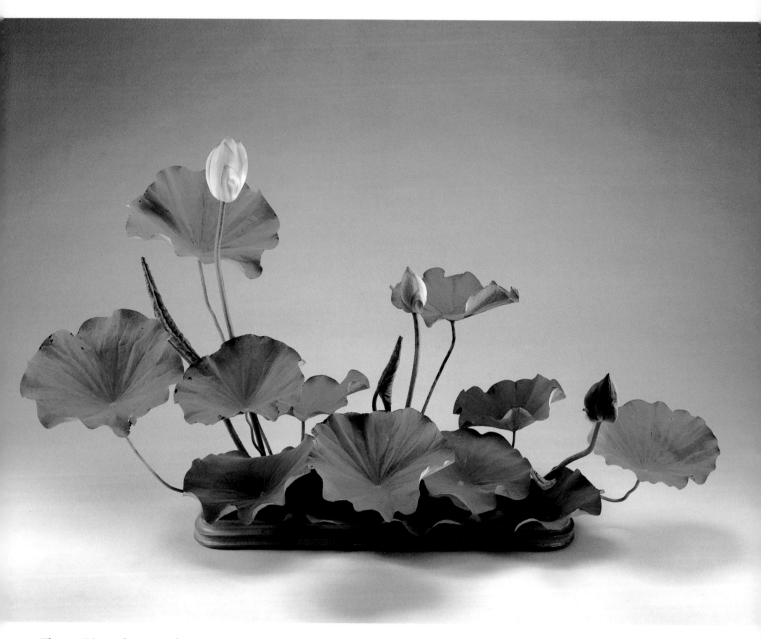

Theme: Distant lotus pond

Thirteen leaves, three flowers and three rolled leaves are used to represent a lotus pond viewed from a distance. To depict lotus at its most splendid, it is vital to arrange each and every leaf in such a way that it appears capable of holding water.

Materials: Lotus: one variety arrangement / Container: Sodeshi-ware rectangular *suiban*

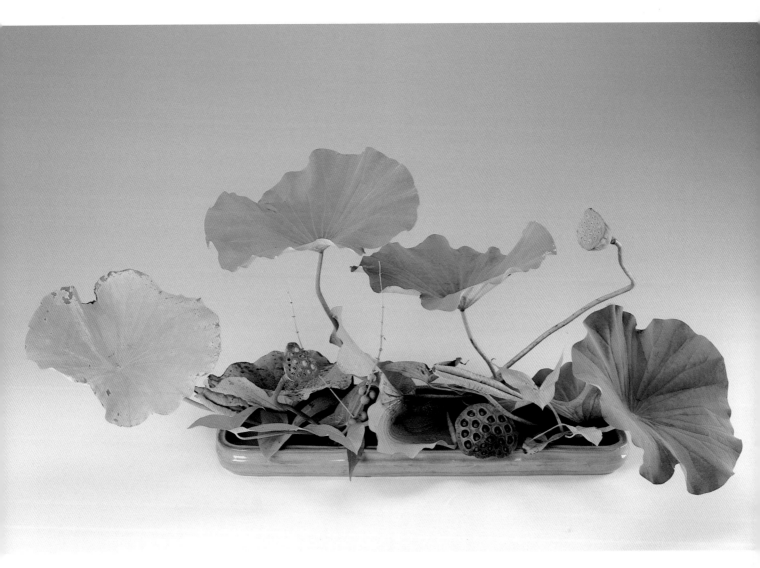

Theme: Transience
Transience affects all things. When the lotus flowers turn to seed pods, the leaves grow large, lose their shape and settle over the surface of the pond. Then arrowhead shows itself through the leaves and we feel the strength and vital energy of water plants.
Materials: Lotus, arrowhead / Container: Sodeshi-ware rectangular *suiban*

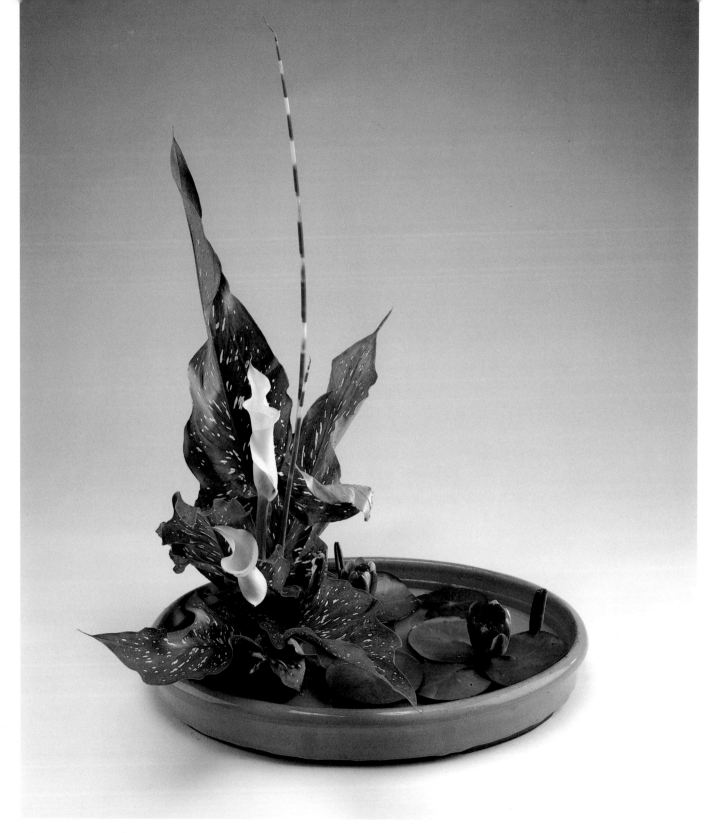

Theme: Water goddess

The calla lily's flower-like spathe emerges from the stalk within the leaves. Although calla lily grows on land, it has the appearance of a water plant. Here, the striped bulrush rises as if forced upward from the root of the spotted calla lily, while two water lilies bloom in summer sunlight on the sparking surface of the water.

Materials: Spotted calla lily, zebra bulrush, water lily / Container: Celadon-glazed oval *suiban*

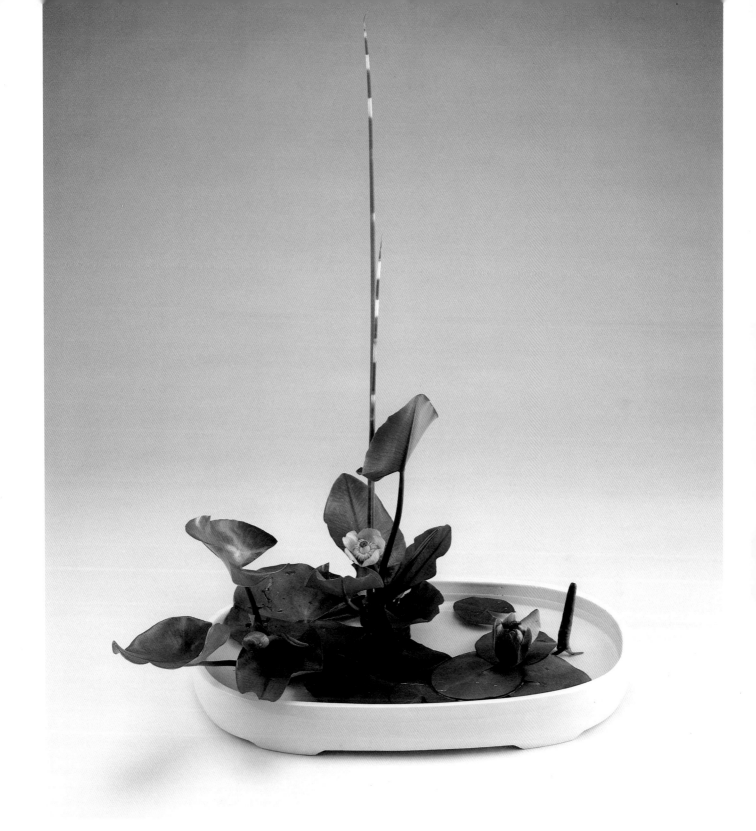

Theme: In a sudden shower
The leaves of pond lily alter their direction in accordance with the flow of the current in which the plant grows. This kind of realistic observation of nature is represented in miniature within the limits of a small, shallow container. Two striped bulrush add interest to the scene, and the single clump of water lily serves as an accent on the surface of the water.
Materials: Pond lily, zebra bulrush, water lily / Container: Tobe-ware porcelain oval *suiban*

Autumn

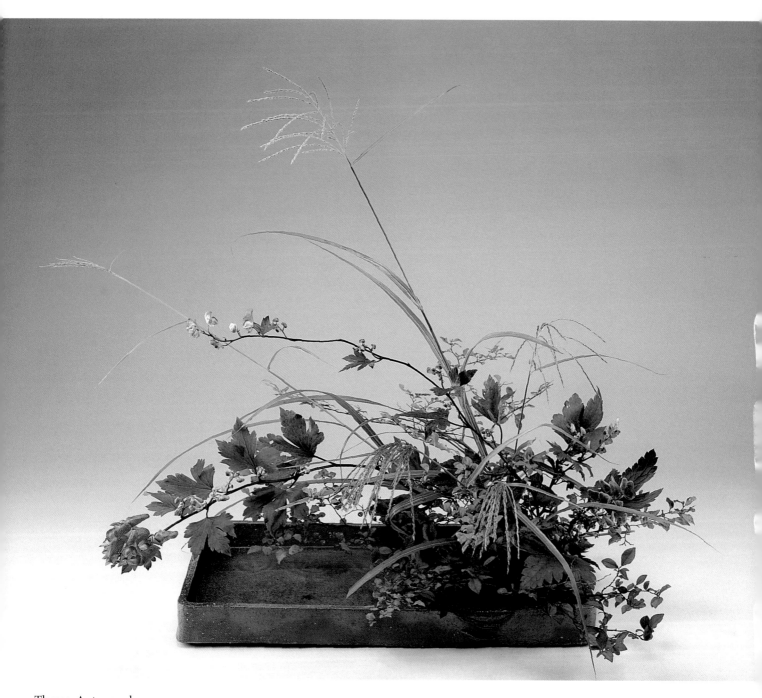

Theme: Autumn elegance
Flowers of monk's hood hang from stems over a mountain stream as thread-like flowers of Japanese pampas grass sway in the breeze above bushes of *vaccinium oldhami,* creating an elegant feeling of autumn.
Materials: Monk's hood, *Vaccinium oldhami,* Japanese pampas grass / Container: Shigaraki-ware square *suiban*

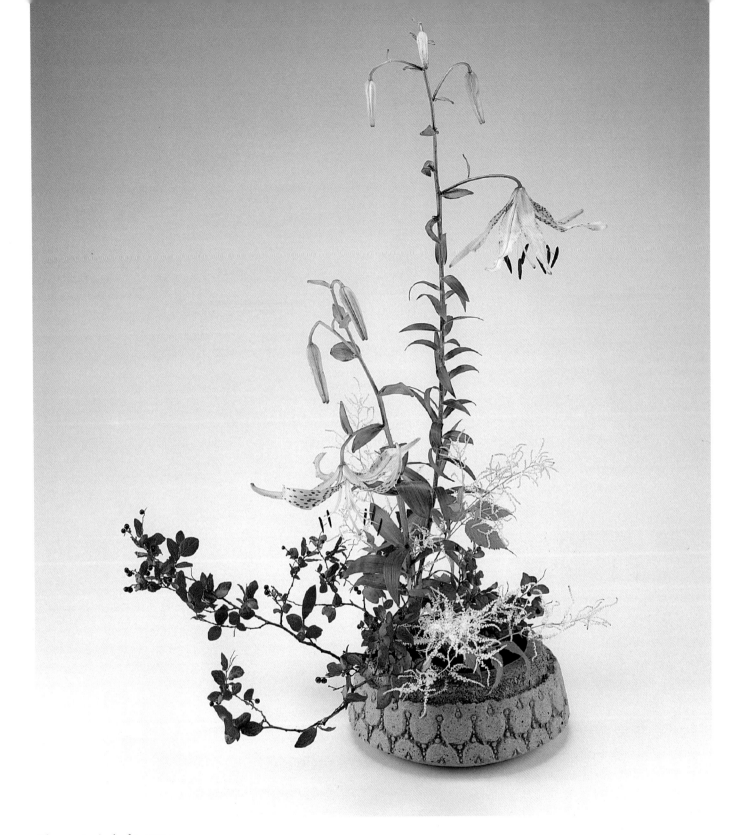

Theme: Arrival of autumn
In the first blossoms of Maximowicz's lily and the refreshing feel of cimicifuga, we sense the approach of autumn. The moist *vaccinium oldhami* makes a gently tasteful accompaniment to the stone *suiban*.
Materials: Maximowicz's lily, *Vaccinium oldhami*, cimicifuga / Container: Stone *suiban* with engraved pattern

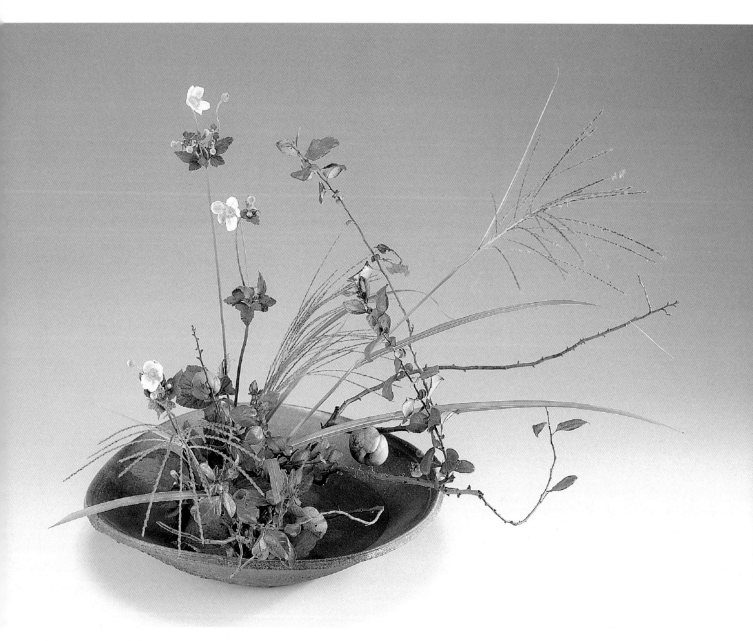

Theme: Autumnal fragrance
Swaying, thread-like flowers of Japanese pampas grass and fruit-bearing quince evoke the deepening autumnal mood. The addition of Japanese anemone with its light, graceful form effectively captures an autumn scene in the countryside.
Materials: Fruit-bearing quince, Japanese pampas grass, Japanese anemone / Container: Shigaraki-ware *suiban*

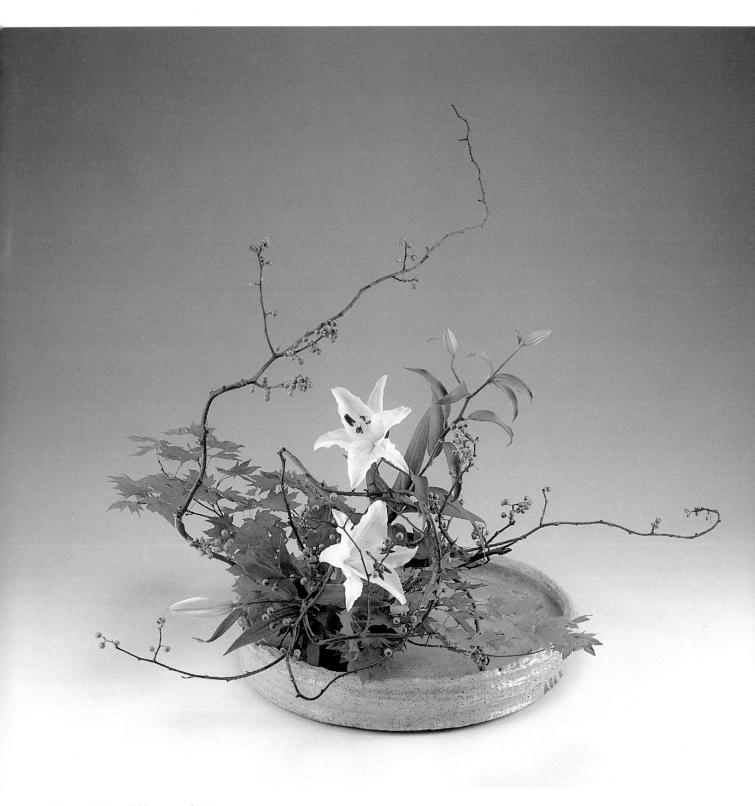

Theme: The wild beauty of vines
In the tangled, intertwined lines of Japanese bittersweet, there is a rich sense of wild natural beauty that is characteristic of vines in autumn. Marco Polo lilies bloom in a thick growth of maple, casting their shadows upon the autumn waters.
Materials: Japanese bittersweet, green maple, Marco Polo lily / Container: Original work by Yuji Ito

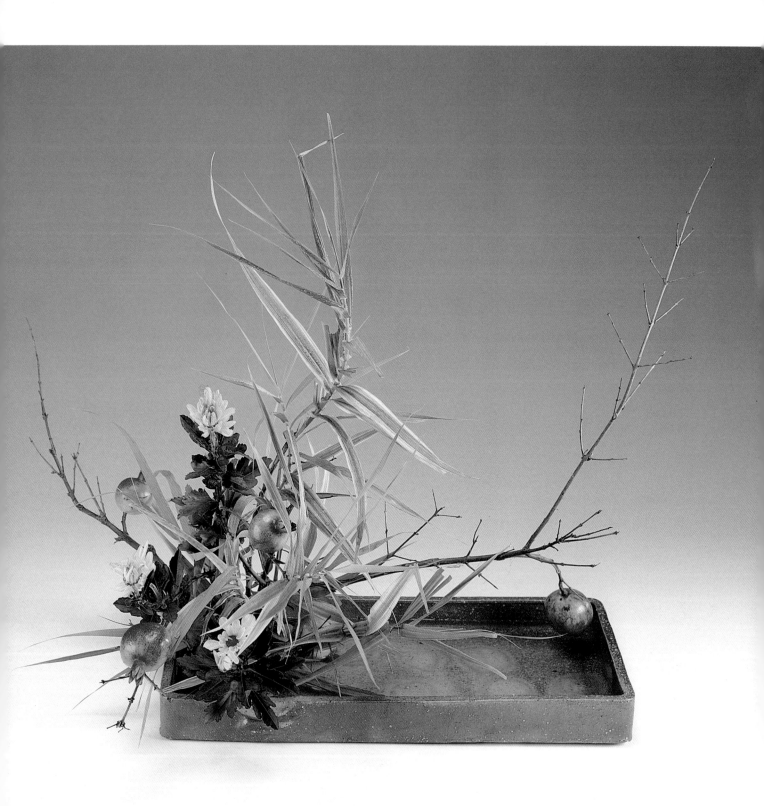

Theme: Daybreak
Daybreak at the water's edge in the marshlands is depicted in this arrangement of pomegranate, extending its fruit-bearing branches of over the water, and chrysanthemums accompanied by stalks of giant reed with their fresh, lively movements.
Materials: Pomegranate, giant reed, chrysanthemum / Container: Shigaraki-ware square *suiban*

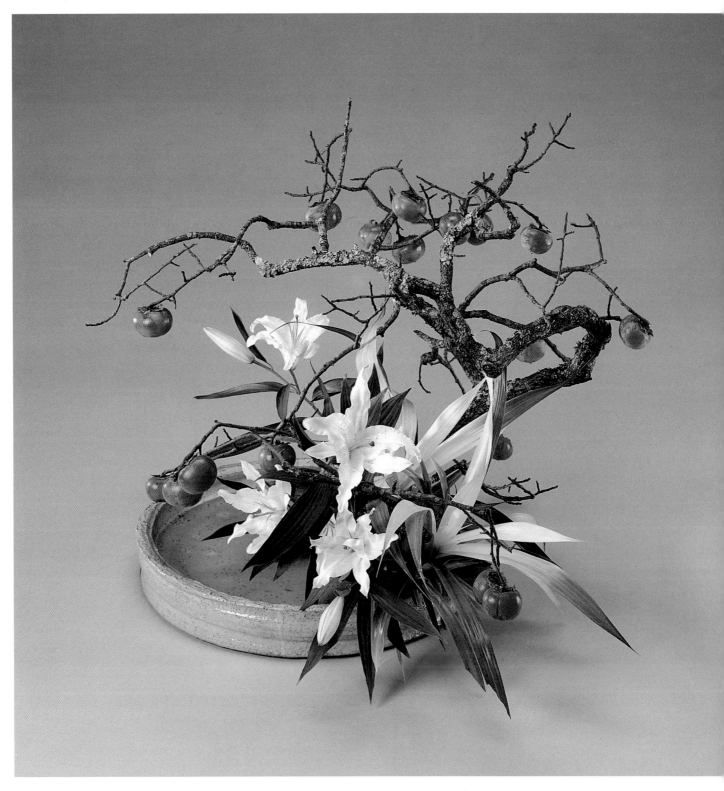

Theme: Clouds at dusk

Persimmon branches heavily laden with fruit are arranged with pandanus leaves in this scene at dusk. The lilies symbolize the soft clarity of that moment before nightfall.

Materials: Persimmon, lily, pandanus / Container: Original work by Yuji Ito

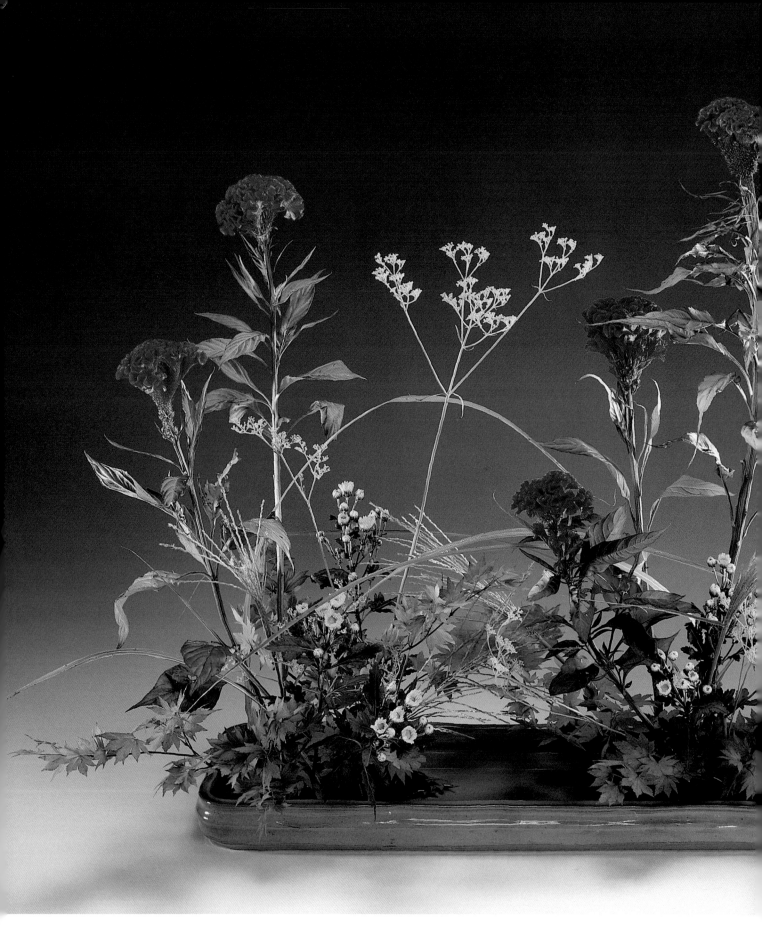

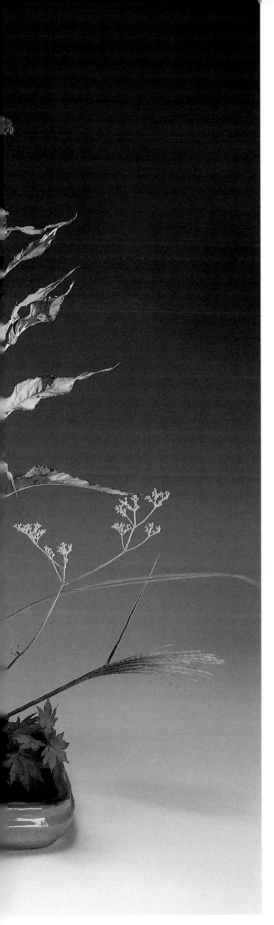

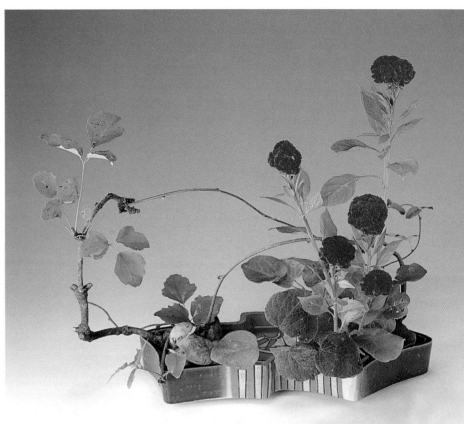

Theme: After the rain
The brightly colored cockscomb flowers, a group of fresh leaves of Japanese witch hazel and the vines and fruit of akebia evoke a scene in autumn after the rain.
Materials: Akebia, cockscomb, Japanese witch hazel / Container: Oribe-ware fan-shaped *suiban*

Theme: Rustic scene
Here is a typical scene in an autumn field where cockscomb, patrina and small chrysanthemums bloom from a base of maple and Japanese pampas grass with its delicate thread-like flowers.
Materials: Cockscomb, patrina, Japanese pampas grass, small chrysanthemums, maple / Container: Sodeshi-ware rectangular *suiban*

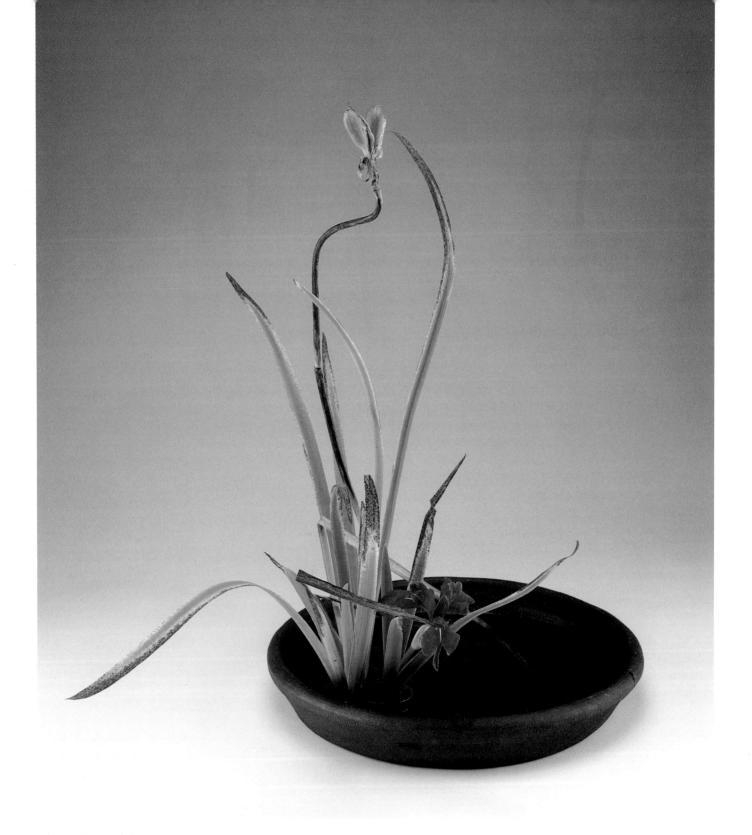

Theme: Time of change

In late autumn, rabbit-ear iris produces seed pods and its last flowers bloom low. Some leaves wither and break; others are damaged by insects. Here the mood is one of lonesome desolation in a time of change.

Materials: Rabbit-ear iris: late autumn / Container: Nanban-style *suiban*

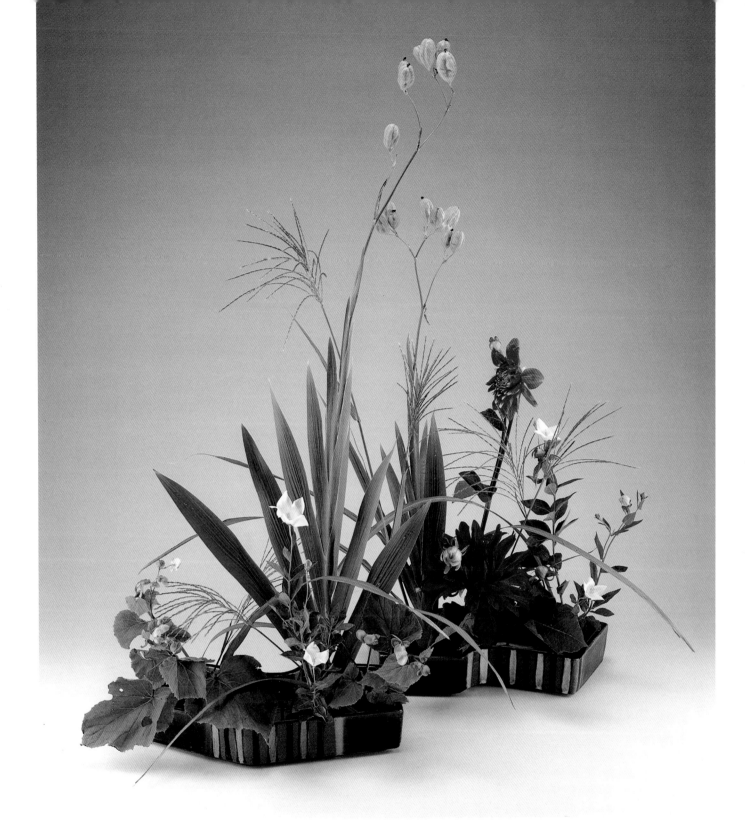

Theme: Poem of autumn

In Japanese, the berries of blackberry lily are called *nubatama*, literally black balls.Composed of dahlia, Chinese bellflower, bego-
nia, and flowering Japanese pampas grass, this work is a symphony on the theme of autumn flowers and grasses.

Materials: Blackberry lily, dahlia, Chinese bellflower, begonia, Japanese pampas grass / Container: Oribe-ware fan-shaped *suiban*

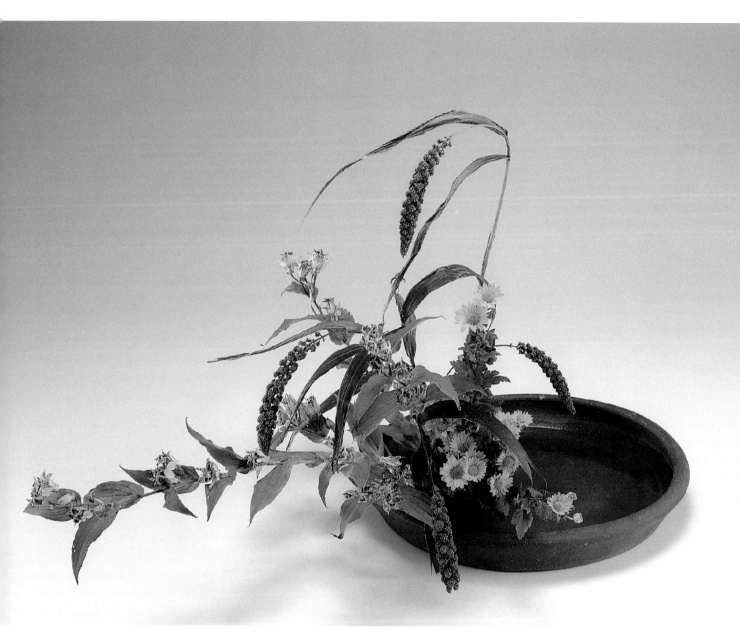

Theme: Autumn in the countryside
Amidst a tangled growth of flowering toad lily and small chrysanthemums, hanging ears of millet evoke the ambiance of a lonely village and advancing autumn in the countryside.
Materials: Toad lily, millet, small chrysanthemum / Container: Nanban-style *suiban*

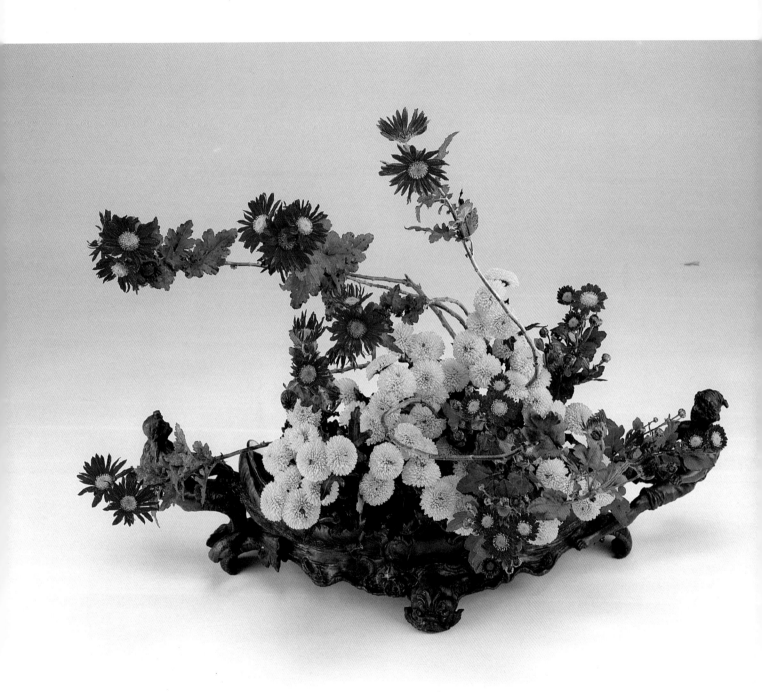

Theme: Wild dance
When autumn colors deepen, chrysanthemums on long, curving stems come into bloom. Arranged with a small, round variety of striking design, the two kinds of chrysanthemums seem joined in a wild dance.
Materials: Chrysanthemum (two varieties) / Container: Antique copper

Theme: Sensuous autumn
Among the tinted maple leaves, the small purple fruit of beauty berry evokes a rich autumnal atmosphere, and white camellia blossoms further deepen the elegant mood.
Materials: Maple, beauty berry, white camellia / Container: Arita-ware porcelain *suiban*

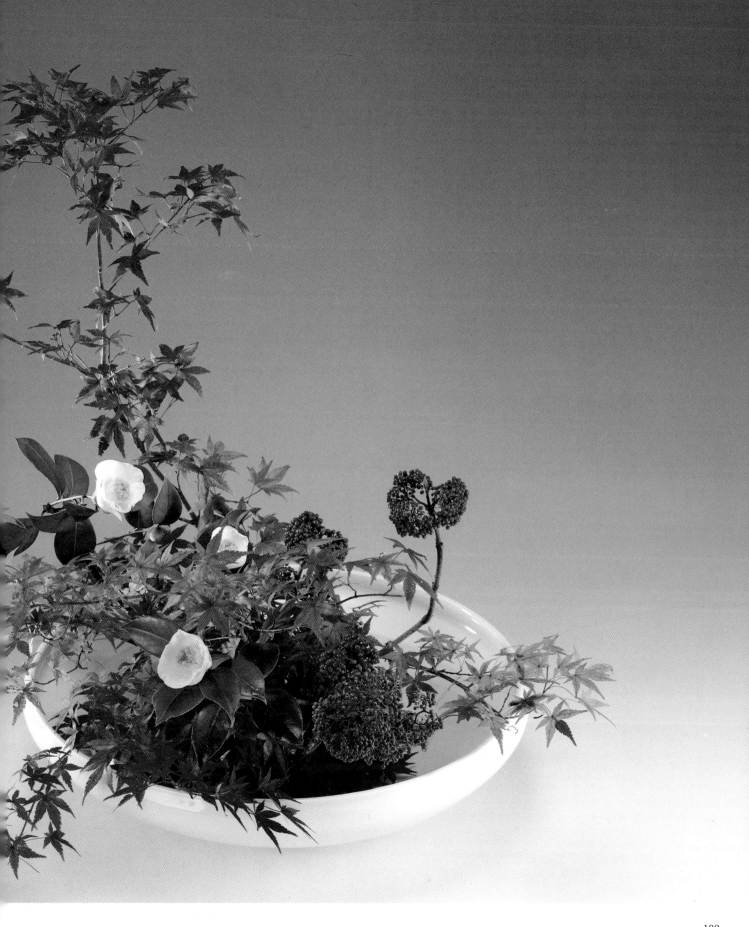

Winter

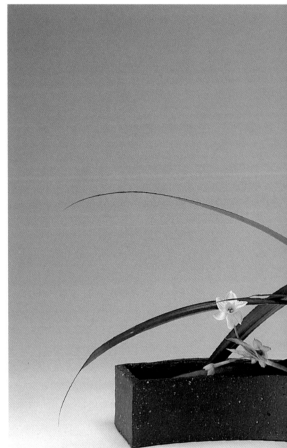

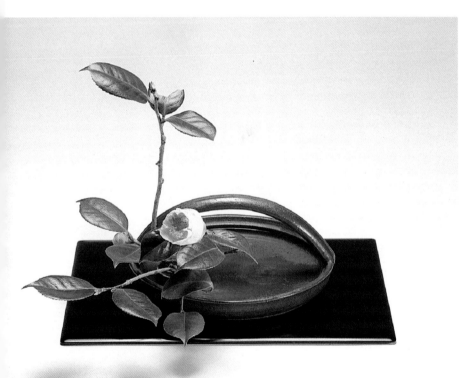

Theme: One flower, eleven leaves

After the stem has been severely trimmed of leaves, shiratama camellia is arranged as a twig broken off from a large bush. The point of this technique is to express through a small arrangement the vast inner nature of the camellia. Remove all but an odd number of leaves from the stem, or an odd number plus a single leaf, half of which has been torn off.

Materials: Shiratama camellia; one-variety arrangement / Container: Ceramic bowl with a handle

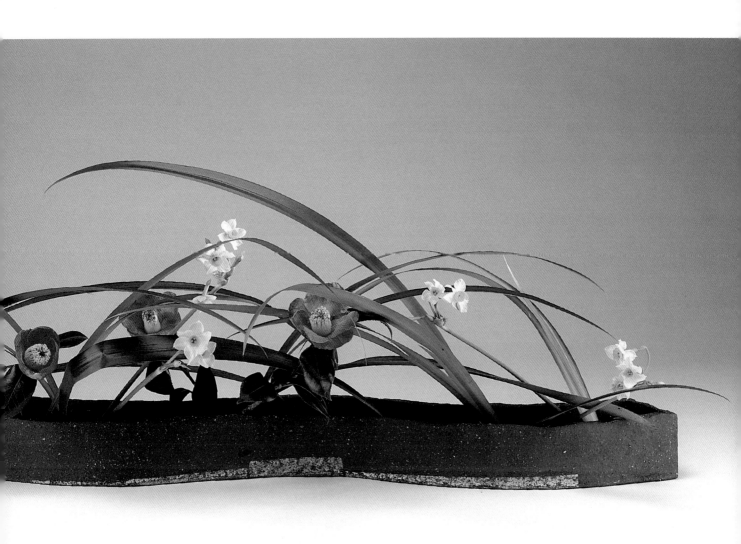

Theme: The effect of one leaf
Camellia is highlighted in the tense space created by the crossing blades of fringed iris. The narcissus flowers studding the space produce a melodious effect.
Materials: Narcissus, camellia, fringed iris / Container: Original *suiban* by Kazuhiko Sato

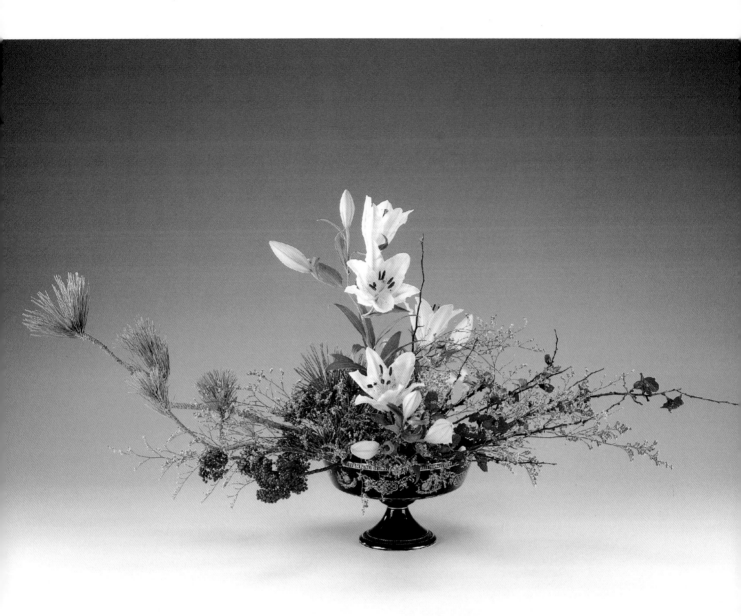

Theme: Winter colors
Le Rêve lilies and misty blue statice placed among the branches of pine and beauty berry that spread expansively to the left and right add color to the wintry mood.
Materials: Pine, flowering quince, beauty berry, Le Rêve lily, misty blue statice / Container: Compote

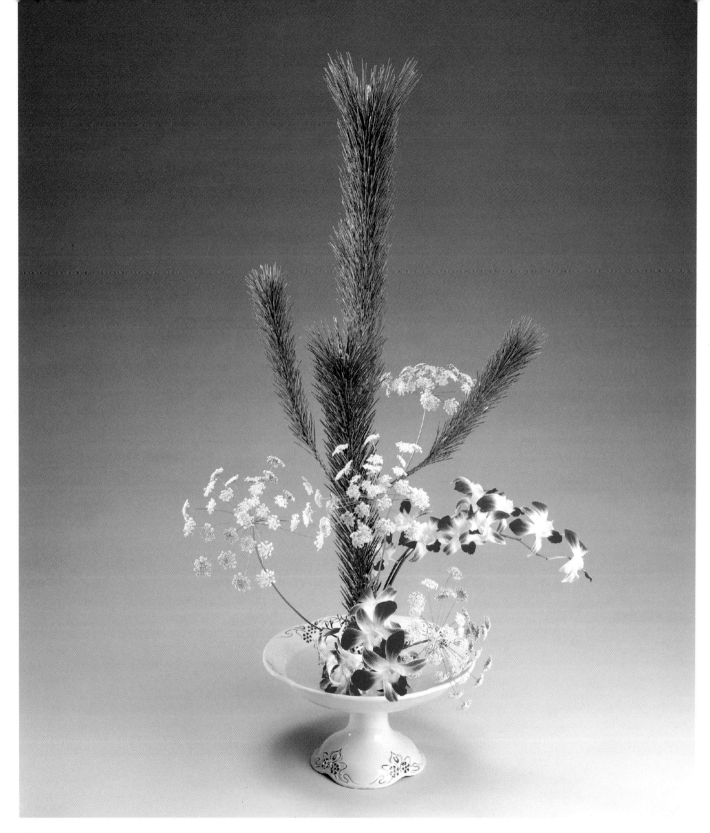

Theme: Resplendent amidst severe cold
A resplendent form emerges when *dendrobium phalanepsis* and lace flower are arranged with the boldly rising figure of young pine.
Materials: Young pine, *Dendrobium phalanepsis,* lace flower / Container: Compote with colored pattern

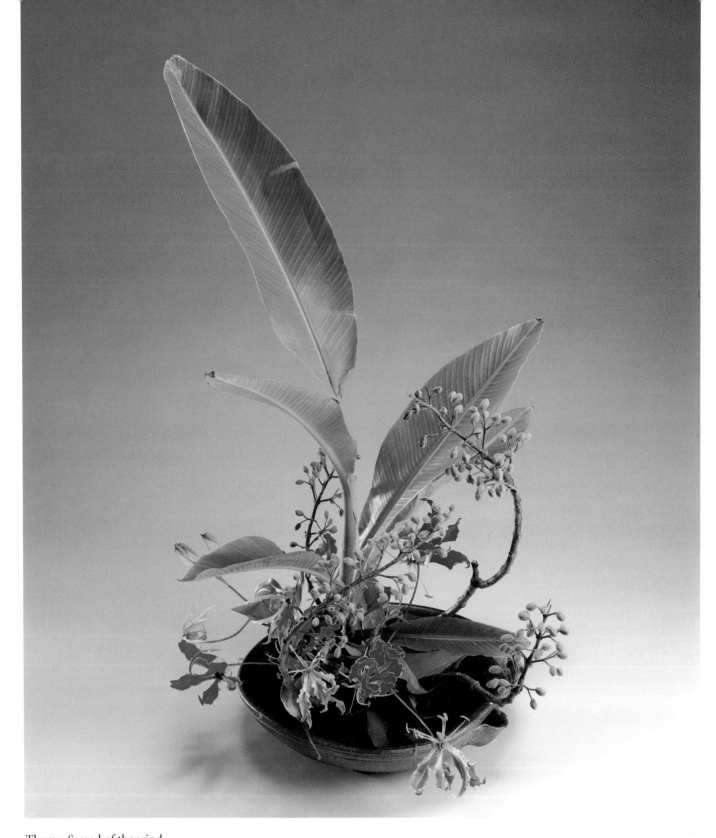

Theme: Sound of the wind
There is something exotic in the encounter of Ryukyu banana leaves and paulownia. With the addition of gloriosa lily, this Moribana takes on the poetic air of a work in the *bunjin* manner, a kind of ikebana inspired by Chinese literature and painting.
Materials: Ryukyu banana leaf, paulownia, gloriosa lily / Container: Shigaraki-ware *suiban*

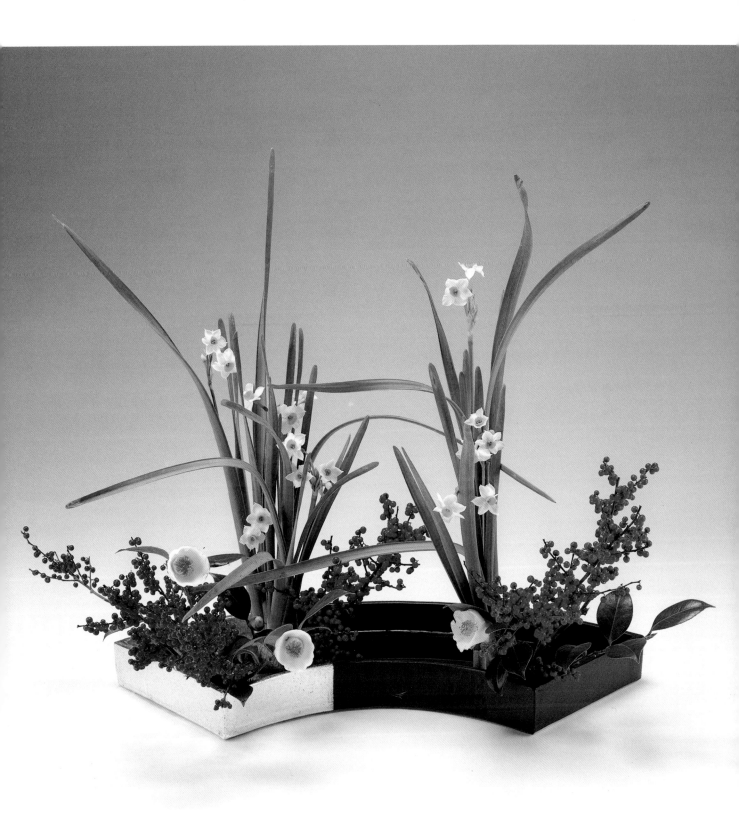

Theme: Budding

Narcissus flowers and leaves are gathered into bold, upright clumps that have a strong design effect. They are placed facing each other, and at the base of the clumps, white camellias and Japanese winter berry emerge to the left and right in symbolic expression of the spirits of the budding flowers.

Materials: Narcissus, Japanese winter berry, white camellia / Container: Silver fan-shaped *suiban*

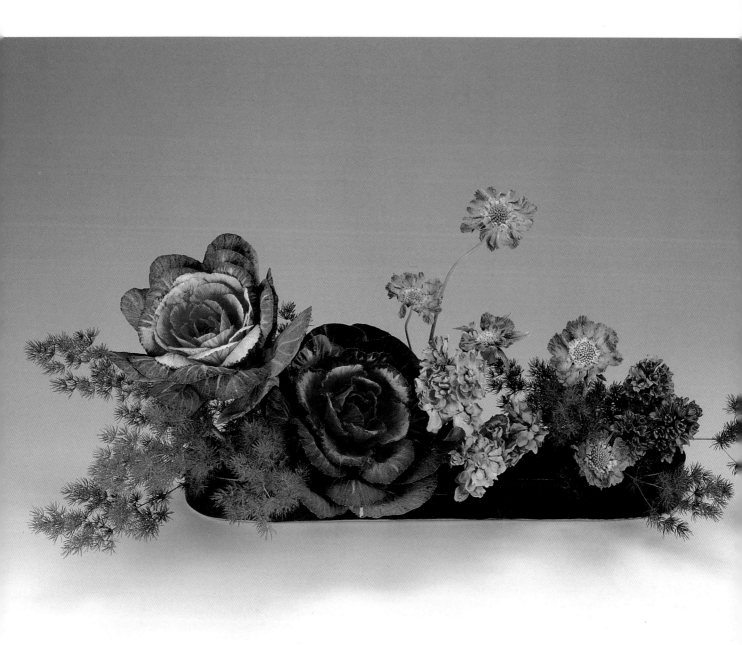

Theme: Warm winter
The large mass of flowering cabbage composed of many layers of leaves seems warmly clothed against the winter's cold. With *asparagus myriocladus* as a base, flowers of hyacinth and scabiosa are arranged in masses to complete this horizontal composition.
Materials: Flowering cabbage, *Asparagus myriocladus,* hyacinth, scabiosa / Container: Black-glazed oval *suiban*

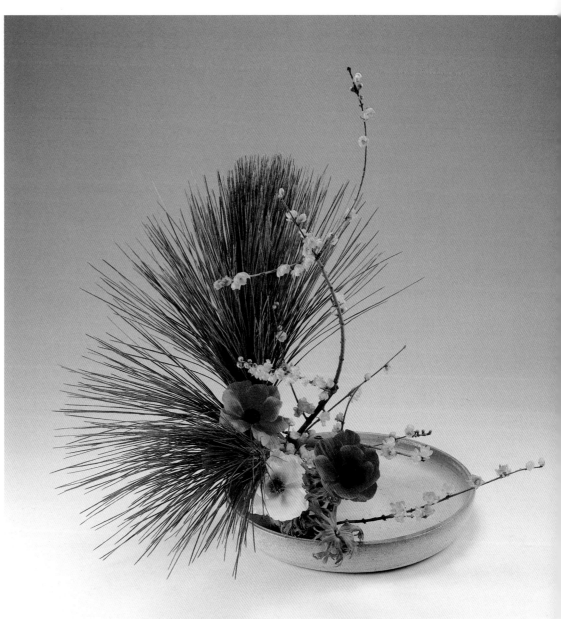

Theme: Near spring

The strong, radial form of long-needle pine seems to repel the cold air. Two sprays of pine are arranged in an upright composition with branches of winter sweet and anemone to suggest flowers that await the coming of spring.

Materials: Long-needle pine, winter sweet, anemone / Container: Gray-glazed *suiban*

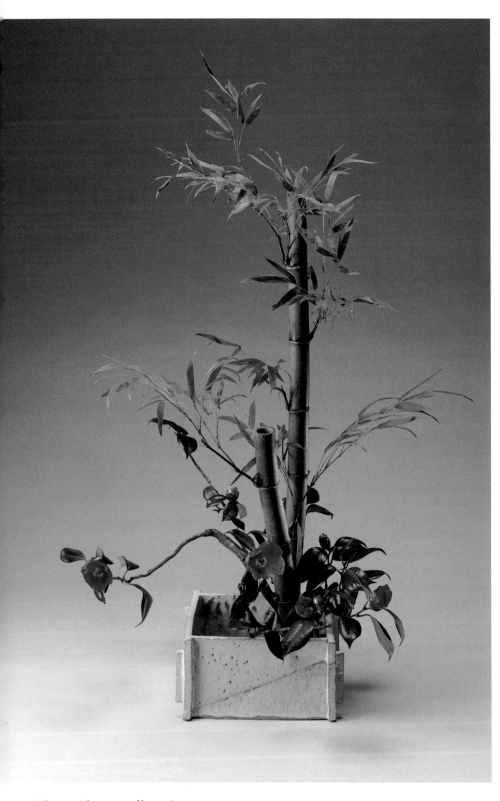

Theme: Elegance of late winter

The winter posture of bamboo with its fresh green leaves, and camellia opening its deep red blossoms in the bitter cold have a pure, taut appearance—the kind of elegance born in the cold winter season.

Materials: Bamboo, camellia / Container: Shino-ware glazed water pitcher

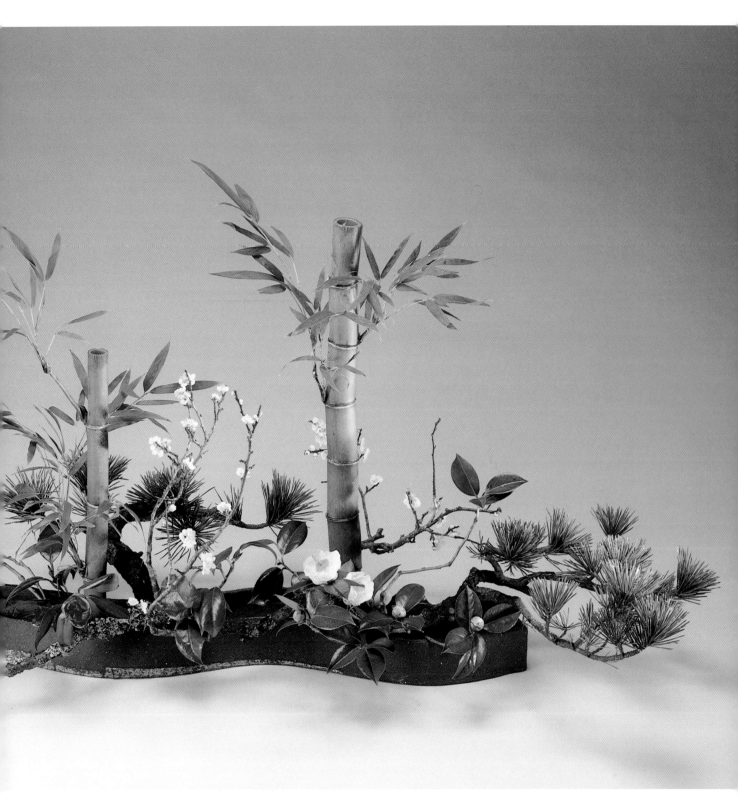

Theme: Winter refreshment

In the tradition of Chinese writers and painters, called *bunjin* in Japanese, pine, bamboo, Japanese apricot and camellia were referred to as the four purities of winter—plants of an elegant purity that bravely revel in the coldest season of the year. They are arranged here in a horizontal composition with a strong pictorial quality.

Materials: Bamboo, pine, Japanese apricot, camellia (white and red) / Container: Original *suiban* by Kazuhiko Sato

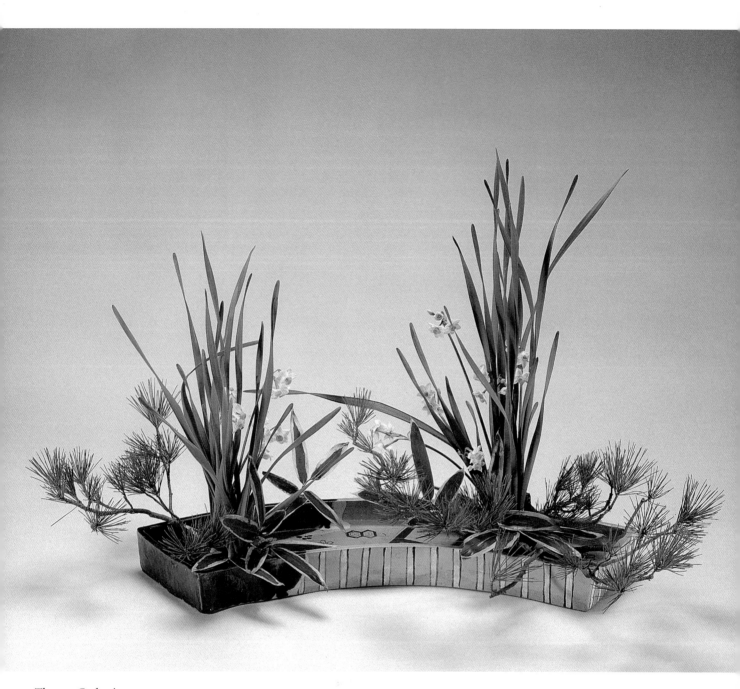

Theme: Gathering
The combination of pine and narcissus was referred to by traditional Chinese writers and painters, called *bunjin* in Japanese, as *gunsenkyoju,* meaning the sharing of joy with others. The addition of sasa bamboo produces a more realistic depiction of nature.
Materials: Narcissus, small pine, sasa bamboo / Container: Oribe-ware fan-shaped *suiban*

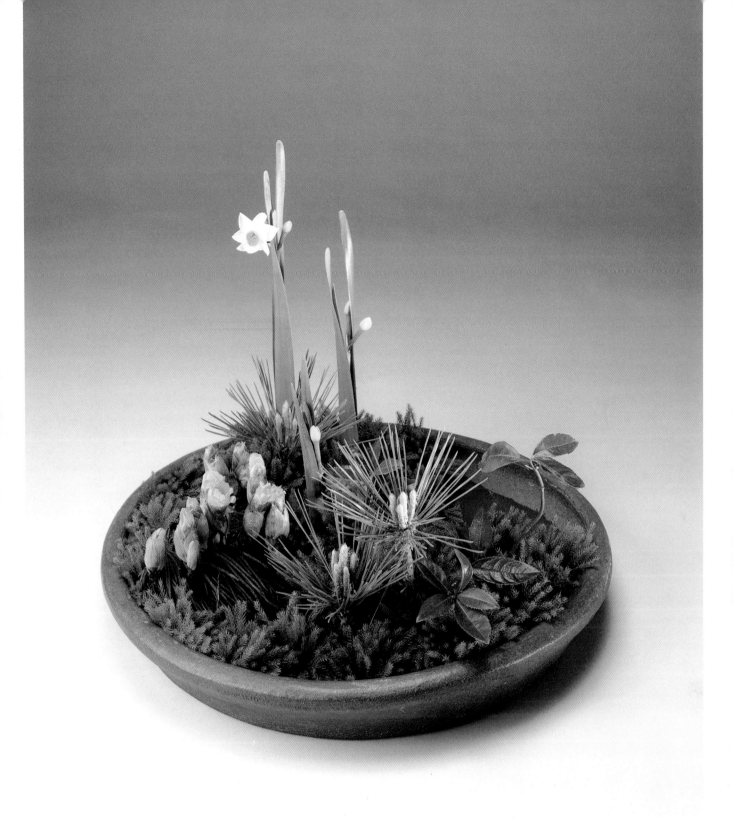

Theme: Sprouting

New shoots of pine appear amid withered pine needles that cover the earth. Nearby, narcissus, *amur adonis* and Japanese ardisia begin to sprout, anticipating the arrival of warm spring.

Materials: Narcissus, sprouting pine, *Amur adonis,* Japanese ardisia, club moss / Container: Nanban-style *suiban*

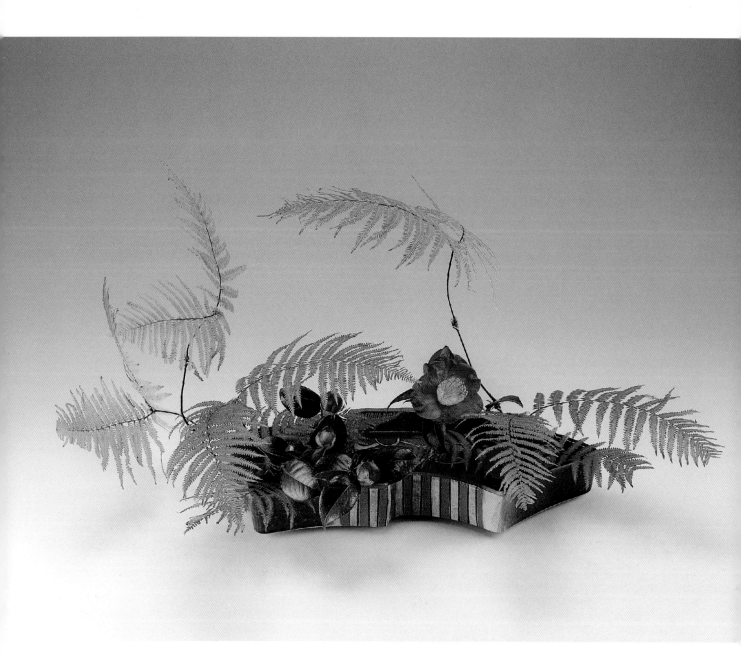

Theme: Winter morning
Fern-like branches of lot tree soar in the cold air, while the Myoren-ji camellia, gazing from its shelter in a sunny spot, opens its large blossom.
Materials: Lot tree, Myoren-ji camellia / Container: Oribe-ware fan-shaped *suiban*

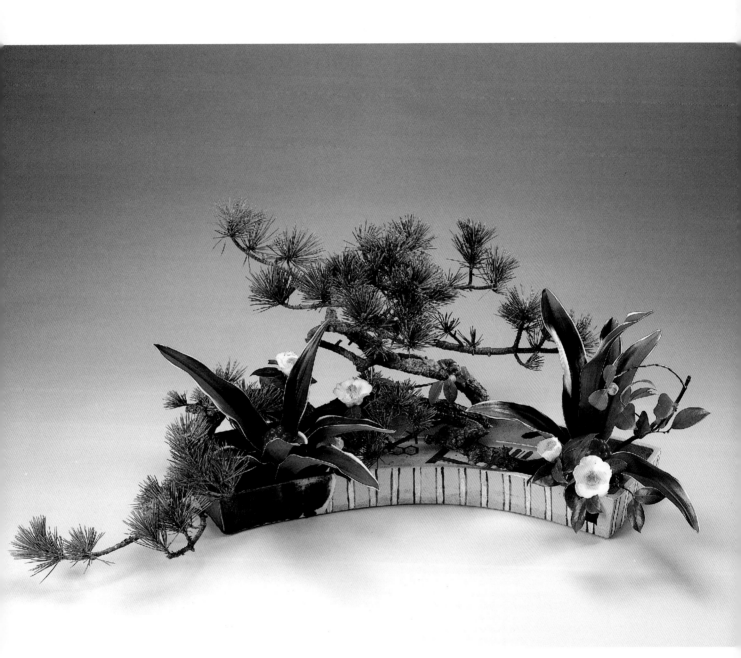

Theme: Elegant charm
The virile figure of pine that has withstood driving snow storms is arranged with two groups of Japanese rhodea in a fan-shaped *suiban* with the emphasis on striking design effects. In this highly stylized composition, white camellias accompany the rhodea in a celebration of the new year.
Materials: Pine, Japanese rhodea, camellia / Container: Oribe-ware fan-shaped *suiban*

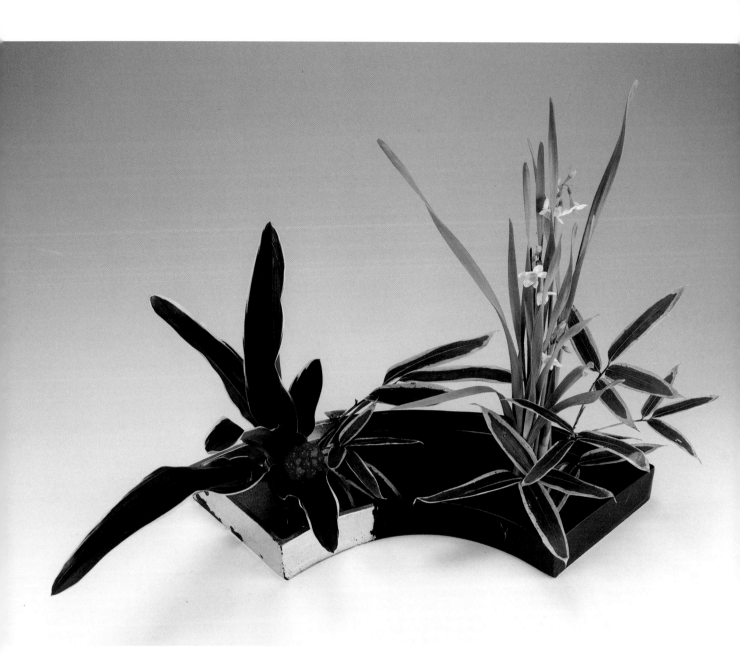

Theme: Glimmering water
Both Japanese rhodea and narcissus live through the winter season. Narcissus blooms in the midst of bitter cold, while rhodea with its deep green leaves and brilliant red berries stands powerfully against the crisp, chilling air. They are arranged in separate groups and accompanied by strikingly patterned leaves of sasa bamboo in this view of the water's edge bathed in glittering winter sunlight.
Materials: Japanese rhodea, narcissus, sasa bamboo / Container: Silver fan-shaped *suiban*

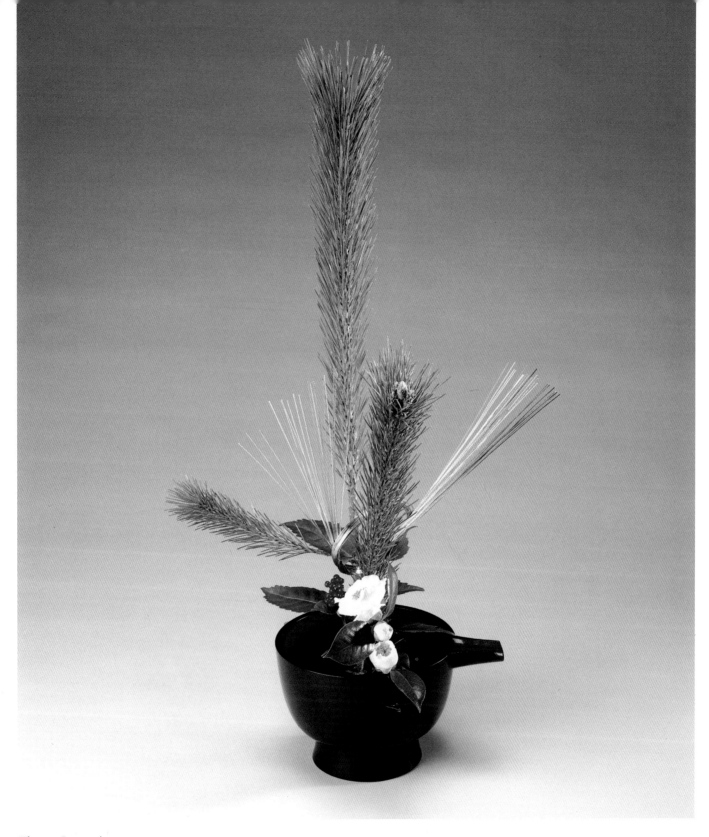

Theme: Longevity

The bold upright form of pine is tied with gold and silver strings, a type of decoration reserved for auspicious occasions. Arranged with white camellia and senryo as a sign of celebration, this arrangement symbolizes long life at the beginning of the new year.

Materials: Young pine, white camellia, senryo (*Chloranthus glaber*), gold and silver decorative string / Container: Lacquer ware

IV
Free Style Moribana

Free Style Moribana is an abstract form of ikebana in which materials are used not as they are in nature but as objects for the artists' personal expression. With special attention paid to color, shape and texture, compositions are created sometimes by distorting, sometimes by totally transforming the materials.

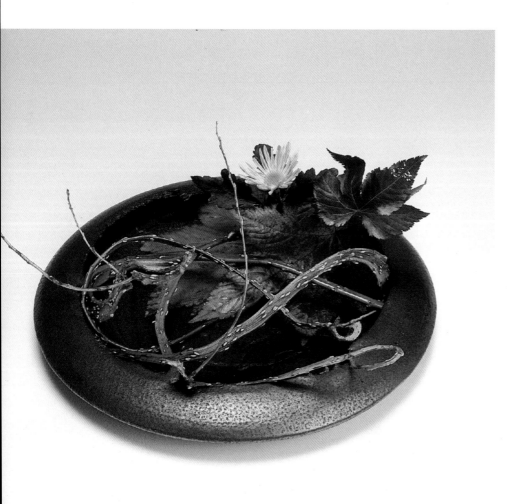

Theme: Winter seclusion

The belt-like branches of fasciated willow are bent into forms confined within the disc-shaped container. Large, autumn-tinted raspberry leaves are used for design effect, and the single chrysanthemum suggests the point at which motion begins.

Materials: Fasciated willow, tinted autumn raspberry, chrysanthemum / Container: Mobach *suiban*

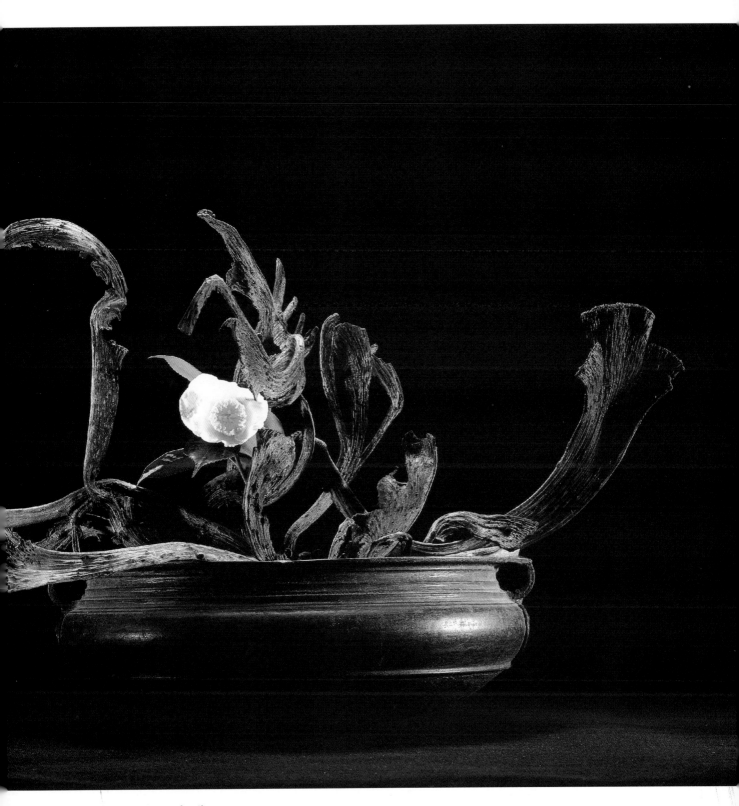

Theme: Living spirit among fossils
Belt-shaped stems of fasciated broom with their fossil-like forms writhe and leap from the copper bowl, creating a bizarre, mysterious atmosphere. A single white camellia, placed quietly among them, invokes the spirit of a living flower.
Materials: Fasciated broom, camellia / Container: Copper bowl

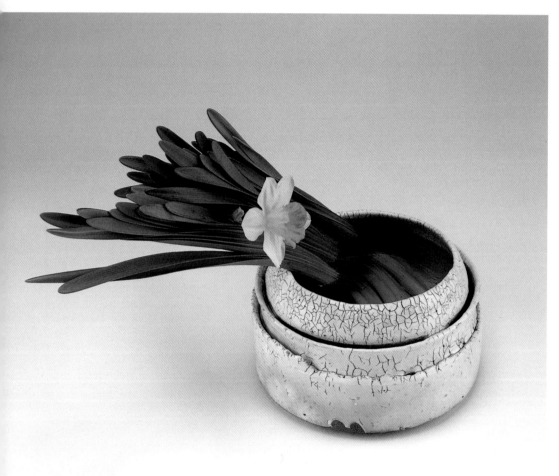

Theme: Prince Narcissus

The leaves of daffodil are gathered roughly together and placed leaning against the rim of a container which is filled with water. A single daffodil flower inserted among the leaves seems almost on the verge of speech.

Materials: Daffodil / Container: Original work by Koji Ito

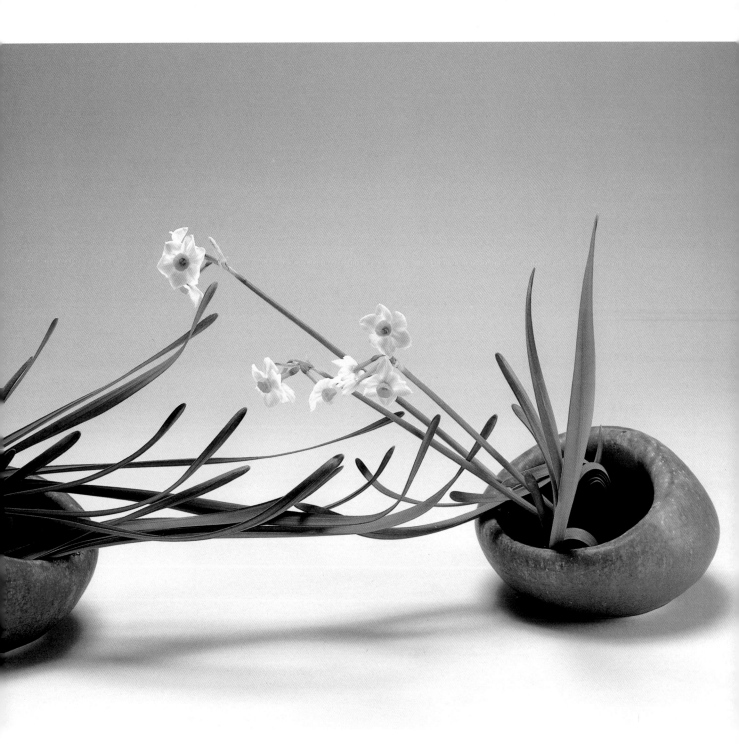

Theme: Attracted by a soft touch
The leaves of narcissus extend their soft, slender forms as if chatting to each other from two similar bowls placed on the left and right. Attracted by the gentle touch of the leaves, the pure, graceful flowers extend their stems, filling the air with a faint fragrance.
Materials: Narcissus: one-variety arrangement / Container: Flower bowl (two)

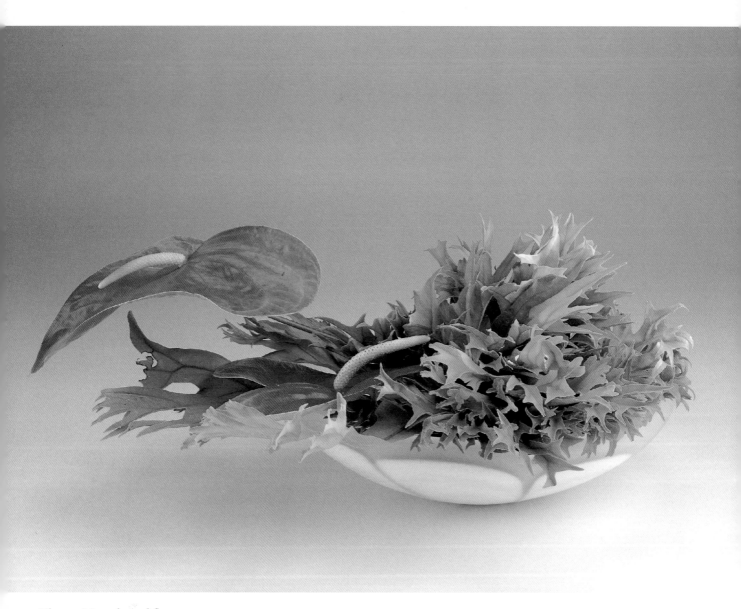

Theme: Many-legged flower
When the leaves of polypodium are piled together, the tips of the piled leaves look like tiny fluttering legs. Anthurium flowers emerge from the leaves, producing a single unified form.
Materials: Polypodium, anthurium / Container: White glass

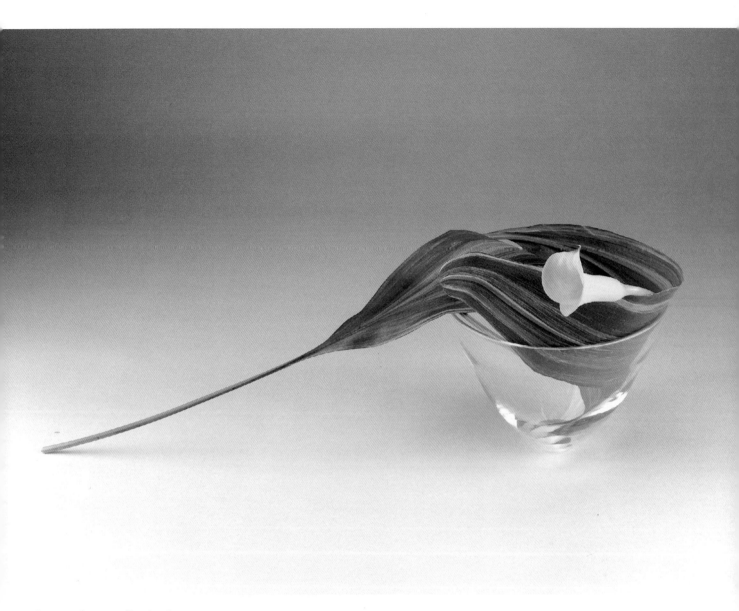

Theme: Like a small animal

Within a transparent glass bowl, the wide tips of two leaves of aspidistra are coiled and one stem flows outward. The yellow calla lily emerges proudly from the leaves as if it were an aspidistra flower. This is an example of the technique called *karibana* (literally "borrowed flower") where flowers and leaves of different plants are combined to create a new form.

Materials: Aspidistra, yellow calla lily / Container: Transparent glass bowl

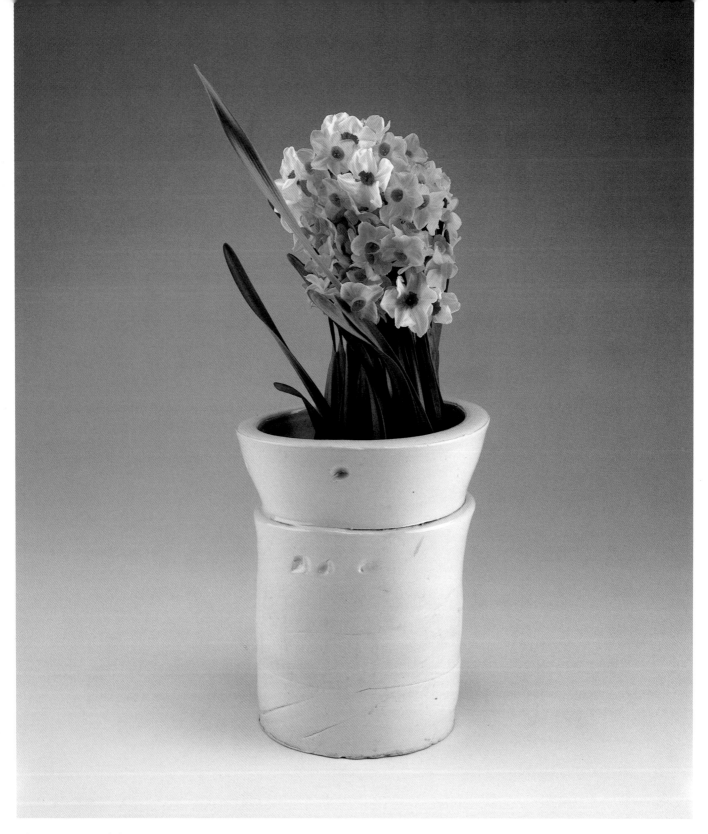

Theme: Narcissus' dream
The massed group of narcissus flowers and leaves seem to recount the dream of Narcissus from Greek mythology. Taking an anthropomorphic approach to a material can reveal unexpected aspects of its unique character.
Materials: Narcissus / Container: Original bowl by Ryoji Koie

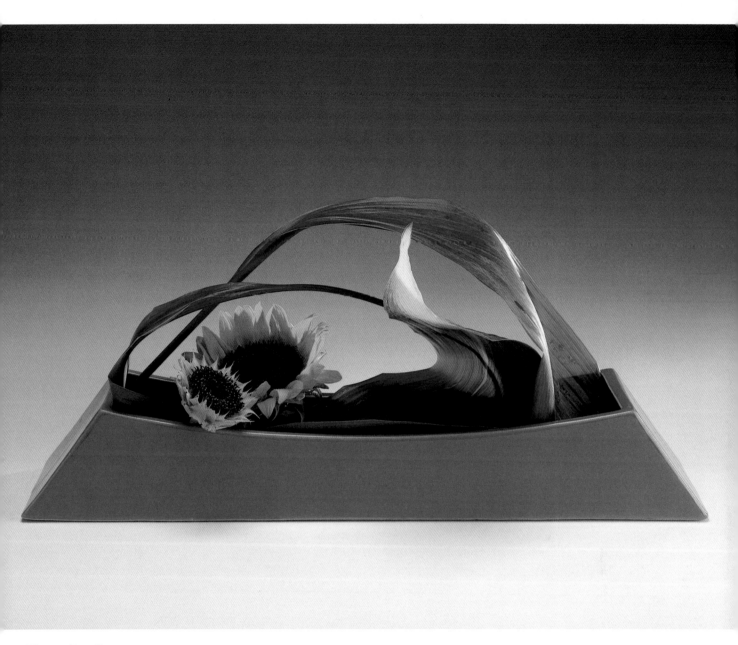

Theme: Two forms
Two sunflowers share the shelter of a canopy of variegated aspidistra. The contrast between the large one with bright yellow petals and the small one with the green calyx is eloquent of the passage of time.
Materials: Variegated aspidistra, sunflower / Container: Hanamai container

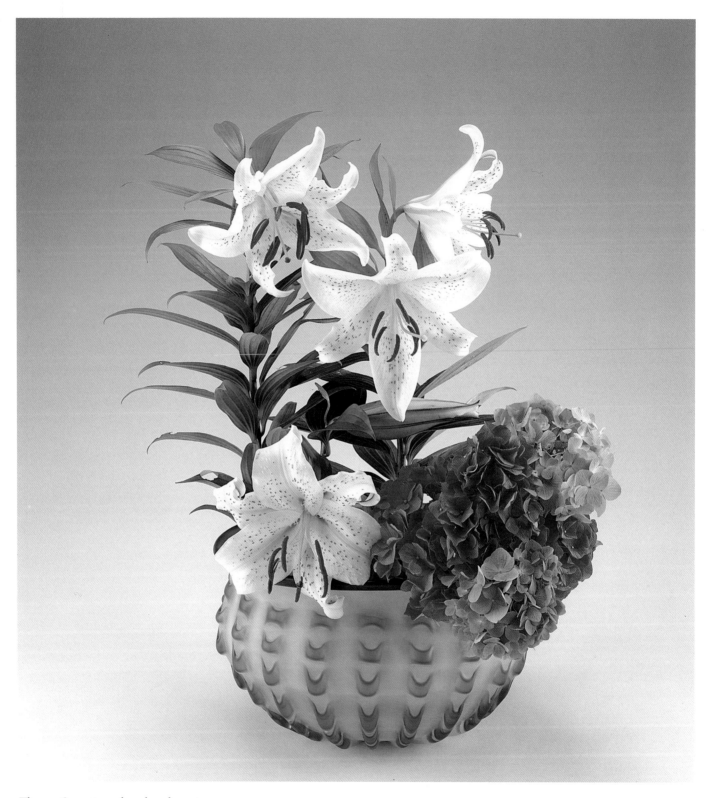

Theme: Sumptuously colored co-stars
With their gorgeous colors, the gold-banded lilies and the mass of hydrangea blossoms co-star in the colored glass bowl. Avoid technical tricks when using large flowers. They should be treated generously, so that their natural features can be expressed in the arrangement.
Materials: Gold-banded lily, hydrangea / Container: Original blown glass by Koji Ishii

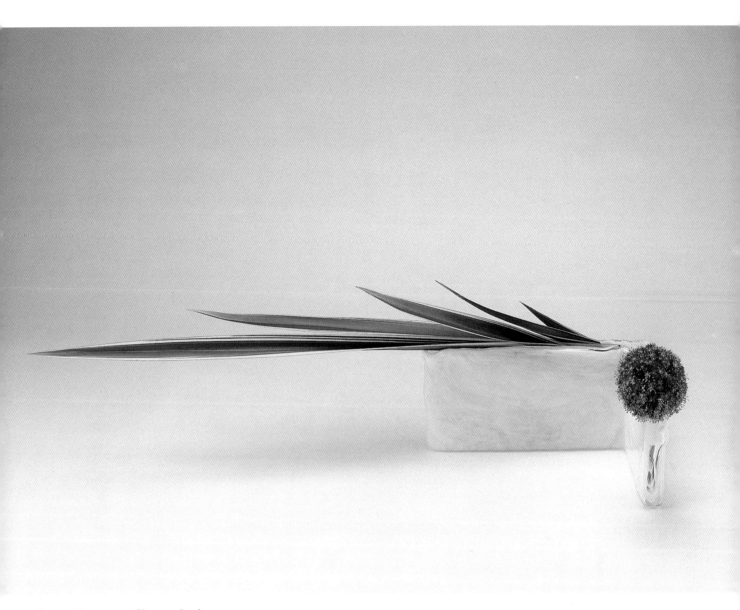

Theme: Harmony of line and sphere
The contrast between the sharp lines of New Zealand flax and the spherical allium creates a simple, abstract form in the L-shaped glass container.
Materials: New Zealand flax, *Allium giganteum,* / Container: White glass

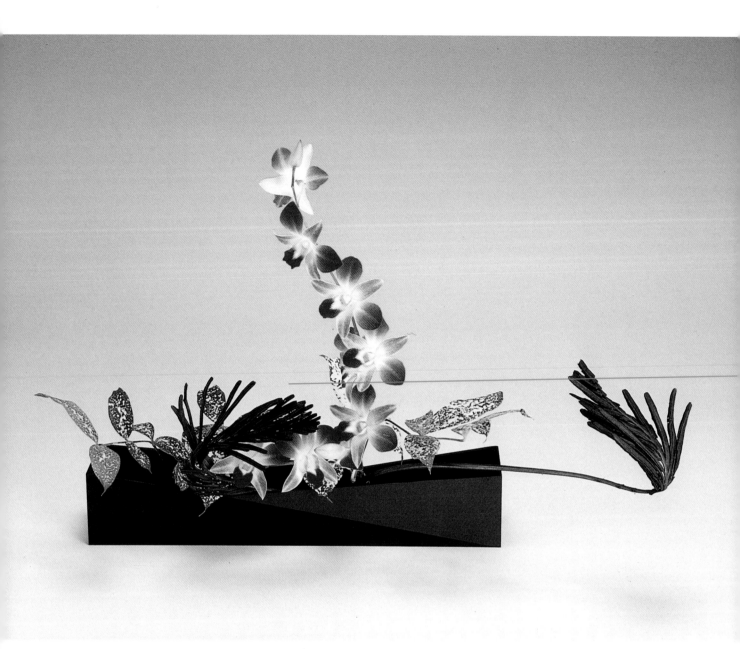

Theme: Beckon

The spotted leaves of the dracaena support the rising form of the dendrobium orchids. Using leaves and flowers of different plants together in this way is called *kariba* (literally "borrowed leaves"). The gansoku ferns placed as if beckoning the viewer add a sense of movement to the work.

Materials: Gansoku fern, Godseffiana dracaena, *Dendrobium phalaenopsis* / Container: Plastic box-shaped *suiban*

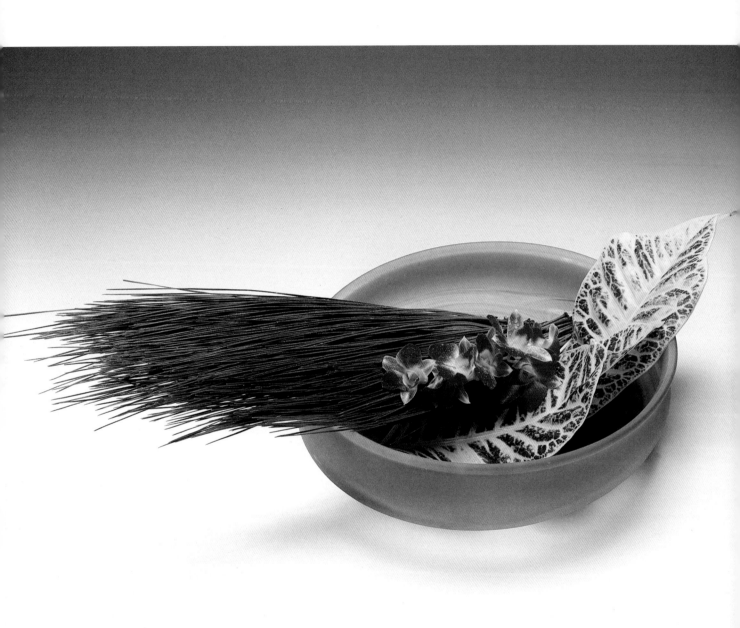

Theme: Contrast of leaves and needles
The pile of long pine needles and the overlapping croton leaves present a beautiful contrast in the colored glass container. The dendrobium flowers are inserted in the pine needles to link the two different forms.
Materials: Long-needle pine, croton leaf, *Dendrobium phalaenopsis*/ Container: Original glass work by Koji Ishii

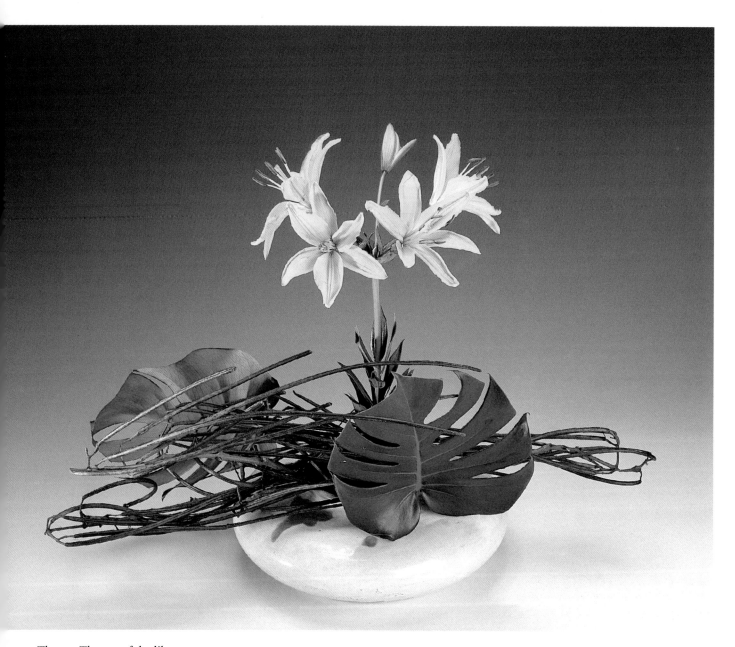

Theme: The cry of the lily

The rebounding lines of the branches and seed pods of Indian bean tree contrast beautifully with the wide surfaces of the monstera leaves. The standing lilies that seem to be calling out produce a balanced form.

Materials: Indian bean tree, monstera, elegant lily / Container: White porcelain bowl

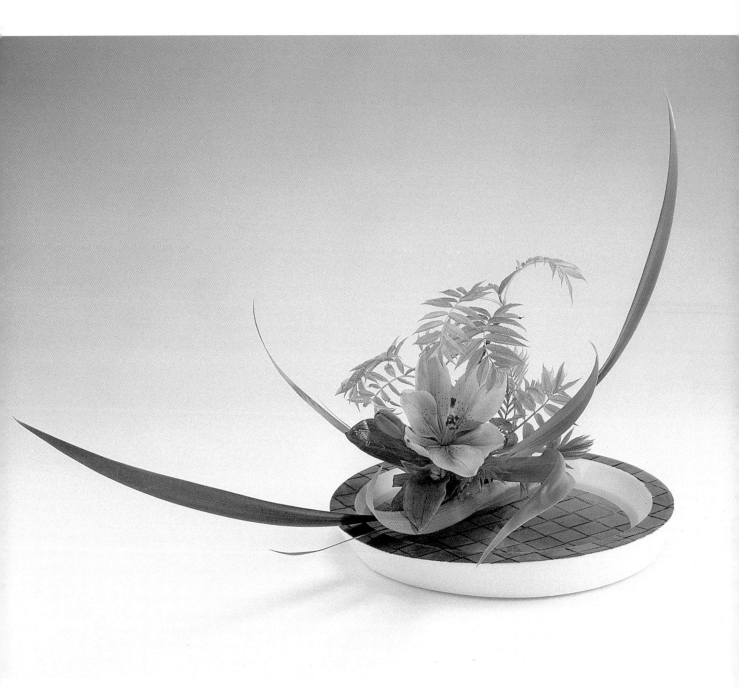

Theme: Leaping leaves
Fringed iris leaves, used as individual forms, can render a dramatic, springing line. The lily is placed as a single focal point with young green leaves of mountain ash added to complete a work that symbolizes youthful life.
Materials: Fringed iris, mountain ash, elegant lily / Container: Multi-colored *suiban*

V
Moribana at Exhibitions

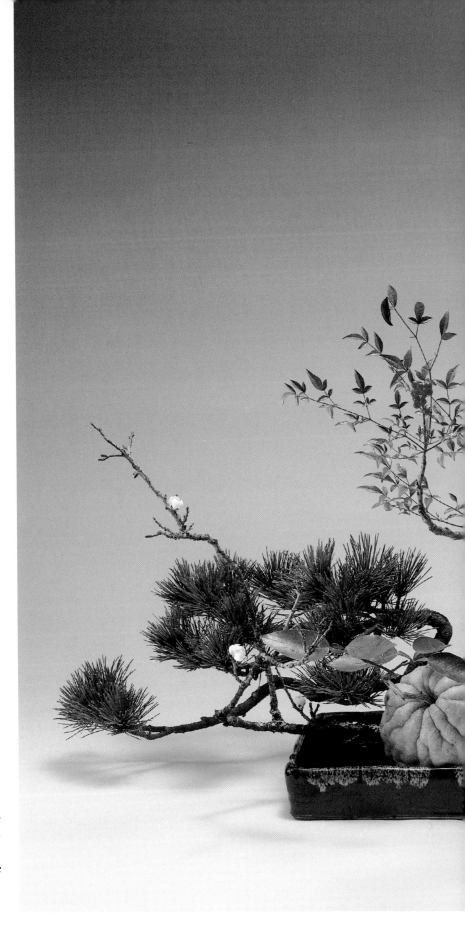

Theme: In praise of Rimpa

Works of the Rimpa school of traditional Japanese painting, which took plants as its subject, provide the model for this arrangement. Here, materials are lined up in a shallow space and each form is stylized and exaggerated to produce a bold design effect. Pine is used to link individual elements into a harmonious whole.

Materials: Nandina, lichen-covered Japanese apricot, pine, vanda orchid, *yuzu* orange

Container: Takatori-ware rectangular *suiban*

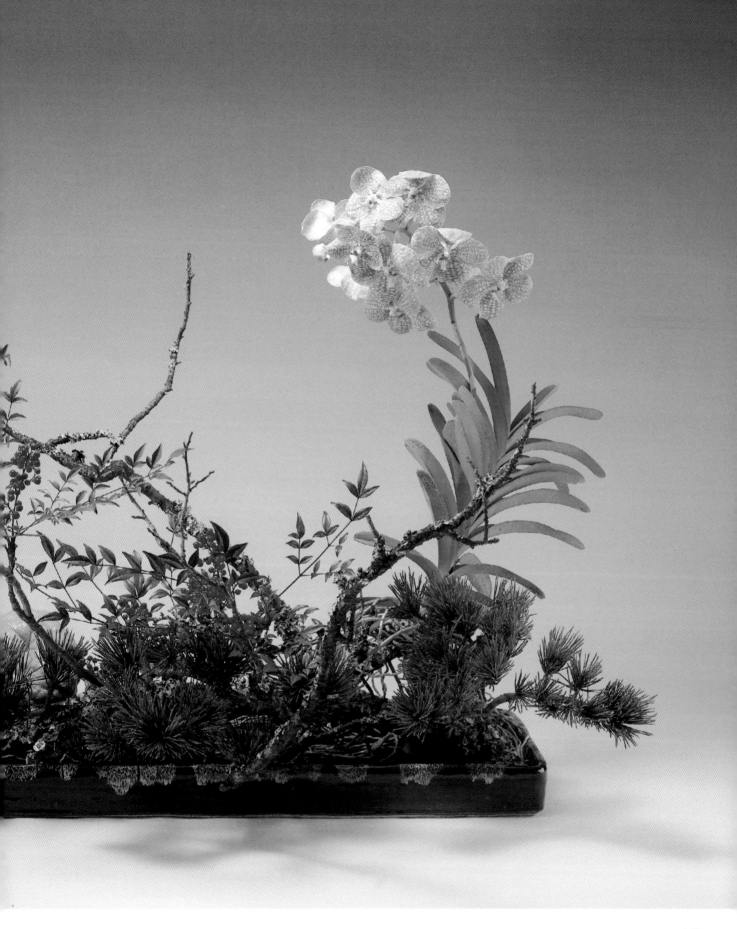

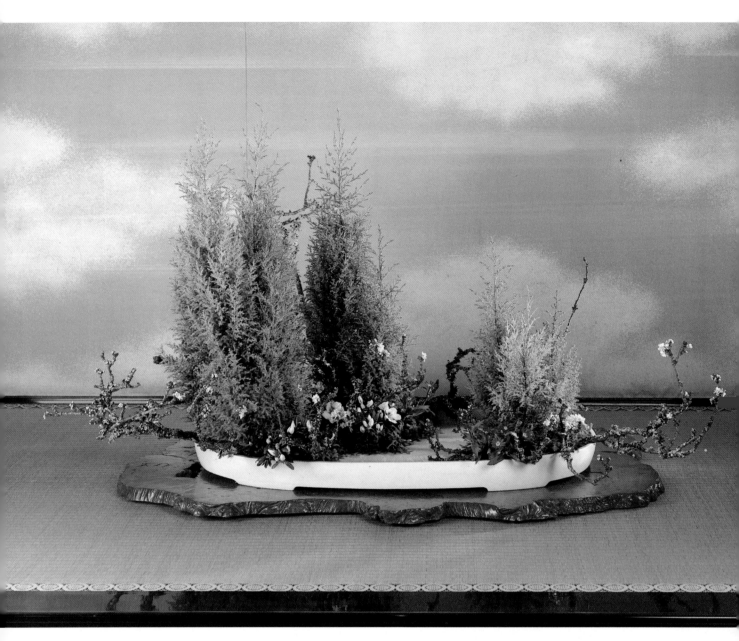

Theme: Spring by the riverside
The arrangement in this *suiban* captures a scene at the edge of a deep pool in a river. Branches of cherry have begun to put forth their blossoms under trees standing on curving riverbanks spread with azaleas and asters blooming in profusion.
Materials: Gold crest, lichen-covered cherry, azalea, aster, club moss / Container: Tobe-ware oval *suiban*

opposite page:
Theme: Symphony of leaves
This seven-variety Moribana is composed entirely of foliage plants. Although the successful combination of leaves of different colors and shapes in a single arrangement is extremely difficult, the Moribana style makes such works possible. The most important point is to begin by choosing three varieties of leaves to establish the basic framework.
Materials: Ryukyu banana leaf , alocasia, Indian dracaena, rainbow dracaena, monstera, sanseviera, geranium / Container: Yellow-glazed *suiban* with a dragon design

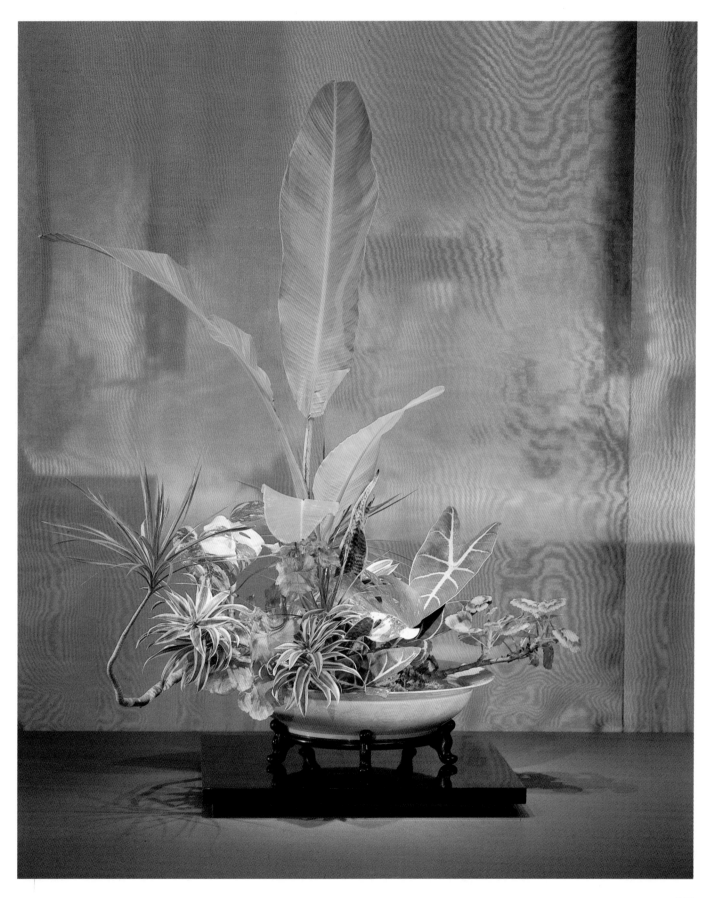

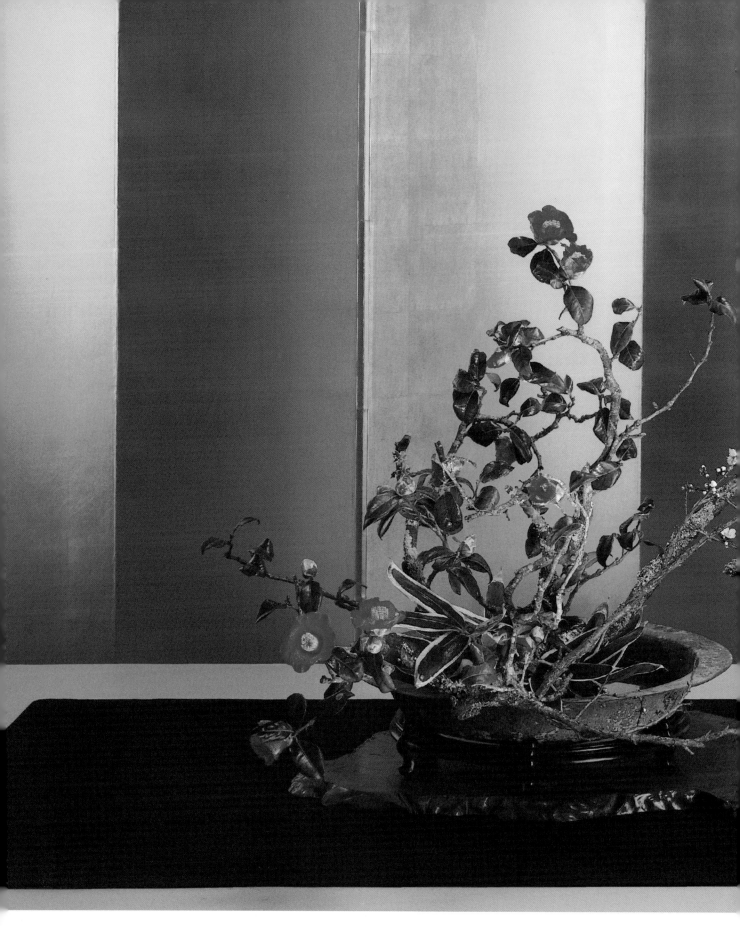

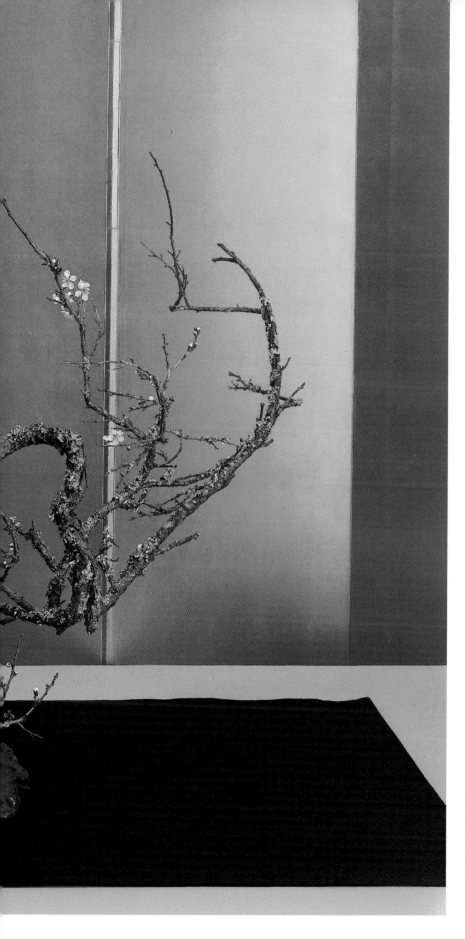

Theme: First to bloom
Emerging from the bronze container, a branch of lichen-covered Japanese apricot that has survived many cold winters has a sublime quality about it. In the encounter with the lively movements of aged branches of wild camellia, we can sense the persistence of a unique world with a rich tradition of elegant taste.
Materials: Lichen-covered Japanese apricot, camellia, sasa bamboo / Container: Han bronze *suiban*

149

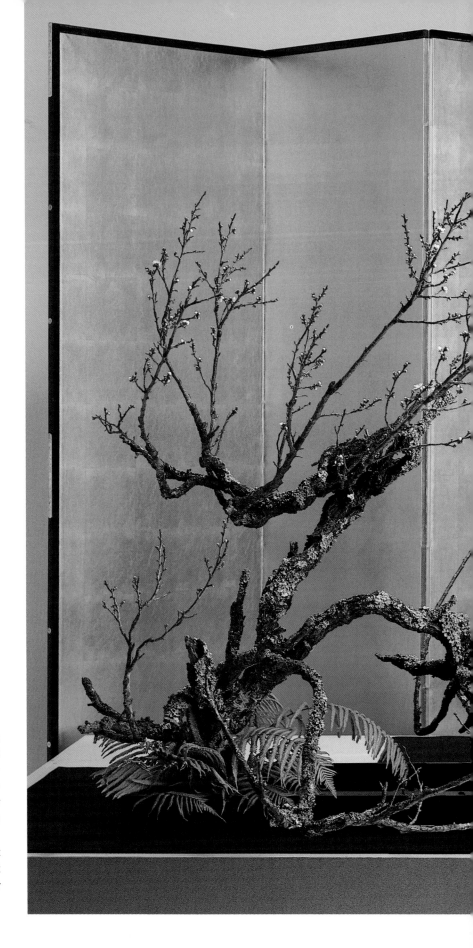

Theme: Winter promise
Two lichen-covered Japanese apricot trees, one white, the other red, stand facing each other across the water. The white symbolizes the male, while the female is represented by the red. Even as they put forth lovely young blossoms, there is a quiet elegance to the seasoned shapes of these aged trees.
Materials: Lichen-covered Japanese apricot (white and red), sasa bamboo, lot tree / Container: Lacquered rectangular *suiban* (2)

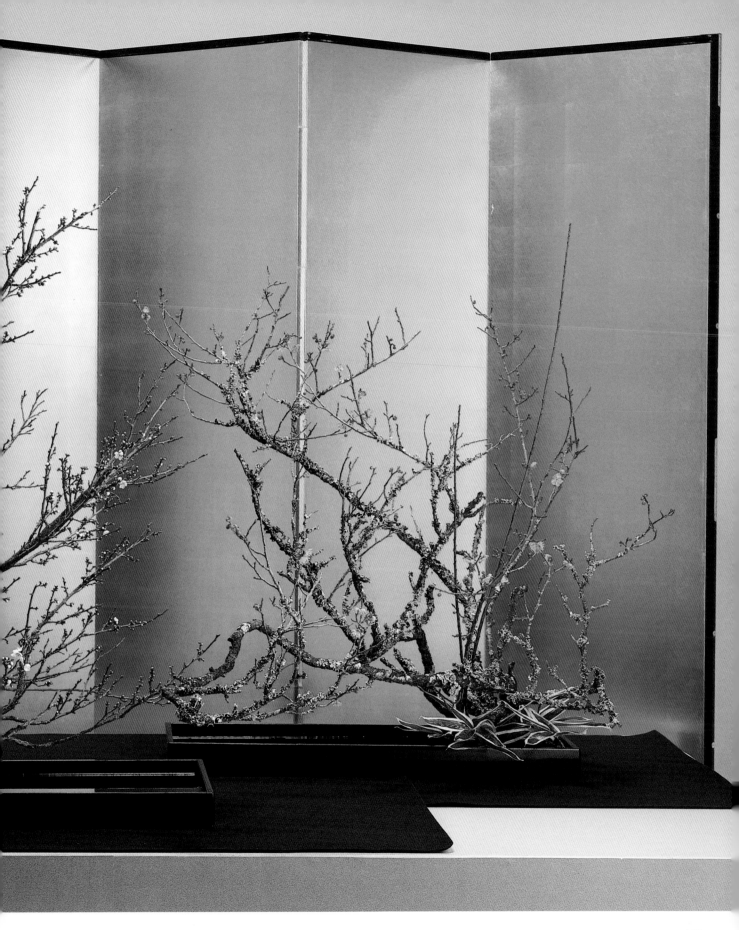

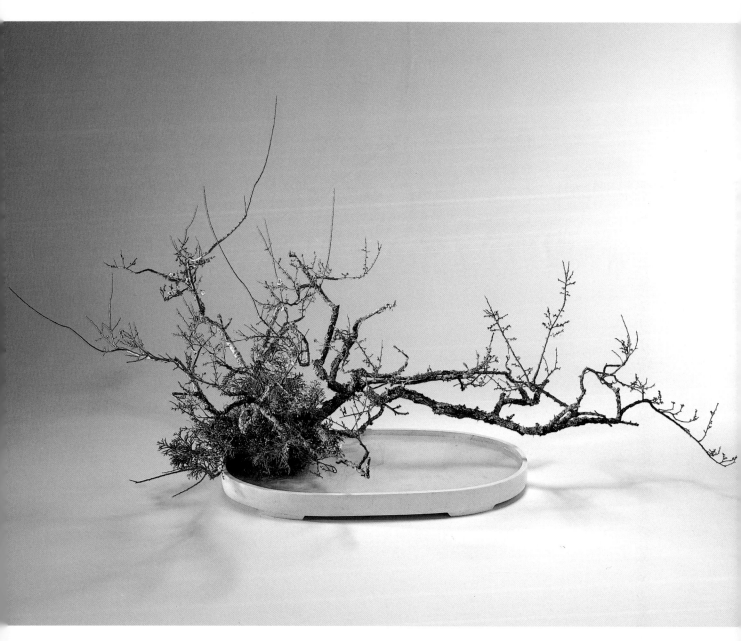

Theme: Viewing the water
This encounter of lichen-covered Japanese apricot and asunaro cypress has the ambiance of a *sumie* ink painting. An apricot branch covered in rough bark extends over the container, casting its shadow across the surface of the water.
Materials: Lichen-covered Japanese apricot, asunaro cypress / Container: Karatsu-ware oval *suiban*

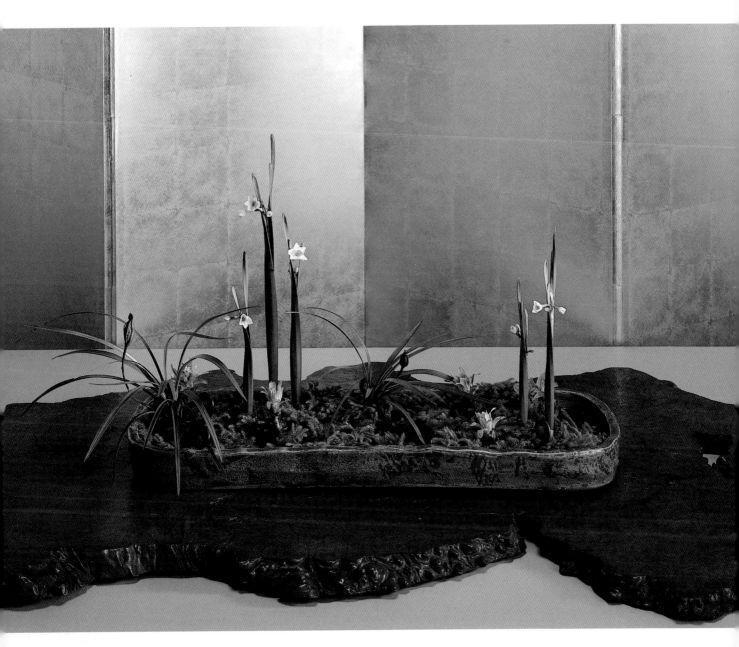

Theme: The sprouting earth
Narcissus flowers bloom tall above the earth as two clumps of Japanese cymbidium, still bearing seed pods, put out new buds. Butter burr breaks through the surface of the ground and comes into flower. When the earth begins to sprout with plants, we can at last feel the coming of spring.
Materials: Narcissus, Japanese cymbidium, butter burr, royal tree fern, club moss / Container: Inabo-ware rectangular *suiban*

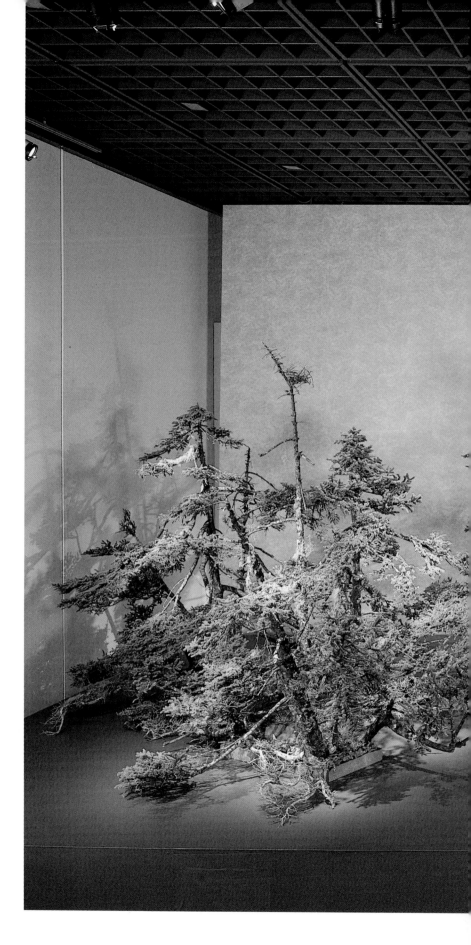

Theme: Spring in Ezo (Hokkaido)
This arrangement depicts a forest of Ezo pine trees in Hokkaido in northern Japan. Ezo pine has a natural tendency to grow in stands of orderly rows. Twenty branches arranged in nine containers evoke the appearance of a northern Ezo pine forest that has survived many severe winters.
Materials: Ezo pine, driftwood, rhododendron, aster, black lily, lily of the valley, butter burr, club moss / Container: Original *suiban* (9) by Kazuhiko Sato

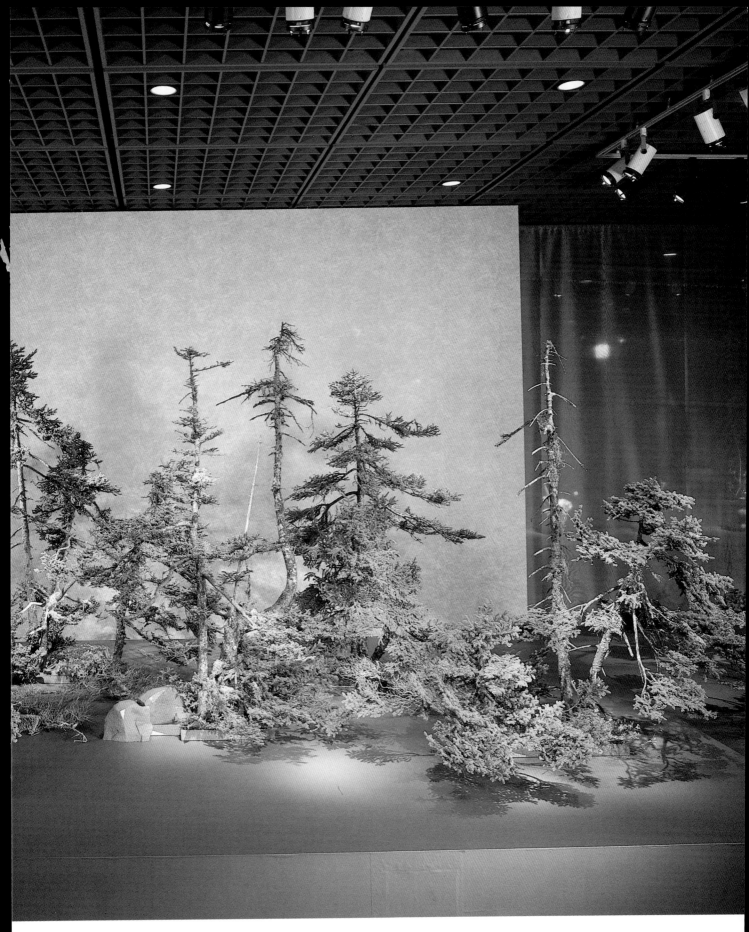

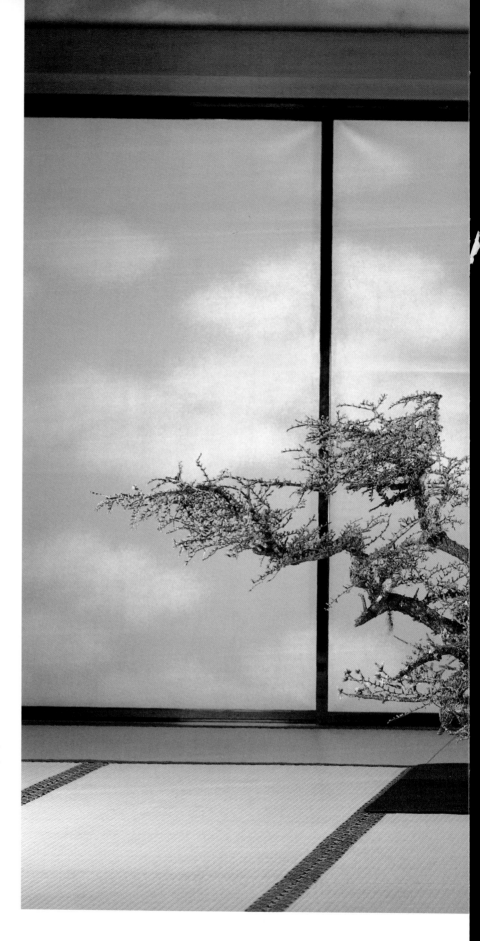

Theme: Marshland road deep in the mountains

The cherry blossoms are already past their prime by the time larch trees put out new green needles and flowers of skunk cabbage appear on the ground. An image of marshlands deep in the mountains is expressed in this imposing container.

Materials: Larch, lichen-covered cherry, rhododendron, skunk cabbage, club moss/Container: Rectangular *suiban* with swirl pattern and legs

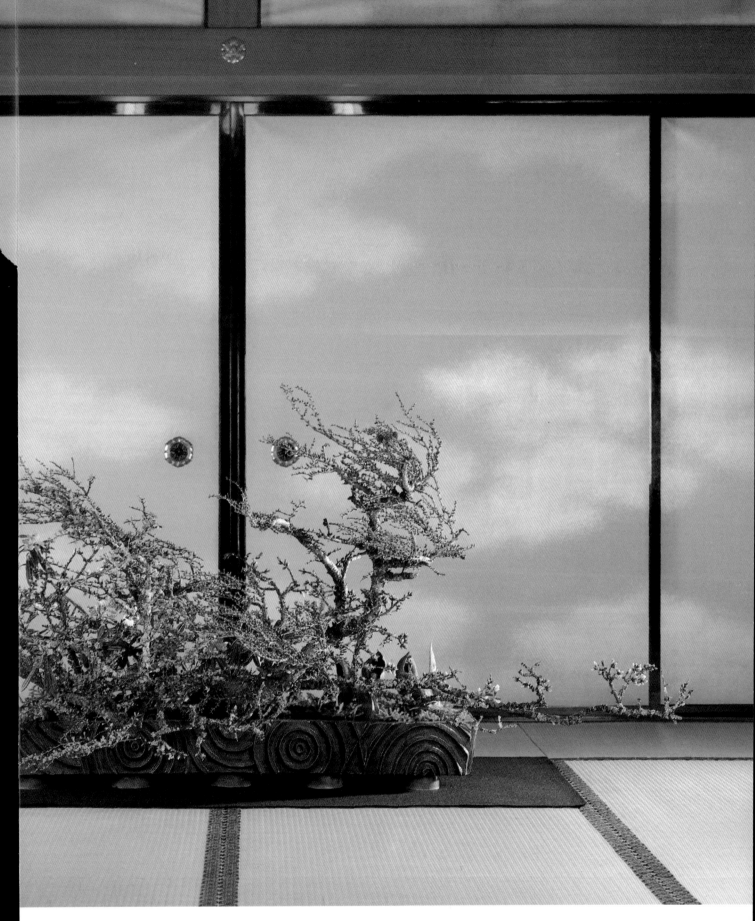

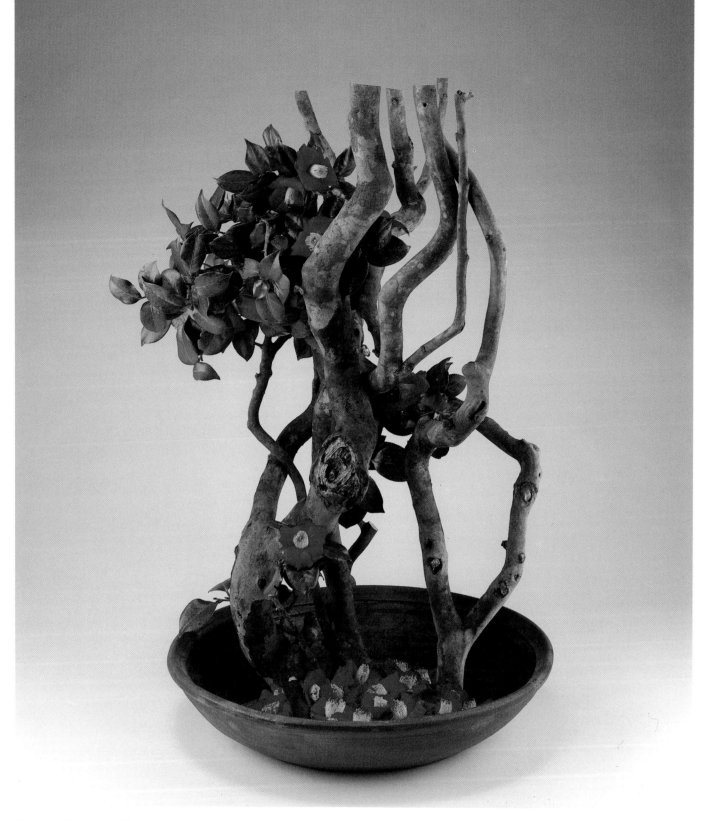

Theme: Fallen camellia blossoms
Thick, curving branches and massed blossoms of camellia are treated as abstract forms. In the container at their base, fallen camellia blossoms wriggle like living creatures in this depiction of the mysterious essence of the camellia.
Materials: Camellia branches and flowers / Container: Bizen-ware *suiban*

158

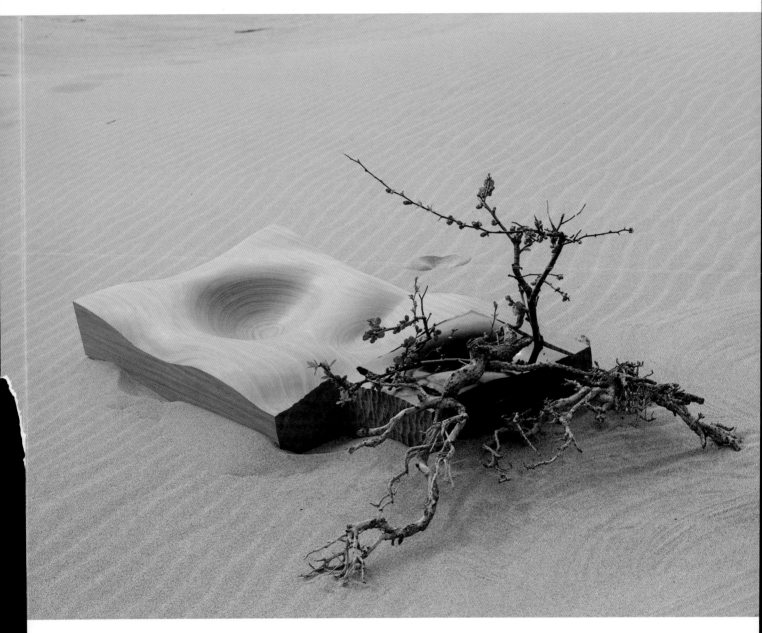

Theme: On a sandy beach
A new form of plant life emerges from the wood and stone objects that lie on a sand dune. The ripple pattern on the windblown sand creates a world of fantasy.
Materials: Driftwood, quince, wood carving / Container: Black stone carving

About the Author
(Relating mainly to activities abroad and currently held positions)

May 1952:

 Awarded Minister's Prize at 3rd Japan Ikebana Exhibition sponsored by the Ministry of Education; Begins career in ikebana

June 1963:

 Teaches for one month as visiting instructor in ikebana, University of Hawaii, Summer School

February 1969:

 Participates in Ikebana International Regional Conference and gives demonstrations in Australia and New Zealand

November 1970:

 Gives demonstrations in Bombay and New Delhi, India

September 1971:

 Holds one-man exhibition, "Microcosm," at the New Otani Hotel, Tokyo

March 1972:

 Participates in the Traditional Arts Section at the Japan Arts Festival in Italy

September 1975:

 Participates in the Ikebana International South American Regional Conference and gives demonstrations in Chile

December 1979:

 Holds ikebana exhibition in the Workers' Palace of Culture, People's Republic of China

September 1981:

 Holds one-man exhibition, "Ki," at the Central Museum of Art, Tokyo.

October 1982:

 Participates in the Ikebana International North American Regional Conference and gives demonstration in Denver

February 1984:

 Exhibits and holds demonstration at Pennsylvania Gardening Culture Association, Pennsylvania, USA

February 1989:

 Gives demonstration in Bombay, India, and directs an ikebana exhibition

September 1989:

 Gives demonstration at the Cleveland Art Museum, and in Boston and Seattle, USA

October 1991:

 Presents an ikebana performance, "Ten no Hanamichi," at the Melbourne Town Hall, Melbourne, Australia

November 1992:

 Holds one-man exhibition, "Koun Ryusui," at Espace Ohara, Tokyo.

March 1994:

 Holds one-man exhibition, "Mao," a flower oratorio, at The Museum, Bunkamura, Tokyo

Present positions:

 Vice-President, Japan Ikebana Art Association Inc.

 Executive Director, Ohara-Ryu Ikebana Foundation Inc.

 President, The Council of Ohara Professors

 Chairman, Ohara Kenbikai

 Chairman of the Board, Kenbi Inc.